Now, finally classical effects animation gets its day in the sun with Joseph Gilland's fascinating new book. It's a revelation of the amazing blend of the art and craft behind the magic of this wonderful artform.

—Don Hahn, Academy Award-nominated Producer *of Beauty and the Beast* and *The Lion King*

Veteran Disney animator Joe Gilland's informative book delivers, for the first time, the real nitty-gritty on the art of hand-drawn special effects. The mysteries of how to believably animate abstract forms representing rain, fire, smoke, etc. are revealed in articulate prose, revelatory graphs and elegantly beautiful sequential imagery.
A must-have guide for animation pros, teachers and students!

—John Canemaker, Academy Award-winning animator, internationally-renowned animation historian and teacher.

Joseph Gilland will excite any artist with the prospect of animating a water splash. And that is just for starters. *Elemental Magic* is an essential reference not only for special effects artists, but for character animators. An excellent performance sparkles all the more when the special effects are right. Animated applause for Joseph Gilland and his wonderful book, *Elemental Magic*.

—Ed Hooks, author, *Acting for Animators*

Elemental Magic

Elemental Magic

The Art of Special Effects Animation

Joseph Gilland

With a Foreword by Michel Gagne

CRC Press
Taylor & Francis Group

A FOCAL PRESS BOOK

First published 2009 by Focal Press

Published 2013 by CRC Press
Taylor & Francis Group
6000 Broken Sound Parkway NW, Suite 300
Boca Raton, FL 33487-2742

CRC Press is an imprint of the Taylor & Francis Group, an informa business

Library of Congress Cataloging-in-Publication Data
Gilland, Joseph.

 Elemental magic : the
 classical art of special
 effects animation / Joseph
 Gilland. p. cm.
 Includes index.
 ISBN 978-0-240-81163-5 (pbk. : alk. paper) 1. Animated films—Technique.
 2. Drawing—Technique. I. Title.
 NC1765.G49 2009
 741.5_8—dc22

 2008046558

ISBN 13: 978-0-240-81163-5 (pbk)

Dedicated to my parents, Frank and Tommy

Contents

Foreword

I was the luckiest man alive when I landed the job of my dreams and started working for Don Bluth as a character animator in 1986. Somehow though, right from the start, I felt miscast. I watched my finished work move on to the effects department, where all the cool stuff was being added: fire, water, mud, lava … you name it! So, after three difficult years in character animation, I asked to be transferred to the effects department. By far, one of the best decisions I have ever made!

Effects animation was like my newfound freedom. While staying within the stylistic boundaries of the movie, I could design my drawings without having to stick to the strict character model sheets. I could stylize the timing and motion without having to adhere to the confines of a dialogue track. I felt like a scientific magician, moving water molecules, creating lightning, and conjuring fiery whirlpools, all from the tip of my pencil.

I remember the first time I saw a scene animated by Joe Gilland. I was watching a pencil test of a duck splashing around in a pond. I was mesmerized by the intricacy of the water animation and the attention to every detail.

My first exposure to Joe's work left an indelible impression on me. Through the years, while I've drifted onto other mediums, Joe has remained dedicated to the craft of effects animation, creating wonderful work for many feature films and teaching new generations of creative professionals.

Many animators and students have asked me to write a volume such as the one you now hold. Although I saw the necessity for such a project, I never felt the calling to create it. I love doing effects animation, but I have never really tried to understand it beyond what comes to me instinctively. Joe, on the other hand, is a true scholar on the subject. When he told me of his intention to write this book, I breathed a sigh of relief and felt great enthusiasm for Joe. I knew the subject matter was in the most capable hands.

As I've said, I truly love the art of effects animation. To me, it is poetry in motion, inspired by the most primal forces in creation. I hope that the wealth of knowledge and gorgeous artwork contained within these pages will ignite the same passion in the hearts of young animators, and will encourage a whole new generation to carry on the swirling, smoking and sparkling torch of classical effects animation.

Michel Gagne July 2008

Preface

In the spring of 2004, at the Annecy International Animation Festival in France, a dear friend and I had a conversation about animation books. Interesting, we noted, that there is not a single book dedicated to classical hand-drawn special effects animation, even though it is an enormously important aspect of the animation business, and a very specialized and specific art form in its own right. While there is a proliferation of books dealing with various kinds of visual effects work, most of these are focused purely on the kinds of polished photorealistic visual effects that we are used to seeing in Hollywood action and science fiction films, using optical live-action film techniques, and more recently, computer-generated techniques.

Yet the fine art of animating special effects—like water, fire, smoke, pixie dust, and every imaginable kind of magic—by hand with a pencil and paper, has never really been documented thoroughly (much less broken down and analyzed, explained and discussed in depth). On that fateful day, in the picturesque alpine village of Annecy, my dear friend uttered the words, "YOU should write that book Joseph!" After that, I realized that I really didn't have any choice: This book simply had to happen.

So here I sit, late at night, staring into my laptop and pondering the infinite world of hand-drawn animated special effects, and the almost thirty years of my life that I have devoted to animating them. What kind of book should this be? A handbook? A textbook? A "how to" book? A pretty coffee table book? A historical document? Maybe it will be a bit of each of those things. I'll leave that for you to decide.

First and foremost, I hope this will be a book which pays homage to the men and women who have created special effects for animated films spanning the last 70 years. Most of them have worked thanklessly in the trenches, often in complete artistic obscurity, fueled only by their intense dedication to their craft. Considering the insane pencil mileage and the technical difficulties required by such work, one must have true passion to draw effects.

Keep in mind, too, that this has never been a path to great recognition or filthy lucre. For all of the countless animated films that we have all watched over the past seven decades, there is a universe of gorgeous artwork that is largely unknown to the average viewer. It is my goal to honor both the artisans and the craft with this book, to bring to the fore what has often been treated as a secondary, less vital part of the animation process.

Our planet is an infinite source of design perfection!

Regardless of your interest, whether you are a student of 2D or 3D animation or a casual moviegoer, I hope you will find this volume informative, entertaining, and somehow imbued with the magic that initially drew me into this mysterious world. Since September of 2003, I have been involved in teaching animation to both classical animation students and CGI animation students for the first time in my long animation career. Students often bring their special effects questions to me,

and I frequently will make a series of thumbnail sketches to best explain a particular technique or idea. I have accumulated an interesting collection of research material and lecture notes through the years, and I often make copies of these for the students, but again and again it becomes apparent that a special effects handbook would be an extremely valuable companion to other animation books such as "The Illusion of Life" and the "The Animation Survival Kit." For my students, and anyone out there starting a career in animation, I hope that this book will delight you and inspire you to keep on drawing, and pushing the effects envelope. For those of you moving into the wonderful world of 3D visual effects, I hope this book will pique your interest and get you to try drawing these effects, and help you understand them more deeply, before using the fantastic digital tools that you have at your disposal.

An enormous aspect of learning to be an
effects animator has to do with learn-
ing how to see, how to observe
and soak in the phenomenon
of pure energy and life all
around us. As with "art" in
general, and every form of
it—be it acting, or writ-
ing, or dance, or painting
or sculpting—we need to
learn to be observers of life,
to be the antennae of soci-
ety, the first ones out there,
inquisitive, probing, observing,
questioning, examining and inter-
preting life.

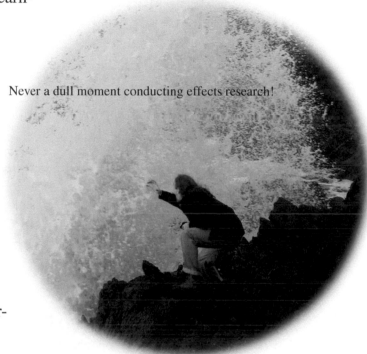

Never a dull moment conducting effects research!

It is that inquisitive spirit that the best
teachers are able to imbue in their students. When we are successful
as art teachers, our students are infected for life, and incapable of ever
seeing this world as anything but magical, mysterious and infinite. The
dedicated effects artist will never know boredom. One never needs to
stop learning on this journey.

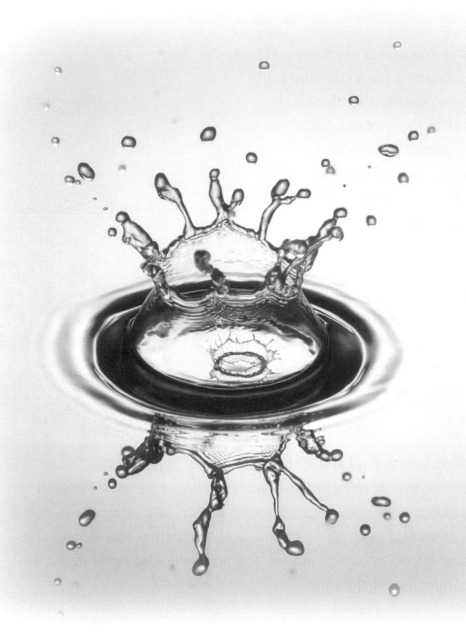

If I can somehow express that spirit of discovery and life itself here in this book, I will have succeeded far beyond my wildest dreams. It certainly has been a continuing magical journey for me, even after 30 years of animating special effects, there remains an infinity of new things to see, to draw, and to bring to life. Not to say that life is without its hardships and low points, of course. Life is certainly always a handful. But the spirit of creative discovery keeps me feeling vibrant and alive, excited, and ultimately very pleased to be writing this preface to this long overdue effects animation book.

I will bring a lot of this accumulated information to bear on this book, and I want to thank everyone I have ever worked with for adding to this wealth of information so that I may share it in this book. I cannot thank you all here, there are too many of you, and I can never thank you enough. But if you've worked with me in the past, you know who you are, and I thank you all. It has been an honor working with you.

And to those students who have asked me the hardest questions, thank you for helping to keep the spirit of discovery alive for me, and for generations of students to come. You are infected with the effects animation bug now. There is no turning back!

It is important as well, for me to note here, what this book is not. It will
touch on some of the history of special effects animation, but it is not
a history book. I will touch on some of the technical aspects of special
effects, but this is not a book about the "camera trick" aspects of special
effects animation, or the deep technical side of special effects animation,
the putting together of all the artwork, the compositing, the art direction,
the picking and choosing of exposures, densities, or colors. Volumes
could and should be written about all of these fascinating topics, but I
want to keep this one straightforward and to the point. How to *draw* and
understand special effects animation.

Acknowledgments

It has been a long journey to finally get this book out of my system and out into the world, and there are countless people to whom I would like to express my gratitude for helping me along the way. Not only those who actually helped me complete the book, but the many who helped me earlier on in my animation career, and my life, long before this book was even an idea in the back of my head. Surely I will leave someone out who deserves mention here, but it means a lot to me, so I will do my best! For inspiration in the earlier stages of my animation journey, I would like to thank Keith Ingham, Paul Curassi, Ishu Patel, David Tidgwell, Anne Denman, Marv Newland, Barry Ward, Delna Besania, Roseann Tisserand, Dianne Landau, Darlene Hadrika, Jason Wolbert, Jennifer Claire Little, Victoria Goldner, Milt Grey, Tom Hush, Mauro Maressa, Pascal Blaise, Chris Sanders, Dean Deblois, Aaron Blaise, Chad Van de Keere, Thomas Haegle, Onni Pohl, Angela Steffen, all the Classical Animation students at VFS from classes 46 to 64, and many more. Extra special thanks to the late Ryan Larkin. And to my dear friend and kindred spirit, Mary Anne Shelton, who left this life far too soon, but left me with the greatest gift of all, you will live on always in everything that I do.

And then there are those who have contributed very much directly to this book, each in their own special way. First of all, to Rita Street, for imploring me to write this book in the first place. Thank you Rita, for seeing it inside me before I could! To Jazno Francoeur, for helping me so much with the writing along the way, you know you should probably have coauthor credits, Jazno, and I really may not have ever done it without you! To Ed Hooks, for his words of encouragement and his indomitable spirit. John Canemaker for his generous guidance. Phil Roberts, and Rick Doyle, for their inspiring artwork, photos, and encouraging words along the way. To Myriam Casper, for opening my eyes to so much, and sharing her life, her vision and her incredible photography with me. To Jim and Claire for helping me to initially get a handle on Adobe InDesign, and Peter Bromley for helping me get started with the bizarre anomaly of Quark. Special huge thanks to Michel Gagne and his wonderful wife Nancy, for believing in me and getting me started, and continuing to help all the way through to the end. To Carole McClendon at Waterfront for her invaluable patience, guidance and experience. To Chris Simpson, Mónica Mendoza and everyone at Focal Press who believed in my book. And to Marilyn, I could not have made it here without you ...

Chapter 1

A Brief History of Classical Animated Special Effects

Although this is not intended to be a history book at all, I thought it would make sense to run through a very brief history of how hand-drawn special effects animation evolved to become a well-developed art form all its own. It has been, through the decades ill defined at best, but nevertheless, special effects animation can stand on its own as an important, exciting, and vital facet of the art of animation. I'd like to take it from cave paintings to computers, and see where we end up!

While the history of animation as a whole took place not only in North America, but in Europe, Asia and pretty much all over the world, I am approaching the art of animating special effects for the most part from the Western or North American standpoint. Much as a book on the history of the fine arts might focus on a particular art period or place of origin, I cannot help but turn to the American Disney classics such as Pinocchio and Fantasia when discussing the art of hand-drawn

1

effects animation which, during the 1930s and '40s
at the Disney animation studios, was brought
to a level of mastery that has not been
matched since.

For starters, let's go way, way back, to
the dawn of man's creative impulses,
and the earliest recorded sculptures and
cave paintings. What we have decided
to call "art" has often reflected man's
fascination with the elements that shape
the world around him. Throughout the early
centuries of recorded history, we see the sun, the
moon, mysterious constellations of stars in the night
sky, volcanoes, floods and fires represented in man's art. Elements and
occurrences that must have frightened, confused and mystified early
man. Events that we labeled "Acts of God" that awoke within us not
only fear and misunderstanding, but also a profound curiosity about how
the world around us might work. Artists throughout the ages have also
continually depicted spiritual and magical energies. Angels bathed in
light, wizards, faeries and cupids casting mystical spells. And as sci-
ence, geology, astronomy, mathematics and physics evolved, there were
always men and women who probed a little further into the unknown.
The "mad scientists", the inventors, the artists, the Leonardo Da Vinci's

of the world. Often misunderstood by their peers, but nonetheless, the real shakers and movers of mankind's evolutionary path. We have within these two groups, a strange mixture of practical, scientific minds, and fanciful, creative minds. This is the legacy of the creative men and women who have evolved into the modern day special effects animation artists. Scientist/artist/magicians playing with a new set of alchemical tools, playing with light and shadow, and playing God with our imaginations!

Shortly after the turn of the century, an eclectic Frenchman named George Melies began experimenting with special effects techniques in his ground-breaking live-action films, using innovative matte paintings, double exposures, split screens, miniature models, and stop-motion animation to conjure up magical looking scenarios, the likes of which had never been seen before. Although he did not work on animated films,

Melies' did create many special effects that could be considered to be *animated*, and his contribution to the future of special effects animation cannot be underestimated. With his genius for inventiveness and experimentation, Melies innovated on the fly as he made his films, and his work paved the way for generations of animation and special effects artists to follow.

When the history of the animated film began, back in the very early 1900s, special effects such as shadows, water, fire, smoke and motion effects were not yet considered as anything but an occasional addition to the main character animation of the day.

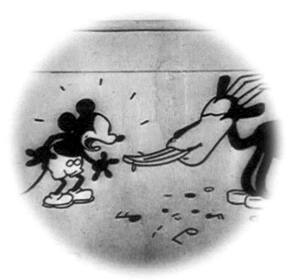

© Disney Enterprises, Inc.

Some of the most influential and beautiful hand-drawn special effects of
the day were seen in Winsor McCay's 1905 classic
"Little Nemo in Slumberland" comic strip, and his 1912 comic
strip "In the Land of the Wonderful Dream" Winsor McCay
was masterful with his renditions of clouds, magic, water splashes, fire
and smoke. His drawings were highly stylized yet somehow incred-
ibly realistic and true to the real underlying physics of the effects being
drawn, especially considering that in that day and age there was no way
of filming these types of phenomena and examining them frame-by-
frame as we can today.

 In the earliest animated cartoons, the special effects were generally
quite rudimentary. There were often exclamation-like designs emanating
from character's heads to indicate when they were surprised or afraid
before sound was added to cartoons, or maybe a character spitting into
a metal spittoon with a loud dinging sound, in time with the music, in
the earliest sound cartoons. A character might pick up an object, like
Mickey in "Steamboat Willie", to bang out a tune with spoon on pots
and pans and other various props scattered around his steamboat.

When in "Gertie the Dinosaur", Winsor McCay's
ground-breaking animation classic, a sea serpent
spat water, there was some simply fantastic
water animation, but not a great deal of
thought or research really went into it, as
the focus was entirely on the magic of
bringing a character to life for the first time.

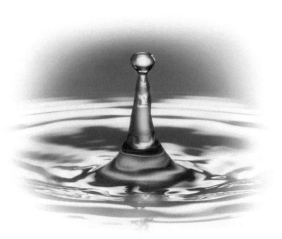

In 1930, Walt Disney Studio's special effects
department was made up of only two artists. Ugo
D'Orsi, who would go on to animate the incredible
water effects in Fantasia's "The Sorcerer's Appren-
tice" and Cy Young, who animated the danc-
ing flowers in Fantasia's "Nutcracker Suite". But that was
soon to change drastically. By 1935 and throughout
what is often referred to as the "Golden Years" of
animation (1935-1941) the effects department
at Walt Disney Animation continued to grow
and develop into a very specialized depart-
ment, and by the late '30's with the produc-
tion of Fantasia, the effects department had
blossomed into a diverse collection of well
over 100 highly specialized artists. Led by the
genius of artists like Carleton (Jack) Boyd, Josh
Meador, and Dan McManus, this department elevated
special effects animation to the level of a truly fine art.

"The men and women who solved these problems were skilled craftspeople of diverse background who had been thrown together in the catchall department, special effects."

—Frank Thomas and Ollie Johnson from "The Illusion of Life"

© Disney Enterprises, Inc.

Through experimentation and observation and a great deal of very hard work, what was once a secondary aspect of animation became more and more vital to the art of animation. These were a new breed of animators, artists with a pronounced interest in nature and the elements, often with a deeply scientific approach, bringing artistic flair and originality to their work. Special effects became a passionate calling for these individuals (as it has for me) who went to incredible lengths to understand the physics behind fire and smoke, and water in all its forms, light and shadow and its interplay with backgrounds and characters, even the simplest falling leaves or flower petals would be studied

intensely to achieve a sense of magical realism. The mastery of the
water animation in Pinocchio's "Monstro" the whale sequence, and
the birthing of a planet, with volcanoes, earthquakes, and typhoons in
Fantasia's "The Rite of Spring", were inspired achievements of anima-
tion which have yet to be equaled to this day. In Fantasia, virtually every
type of effects animation imaginable was explored, researched, and to a
great degree, mastered. In the film Fantasia alone, the effects animation
department handled a staggering array of phenomena.

Earthquakes, volcanoes, lightning, rain, bubbling and spewing lava,
bubbling mud, magical fairy dust, dandelion seed pods, glistening
water drops on a spider web, ocean waves, steam, snowflakes, leaves
and flower petals, magic spells, meteors and swirling galaxies, smoke,
spirits, frost, clouds, and countless forms of water splashes, waves, and
ripples. Even this is only a short list! Special effects, although still a
very loosely defined term covering an incredibly broad range of anima-
tion styles, techniques and technologies, had truly come into its own,

and other studios soon followed suit, turning to artists with a particular penchant for understanding and animating the natural elements necessary to make their cartoons truly come to life. While it is all good and well to romanticize this amazing discipline of bringing the elements to life in animated drawings, there is another side to special effects animation that is not romantic or exciting at all. The sheer volume of work and endless pencil miles required to animate something like a heaving ocean surface or an enormous avalanche rushing down the side of a mountain, is tortuous at the best of times.

Of course animating characters and cleaning them up and adding in-betweens is no walk in the park either, but anyone who has done both can tell you that some special effects scenes will send you to an early grave if you are not prepared for the incredible levels of graphic detail that can be involved. So anyone interested in special effects animation should keep this in mind.

The men and women who pioneered this work were not only ingenious, inventive and brilliant, they were also absolutely crazy! And there were those in the business of making animated films who took full advantage of this newly born department full of inventors and creative outcasts. Thus was born the new hybrid effects animation department, the department that does all the stuff that nobody else in the studio wants to

do. So if it were discovered that no one in the studio had ever drawn or animated an automobile, it would get sent to the special effects department. If a character had to handle a difficult prop of some sort that the character animators didn't want to deal with, it got sent to the special effects department. Of course making animated films is always a highly

collaborative venture, there is generally a lot of back and forth and sharing of difficult tasks, and it would be an oversimplification to say that all the difficult, gnarly animation jobs got sent to the effects department. However, I can say without a moment's hesitation that the effects departments in most animation studios I ever worked in, evolved into being catchall departments for all the oddball jobs that come up when you are making an animated film.

Today, the modern art of animation filmmaking relies more and more heavily on computers. Animation artists have adapted quickly, realizing that computer technology removes a great deal of the difficulty and drudgery involved in producing animated films. Recently, the most successful animated films have been almost entirely computer generated (with the notable exception of the Japanese animé market) and the future of hand-drawn animation in feature films has been brought into question again and again. But the men and women in the studios that are

making the most successful films out there today know better. The success of these 3D films relies heavily on the experience and expertise of classically trained artists who have successfully learned how to work with computers.

The background knowledge of how to bring our artwork to life has not changed. Only our paintbrush has changed. With every new advantage that computers have given us, new challenges have arisen, and the most serious challenge today, is to ensure that the classical art form of learning how things really work is preserved.

Let this book be a testament to the men and women who mastered the art form back in the 1930s and '40s, and left behind for us a body of work that is staggering in its depth of creativity and in its understanding of the elements and physics in general. Anyone who attempts to learn these old school special effects techniques can't help but greatly admire these phenomenal animation artists. And the skill and understanding that this study will bring to any animation artist's work cannot be underestimated.

Today, in the rapidly growing and evolving world of digital technology, we should see the vision of these great artists reflected in all the animation we create, regardless of the technique we choose.

The animation principles outlined in this book need to be studied by *all* special effects animators, particularly the digital animation artists out there today, whose schooling too often simply skims over the real underlying *understanding* of the elements that should be driving all of their work. The study, observation, research and practice of these fundamental but often overlooked principles will make a difference in the quality of the visual effects that we see in the future, thus bringing continuity and integrity into the ongoing history of special effects animation.

Chapter 2

The Art of Drawing and Animating Special Effects

Given the amount of visual effects that bombard us on movie screens around the world today, you would think there would be at least one book dedicated to the process of effects design and visual physics from a more "classical" approach. My greatest incentive for creating this book is the complete lack of such information currently available. Neither animation professionals nor students have adequate references describing in detail the classical approach to drawing and thoroughly understanding special effects animation.

With the incredible digital design and animation tools we now have at our disposal, countless books are being written on this topic, with their primary focus being on understanding how to use these relatively

new digital tools, while less emphasis is being put on understanding the actual phenomena which we are attempting to recreate. More time is being spent teaching young artists how to manipulate complex computer graphics software, and less time is spent teaching them how to observe, how to see and intuit the incredible subtleties of nature's splendor in order to best represent it as artists. This may make them more inclined to depend on a programmer's version of the natural world rather getting their hands dirty. Programmers are coming up with some fantastic simulations and programs that scientifically mimic nature with staggering accuracy and detail, and you can be sure that the people who create these visual effects simulations are out there researching this natural phenomenon in order to break it down (much as the original Disney effects artists did in the 1930s).

In my experience supervising digital artists over the last ten years, I have consistently come across individuals who have developed a high level of design skills as well as a high degree of proficiency with their digital tools, but who haven't developed the sense of feeling the physics of what they were trying to animate. During the course of their schooling, the steps of understanding natural phenomena through the practice of research, touch, feel, personal interaction, and drawing had been all but left out.

This is true of both the digital visual effects animators and digital character animators entering the animation business today. The top CGI studios and directors are well aware that the study of character animation through traditional observation and drawing techniques is the best way to master the craft. I don't think that visual effects animation is any different. Learning to see and feel through hand/eye coordination practice,

observing, drawing, sculpting, animating
by hand–all of these are invaluable if an
effects artist wants to get to that mystical
place where time, space, physics and
motion become fully natural and intuitive.
Get out there and research your subject,
get to know it inside and out, like a
method actor who throws himself into

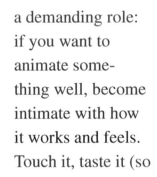

a demanding role:
if you want to
animate some-
thing well, become
intimate with how
it works and feels.
Touch it, taste it (so
long as it's not toxic), draw it,
photograph it, sculpt it, analyze
it, but most of all observe it as
much as humanly possible. At-
tention and observation is key!

I have spent endless hours at the beach watching the ocean, letting it fill in and around my senses. If you are attentive, and receptive, you can let the visual information inform your subconscious simply by being there with your eyes open. Sketching and taking photographic reference is beneficial, but I cannot stress enough the value of simply letting the information in.

Balance this relatively inactive practice with lots and lots of

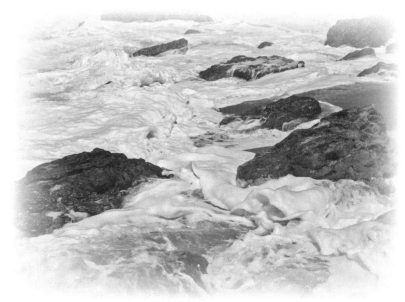

drawing. The hand/eye coordination is of the utmost importance, whether you end up drawing or using a mouse or tablet to draw digitally. Remember that no matter how well you master your drawing technique, if you can't feel the effects you are trying to animate, they will not sing with life. An imagination that is full of life, must inform the well-trained drawing hand!

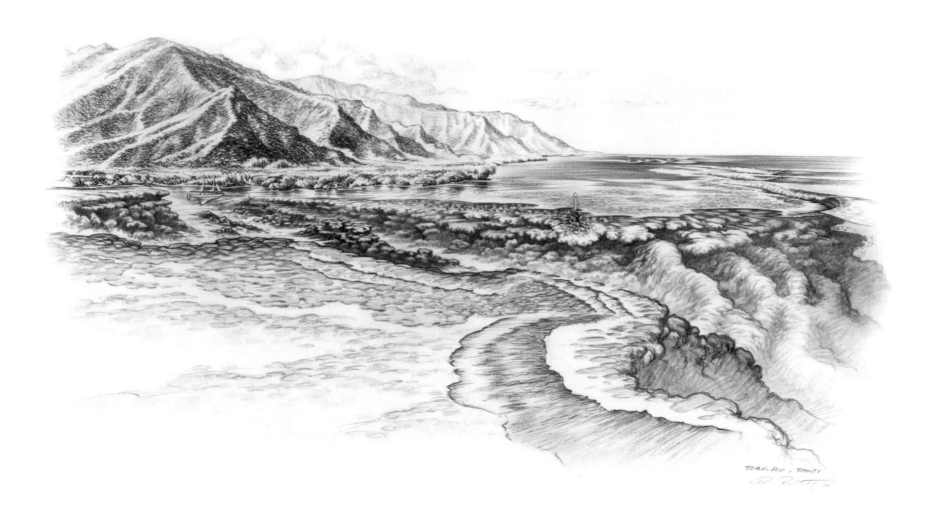

The incredible studies of reef structures and wave behaviors of master surf artist Phil Roberts, are the result of decades of experience and research, coupled with his incredible drawing and painting skills. Wherever your life takes you, keep your eyes opened, as the magical energy of the elements dances all around us, at every moment. Whether we are in a tropical paradise, waiting for the next ocean swell on our surfboards, or being splashed by a taxi in downtown rush-hour traffic, the information we seek is right under our noses!

On the following pages, I have illustrated the relationship between forms commonly found in nature, and the energy patterns that inform all elemental special effects animation, like smoke, fire and water. Whether it is a gnarled up old piece of driftwood, the root system of a tree, a puddle in the sand, a random pile of beach debris, or a perfect curling wave, the same energy patterns are inherent in all forms of nature.

These building blocks of life, connect the very tissue of reality as we know it. It is everywhere around us, if only we open up our eyes to it. From the macrocosm, to the microcosm, the same energy holds it all together, and this magical energy, which science can't yet even begin to fully understand, must inform every stroke of our pencil, when we design and animate elemental magic.

This magical energy must inform every stroke of our pencil…..

As the head of the visual effects department at Walt Disney Feature Animation in Florida, I took my effects crew on several very interesting field trips. On one such outing we spent an afternoon drawing and cavorting at the beach, on another occasion we went to Cape Canaveral to watch the space shuttle lift off.

I also encouraged experimentation whenever possible. The practice of conducting experiments to see how things really work is one of the most fascinating aspects of understanding special effects animation.

Sometimes the experiments and demonstrations were surreal (as evidenced by a fire chief who seemed to enjoy lighting things on fire a bit too much), and other times they were downright scary (as when the Disney theme park folks incinerated a giant cement bunker filled with expired fireworks).

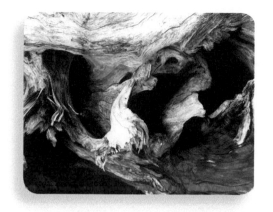

By far the most hilarious experiment was our department's annual "Destructo Day," where all manner of objects were smashed, blown up, or otherwise obliterated. Some of us drew pictures, some took still photography or video, and the rest simply watched.

Not only were these entertaining team-building experiences, but I believe every one of us learned more than we ever could have by sitting in front of a drafting table or a computer.

While on assignment in Hawaii to do visual development research for the film "Lilo & Stitch," it was my job to get out there and study the waves of the beaches, rocks and cliffs of the Hawaiian shoreline. I watched surfers for hours, and shot hours of videotape. I got in the water and felt the swells moving me,

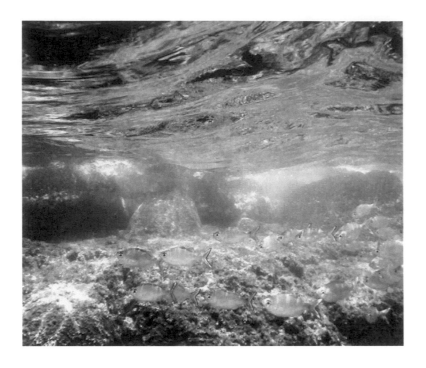

I got under the water and looked up to examine the way the sky, clouds, mountains and trees distorted through the surface. While I was playing in the water, our directors, art director, production designer and animators were observing the Hawaiian people, the villages, the mountains, and the forests through their respective media, i.e., drawings, paintings, photography and video.

This was not frivolous spending on the part of Walt Disney Animation Studios, or some crazy junket contrived by artists chained to their tables too long (and wishing they were in, say, Hawaii). This was because the company knew full well that observation of your subject matter is paramount if you want to imbue your art with soul and integrity. In a nutshell: Know your subject matter. Get out there and experience it, even if it's just in your own back yard.

So, let's say we have done our research, our experimentation and our observation. How do we take all this information and get it onto paper?

What drawing techniques do we need to embrace? How does one capture the extremely complex shapes of elements, like fire and water, and invest them

with "life"? The answer is simple: loosen up, and let your drawing hand flow. In the same way a good life-drawing teacher will encourage us to quickly draw a figure's "gesture," we need to spend a lot of time observing our model, which in our case is the natural phenomena we wish to recreate.

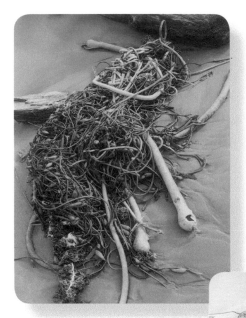

A pile of seaweed can contain all the energy of the universe!

Draw with as much abandon and freedom of movement as possible. Although the designs and patterns we wish to represent may be filled with intricate details, what we need to capture first on our blank sheet of paper is the energy and movement underlying the detail. Every wave, ripple, splash, lick of flame, or plume of smoke has beneath its details a natural energy form much like a human's underlying form of skeleton and muscle. Gravity, hot and cold air, and any number of outside forces may inform that energy pattern.

Once in motion, these energy patterns play out in a uniform force, moving in a beautifully logical way, until the underlying energy dissipates. Whether it is a house on fire, or a 40-foot wave rolling toward the coast of Hawaii, there is cause-and-effect playing out in the metamorphosis of energy patterns. That energy must inform our hand as we sketch our initial effects animation drawing. If we have studied our elements thoroughly, we will instinctively move our hand with arcs and paths of action that possess this very energy. In the chapters to come, we will discuss these patterns in

detail. The emphasis here is to understand that the underlying substance of every effect is pure energy. We will also discuss what happens when that energy collides with an object, or an opposing energy force. Here are just a few examples of this phenomena: light rays hitting an object and casting a shadow; a wave colliding with the shoreline creating splashes, then receding and colliding with the next approaching wave; smoke billowing upwards and spreading out across a ceiling; and raindrops landing on a sidewalk.

So if the structure of our effects drawings contains this energy, this thrust of pattern and motion, then what of the details? Where and how do they fit into the picture? This is the key to every great effects drawing. Every tiny ripple on an ocean's surface, every droplet of a splash, every detail of a nuclear mushroom cloud is informed by a similar energy pattern. Sometimes it is the same force that drives the overall effect; sometimes it is a subset of that energy, or an opposing force. As we finesse our effects drawings and add details, these energy forces must inform

This tree trunk has an incredible amount of energy in its form!

every stroke of our pencil. The droplets that break off of a splash are moving with the same energy of the overall splash. They move within a pattern of energy, and our hand, our brain, and ultimately our pencil must connect with that energy and express its elegant logic. A turbulent river flowing through a canyon is being driven by gravity, everything it does is informed by that energy. However, along the shore

of the river, rock formations may collide with the energy of the water and whip it into whirlpools and eddies, creating splashes

and spiral patterns, mixing the water
with air to create bubbles and
foam. A gust of wind may be
creating small waves on the
surface of the river that move
in the opposite direction
of the river's flow.
All these forces,
or overlapping
actions, need to
be taken into
consideration
when creating
a special effects
scene. While
some highly detailed
effects drawings may
appear to be filled
with random details,
it is very important to understand
that if it is a good effects drawing,
every detail in it is informed with
a pattern of energy. Also intrinsic to
effects drawings are natural design principles,
which are best observed and felt rather than

Whether we are drawing a river flowing downstream, as on the previous page, or a billowing smokey fire as we see here, our effects drawings must be informed with natural patterns of pure energy!

scientifically understood, though I will do my best to describe the more scientific aspects of these design principles in the following pages. By carefully studying patterns in nature, one begins to discover a cosmic similarity in all the natural elements on this planet, which are at once perfect and chaotic, yet wholly unique (for instance, every snowflake has its own discrete design).

The patterns in nature shift between the macrocosmic and the microcosmic, bridging the distance from the cosmic to the cellular. The spiral of a galaxy is reflected in the twist of our DNA, a budding fern, a snake's skeleton, and a snail's shell. The branching out of pure energy as it flows from place to place is evident in a bolt of lightning, in the spreading branches of an oak tree, in the veins that run through our bodies, in a crack on the sidewalk, or in the arterial channels of a river delta flowing into the ocean.

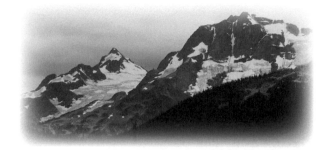

"The fractal beauty of a mountain range that takes our breath away can be seen in ocean waves heaving in a storm."

"The patterns in nature shift between the macrocosmic and the microcosmic, bridging the distance from the cosmic to the subatomic."

By carefully studying patterns in nature, one begins to discover a cosmic similarity in all the natural elements on this planet.

Study nature, observe and feel the patterns of energy inherent in the world we live in.

The fractal beauty of a mountain range that takes our breath away can be
seen in ocean waves heaving in a storm, or in a single rock held in our
hand. Even if we are animating supernatural phenomena, like pixie dust
or flying spirit entities, there must be contained somewhere deep within
our drawings these archetypal principles of natural design. They
are everywhere around us, and yet escape the eye and the hand of a great
many artists.

Study nature, observe and feel the patterns of energy inherent in the
world we live in. To accurately illustrate these patterns is one of the
greatest challenges in creating beautiful, yet accurate, special effects
design drawings. For some reason, there is a human tendency to create
repetitive shapes and to err on the side of bilateral design. Our left brain
takes over and forces our drawing hand to repeat shapes

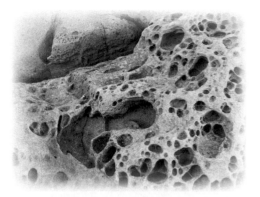

whether we want to or not. This is an aspect
of drawing effects that confounds every practi-
tioner of the craft. Even after all these years,
I've noticed this annoying tendency can still
grip my drawing and turn it into a boring, often
symmetrical affair full of repeating shapes and
parallel lines, which then need to be reworked
again and again. Sometimes the intuitive feeling
of natural phenomenon flows from every stroke of
the pencil, other times I find it is necessary to seek
out and destroy those pesky repetitious shapes,
(or "parallelisms").

What is essential in most forms of
architecture and technical drawing is
the death of a successful organic effects
drawing. (I say "organic" because effects
that are "inorganic," such as props, mov-
ing machinery, crumbling buildings, etc.
require a more linear, pragmatic mode
of thinking and drawing.) Much of this
tendency is a result of pattern recognition,
and our equating certain phenomenon
with clichéd images, like employing
symmetrical repeating popcorn shapes
to describe clouds. "Iconifying" an

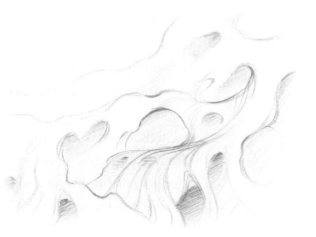

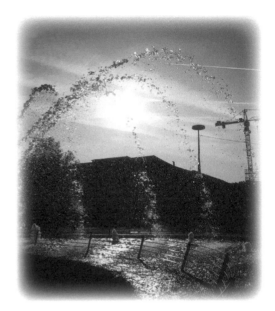

*If we walk by the same fountain every day,
do we really "see" the intricate and wonderfully
varied shapes of the water as it flies
through the air?*

object may work for hieroglyphics and corporate branding, such as the CBS eye logo, but it has nothing to do with the true mechanics of the object it describes. An eye is not an almond shape with a circle in the middle, just as water is not a series of repeating scallop shapes. If you were to take a single water splash and darken it in completely, we would only be left with its "silhouette," which is to say its primary shape. Within the primary shape, there are secondary shapes, where most of the intricate details occur; this also happens to be where much of the twinning occurs.

In hair, fur, and organic objects such as grass and leaves, it is common to unconsciously draw "buzz saw" patterns. The solution is to make sure the spacing is not too even or that shapes do not tangent directly, and that there are a variety of big, medium, and small shapes. This creates contrast, and in every aspect of effects animation one is confronted with the need for it, whether one is drawing splashing water, magic particles, powdery snow, bubbles, a cluster of rocks, or a shattered object. There is a tendency for the new effects artist to "noodle"

*On the left we see an iconic symbol for water, with its scalloped, repetitive
shapes, as we might see on a theatre set, or in a children's story book.
Real water looks more like the random shapes on the right.*

*Here on the left we see the iconified "hot-rod" flames that we typically see on
the gas tank of a motorcycle, or a pair of surf shorts. Real
fire has far more chunky and unusual shapes!*

*The popcorn cloud on the left is very typical of a graphic cloud representa-
tion. Its shapes are repetitive and uninteresting. The cloud on the right
is far more realistic, its shapes are more random.*

the secondary shapes, but neglect the primary silhouette. This often results in highly detailed drawings which are confusing to look at and even more confusing to animate. Sometimes the most complex phenomena happen right under our noses, when we rinse our razor in the sink, when we pour cream into our morning coffee, or when we let out a large breath of air in the freezing cold as we reach for the paper. And yet we automatically default to a mode of non-observation, where these things have no particular significance. Every human being has an innate feeling of how the world works because of these rote, almost unconscious daily observations. That's why even a car mechanic or a civics

At first glance this beautiful photo of some ripples looks extremely simple!

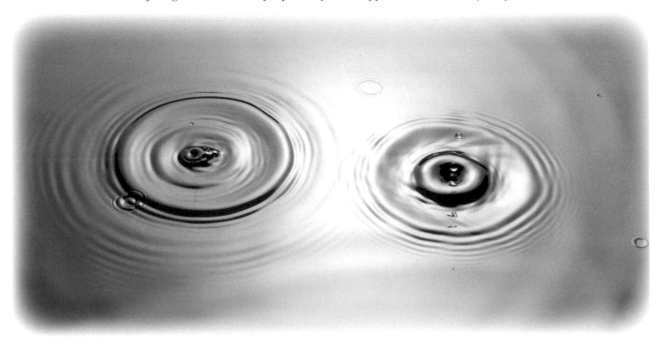

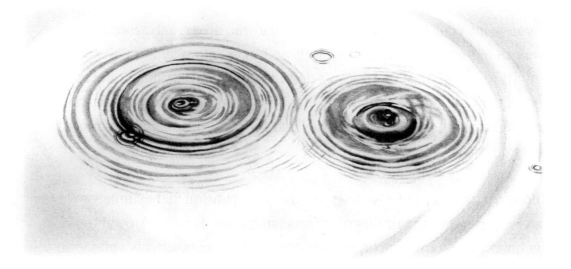

But if you try drawing it accurately, you'll soon find out that there are literally hundreds, if not thousands, of intricate little details which make it look like it does!

teacher could watch an animated film and actually sense whether or not the effects are well animated. Why? Because they know what water looks like … they drink it and shower every day! Therefore they have a built-in sense of what it should "look" like, even if they couldn't articulate why. But if you put a pencil in their hand and said, "Draw water," most laypersons would simply draw the iconic representations they have used since childhood.

This brings me back to the importance of observing nature rather than observing modern art or the graphic arts advertising world, which is filled with simplified representations and clichés (which do little to honor nature's pure design).

If you want your special effects to feel natural, observe the forces at work in the natural world, and put those forces into play through your pencil! Remember, water doesn't think about what it's doing, neither does a ceramic bowl being dropped on the floor. All these phenomena are informed by the laws of physics and follow fundamental patterns of energy.

The same principle of avoiding patterns of repetition and symmetry can be applied to the timing of effects animation. Repeated, even timing quickly becomes apparent and unnatural; to make effects animation more dynamic, we need to overlap the timing of our elements and the directions of overall movement as well.

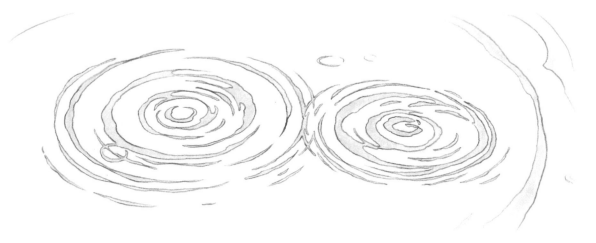

Reducing the amount of detail considerably, we get to a drawing that is actually manageable to animate. Even with 80% of the detail left out, it is still quite challenging to animate!

There are endless ways we can practice the art of avoiding repetition (or "twinning) in effects design, motion, and behavior. If a bottle smashes on the floor, some of its broken pieces will bounce, others will slide along the floor, some will fly off into the air, spinning. Yet if all the pieces do the same thing, if they all uniformly scatter and resolve at the same time, our breaking bottle will look very boring and unnatural. Animation appears stiff and mannered if there is no contrast in the shapes and their respective timing.

We call this variety of movement choreography. Think of it as a magic trick, or ad copy: We need to direct the viewer at all times where to look. Even in moments of supposed randomness and chaos, as in an exploding planet or a huge avalanche, there's always an underlying logic to what is happening, whether one is looking at a single drawing or at a series of drawings.

It is interesting to note that in every crew, there are always those more disposed to drawing certain types of effects. Some specialize in organic elements, and others thrive drawing inorganic things. Both are critical for completing a film. I have always had an affinity for animating water and magic elements, and found that both came naturally to me, whereas to others more comfortable drawing explosions or props, the learning curve might actually be steeper. There are nuances of fire or smoke some might understand more readily than others, whereas I sometimes struggle with a simple smoke scene.

If you desire to become a truly proficient effects animator, you should work extra hard on those effects which do not come naturally. The single most critical yardstick for measuring success as an effects animator is how willingly we embrace the fine art of drawing rough (or "ruff," as veterans are fond of saying).

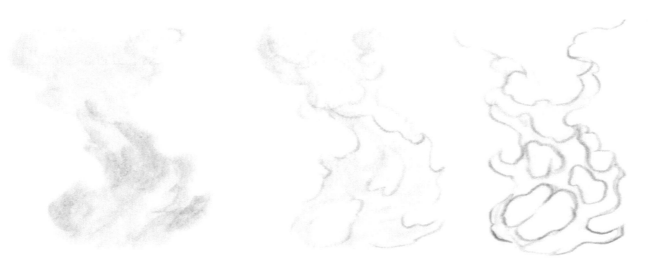

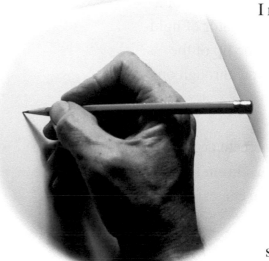

I mentioned earlier the importance of feeling the energy of a particular effect and allowing our hand and pencil to flow with the direction of that energy. If we are trying to draw with our pencil held tightly (that is, pinched in the classical writing style with the point of our pencil pointed directly down toward the drawing surface at almost a 90 degree angle), we cannot even begin to draw elegant, flowing effects animation. Heeding the sage advice from great life drawing artists and teachers, effects animators have learned to draw with the side of the pencil lead, holding the pencil lightly between the thumb and forefinger. This allows us a broader range of motion that originates with the shoulder, instead of the wrist. It also facilitates drawing with more flowing arcs and broader paths of action.

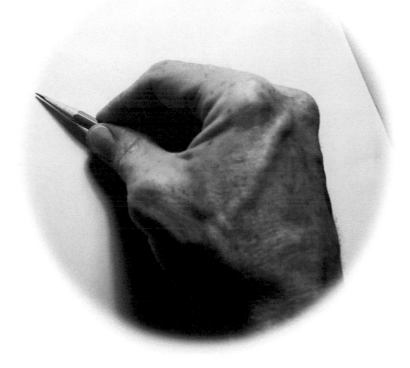

Some effects artists who have honed their skills like to use a very thick, dull, and soft pencil to animate their effects. Working with the side of a stick of charcoal could be a very good way to break an animator of holding a pencil rigidly. The trick is to stop trying to control the tip of the pencil in order to create "shapes" and to let the energy flow through our shoulder, arm, wrist, and hand to create "energy"!

Drawing in this unblemished, raw manner, allows us to create organic shapes and energy patterns that would otherwise elude us. From the sketchy-looking scribbles of a rough effects drawing, one can extract the most marvelous shapes and patterns!

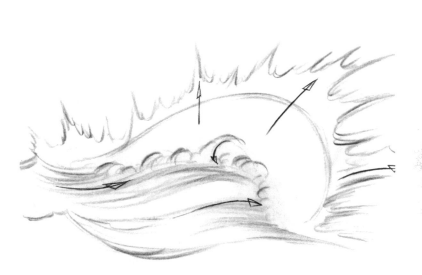

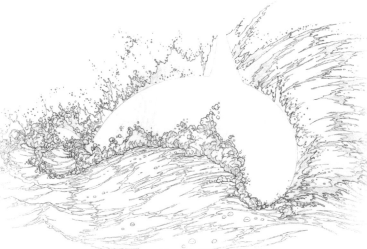

Keep the rough animation relatively simple and focus on powerful energy and dynamics rather than the intricate details.

Once the rough animation is working well, the details can be added to add scale and realism if necessary.

The sketchy, rough drawing on the left has a strong directional energy flow, and provides a strong basis for the elegant effects drawing design on the right. A quality effects drawing should always start this way!

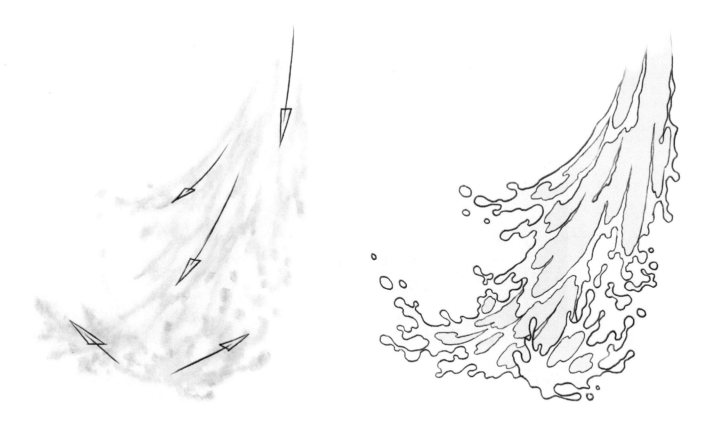

Sensitivity to style is another crucial layer in the effects animation process, which determines how the look of the drawings fit in with the art direction of a film. It's also important to realize what purpose the effects are serving in any particular scene. In most cases, effects are used simply to add a subtle sense of realism to a scene, as with shadows, lighting, or reflection effects. A basic splash should never draw undue attention to itself if the audience's attention is intended to focus on a character in the scene. It's basic stagecraft: Always know your part, and never upstage another character or story element

These scenes from Disney's Mulan are an excellent example of special effects animation being used to drive the humor in a story. Having inadvertently set her matchmaker's rear end on fire, Mulan then gets herself in even more trouble by extinguishing it with a pot of tea! The effects were key in making this sequence work.

© Disney Enterprises, Inc.

simply because you want to demonstrate your skill. As a rule of thumb, effects should hardly be noticeable and should always complement the scene more so than dominate it. In some scenes, the effects animation may be driving the humor in a gag, and will therefore need to be more conspicuous. The effects still should play second fiddle to the character animation, where the viewer's attention is focused.

The exception is the "effects driven scene" (or "the money shot") where the effects are the primary focus and the most important driving element of the scene. These scenes include exploding planets, avalanches, forest fires, and collapsing buildings. The volcanoes and earthquakes of Fantasia's "Rite of Spring" sequence are excellent examples of effects driving the story.

In all of these different animation scenarios, every special effect draw-
ing must embody the art direction of the film, so that ultimately they
appear to have been created by the same artist who drew the characters,
constructed the layouts, or painted the backgrounds. This attention to
the artistic direction of the film can make the difference between merely
adequate effects animation and truly great effects animation.

It was a fascinating process to work on some of Disney's feature films,
in which the effects were painstakingly integrated into the overall artistic
style of the film. "Mulan", "Hercules," and "Lilo & Stitch" are examples
of films containing effects animation that fit flawlessly into the overall pic-
ture, a result of working closely with the directors and art director to make
sure every element directly reflects the artistic style of the film.

Which brings us to the great importance of stylizing our special effects drawings, not only to better integrate our effects artwork with the style of the film we are working on, but simply bring our drawing to a level of detail which is possible to draw. Upon analyzing a single large wave or splash, you would quickly realize that the amount of detail it contains is staggering. If we attempt to draw every detail, we would be bogged down in no time. But this can work to our advantage! There is a wonderful design challenge to represent a highly complex element with a relatively simple drawing—and there is a beauty in simplicity, as every great artist has discovered through the ages. Hokusai's "Great Wave" painting is a gracefully simple representation of an enormous cresting ocean wave, yet it is powerfully effective.

Lilo bodysurfing on a wave which was carefully designed to have the same gentle, friendly style as Chris Sander's original character designs, from Disney's beautiful feature film "Lilo & Stitch". In this scene the effects certainly are carrying the character. Literally!
© Disney Enterprises, Inc.

The gorgeous special effects designs in "Lilo & Stitch" were the result of many, many, months of meticulous designing and planning on the part of the effects crew. The result was a film with a consistent design theme throughout all its varied elements.
© Disney Enterprises, Inc.

In representing our effects through simplified versions of reality, we are free to focus our attention on the forces underlying the effects, the patterns in motion, the timing and the physics. Details can always be added once our effects animation is working well in all these respects, but if we get lost in the details, we will have lost the natural physics of our effects animation. Stylize, simplify, and find the energy focus!

As far as creating scale and perspective in our effects, we need to exaggerate as much as possible. This can be achieved in a number of ways. If we want to insinuate a massive size, it is necessary to create highly detailed drawings, which will be animated with a ponderous, heavy motion.

This increases the amount of work involved exponentially: more details + slower speed = tons of complex drawings. In many cases, when I've heard a director asking for some wild and crazy effect that is ridiculously grandiose in scale, I will do everything in my power to talk him/her out of it.

Until you have hand-animated something like an enormous avalanche, with so much detail that you can only complete one drawing a day, it is hard to imagine how work-intensive these effects can be. Having said that, always attempt to push your drawing designs a little further, to err on the side of the more dynamic. The importance of exaggeration cannot be emphasized enough! You can always scale back an overly exxagerated drawing, but it's far more difficult to breathe life into a stifled one.

The most common mistake I see effects artists making when they
try animating special effects for the first time is they don't push
their animation far enough. There seems to be a fear of over-
doing it, or an attempt to keep it all under control, but the best
advice I often give beginners is to push their effects animation as
far as humanly possible, exaggerating the physics, motion, design
and perspective. It is easier to pull everything back if you have to,
than it is to slowly and gingerly push everything farther and farther.
The real payoff to drawing with this approach is the energy that
you can get into your drawings by pushing and exaggerating.

Remember, when you animate special effects you are animating
energy! Therefore, animate with energy and exuberance!

If you commit to being a serious student of effects animation, be forewarned: it is an extremely difficult and time-consuming craft and it requires patience and a driving passion for understanding nature! On your journey, you will undoubtedly have moments of unmitigated frustration, but don't let it keep you from soldiering on. It's worth it, I tell you, to wake up one day and realize you've become one of those crazy people who are happy to animate crashing waves, incendiary firestorms, celestial cataclysms, and other acts of God!

So pick up your pencils and your surfboards, your paper and your pyromania, and welcome to the amazing world of traditional visual effects animation!

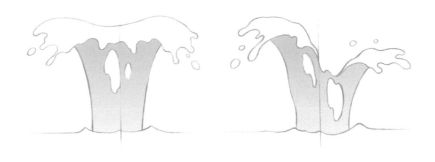

It is important to avoid symmetry when designing or animating special effects. Although in nature we may sometimes observe fairly symmetrical shapes in a splash or a puff of smoke, in order to create appealing, dynamic, and visually interesting special effects drawings we must exaggerate and stylize. The drawing on the far left contains some details which are not symmetrical, but the overall silhouette of the design is quite symmetrical. The overall silhouette as well as the details should be asymmetrical, as in the example on the right.

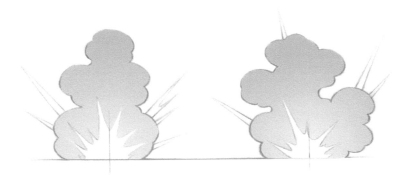

The explosion drawings here illustrate the same symmetry problems and solutions as the splash drawings above. The explosion on the left does have some very minor differences in its details, but overall its silhouette is extremely symmetrical, somewhat resembling a snowman. Although the energy of an explosion actually radiates outward in every direction at almost the exact same velocity, breaking up its silhouette asymmetrically, and overlapping its animation timing, creates a far more interesting and appealing drawing.

Here are two simple drawings of what could be a piece of ice or a ceramic bowl, smashing upon impact with the ground. Again, the example on the left contains elements which aren't entirely symmetrical, but overall the design's silhouette is quite symmetrical. Anyone who has dropped a bowl or a glass on the floor, has witnessed the way a few pieces always end up several feet away from the point of impact. The pattern of pieces left over is not symmetrical, nor is the splashing pattern of pieces emanating outward upon impact.

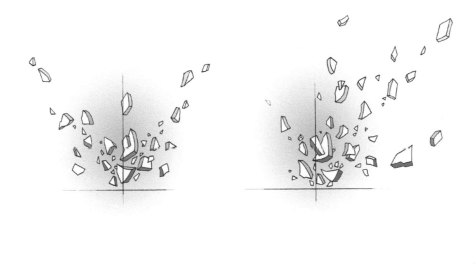

In these two examples we see a bolt of lightning, or electricity. The example on the left is offset a little, but is quite symmetrical. Observing hundreds of photographs of lightning bolts, we may actually see quite a few bolts which are pretty symmetrical looking, like the example on the left. However, when we animate electricity, we want to "push the drawing" and render our drawings far more dramatically than reality. Breaking up symmetry, we avoid "twinning" our shapes, and we push our designs as far as possible to keep things interesting.

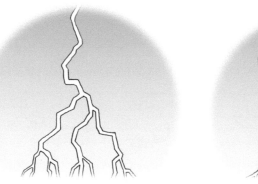
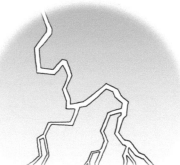

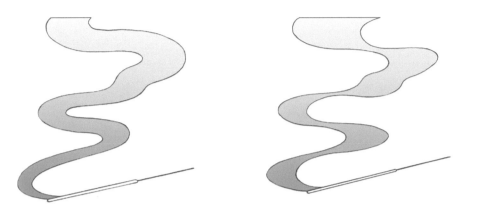

Another important principle important in the designing of good special effects animation is to avoid parallel lines as much as possible. Patterns in nature are rarely if ever truly parallel, and once again, we use exaggeration to add drama to our drawing designs. The incense smoke on the left tapers gently as it rises, but it is far too parallel. Using the same line on the left of the design, the smoke on the right is pinched tighter and spread wider in different areas, making for a much more interesting, realistic, and dynamic shape to animate.

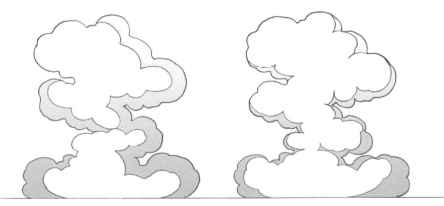

The tonal areas of these two very similar smoke designs illustrate once again where we often see a tendency to draw parallel lines in special effects, and miss out on a chance to add weight and volume to our drawings. The tonal or shadow areas of the drawing on the left, closely follow the outline, and do little to describe the mass of the smoke, whereas the tonal designs on the right vary greatly in width, and describe far more dynamically the actual volumes of the smoke effects. These are simple, yet highly effective drawing principles.

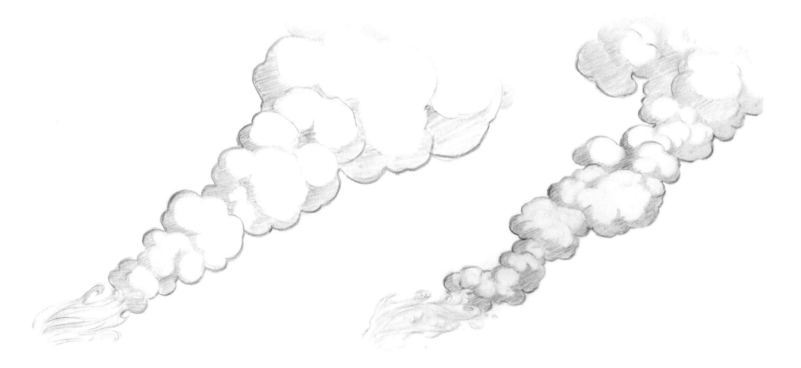

Here is an example of symmetry and parallelism being detrimental to a special effects design. In this case, a large plume of smoke like we might see rising from a burning building. In the drawing on the left we see the smoke expanding upwards and outwards very evenly. If we were to turn this smoke on end so that it was perfectly vertical, we would see that it is almost perfectly symmetrical and quite parallel as well. This is a common problem with smoke effects design, and it is often seen today in digitally created particle effects smoke,

especially "canned" or pre-programmed digital smoke effects. If care is taken to introduce more turbulence into our smoke effects, the result will look more like the smoke drawing on the right. Of course we must take into consideration the amount of wind in our scene, as well as how much heat the fire is generating. The asymmetrical qualities of a plume of smoke such as this can vary greatly, but even on a dead calm windless day, a plume of smoke should demonstrate far more turbulence and asymmetry than the drawing on the left.

The principles we have discussed in this chapter thus far can be applied to any and all special effects elements, including magical effects like pixie dust. In the drawings here we see a loose, "ruff" drawing, demonstrating good fractal randomness, which avoids symmetry, repetition, and parallel lines. There is a feeling of directional energy in the drawing as well, which gives our pixie dust effects a sense of purpose, as if it is going somewhere for a reason, not just randomly traveling across our field of vision.

Whether we are drawing or animating liquids, waves, splashes, fire, smoke, electricity, lighting, breaking objects, waving grass or a flapping flag, slowly crawling mist or a dynamic explosion, you name it—*these basic principles should be applied to our special effects animation*. These principles apply equally to the creation of digital special effects, if we want to imbue our effects with "The Illusion of Life" to borrow from Frank & Ollie's timeless book on animation.

This could be a drawing of ice, rocks, wood, hard-packed snow, smashing porcelain or glass. Reflecting the design principles outlined in this chapter, every individual chunk avoids parallel lines as well as symmetry, and the overall placement of the pieces carefully avoids a symmetrical silhouette as well as demonstrating a great variance of sizes and shapes. Even though we have no idea why these shapes are placed as they are, or what outside energy force is at work, there is a sense of natural energy in this drawing. Underneath the details there is a lot of information—energy informing the drawing and making it speak to us of its origins.

This is actually a drawing of smashing ice chunks. Much observation and research went into examining the subtleties that differentiate the shapes that one might find in the elements mentioned above. Ice breaks up somewhat differently than glass, or wood, or rocks. It also breaks up differently depending on how dense it is, what impurities are in it, and what the water was doing when it began freezing. There is no end to the research we can do to make our effects animation look fantastic!

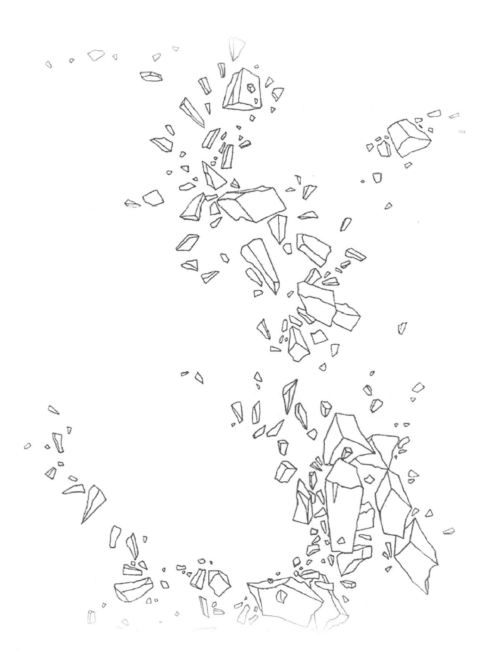

Every good effects drawing must begin with a solid foundation. This requires an understanding of the environment and its proper perspective. An accurate perspective grid can be immensely helpful at this point.

Working with this strong underlying foundation, the effects artist can now relax and feel out the style and details of the drawing, with a loose, easygoing pencil stroke. No worries about details at this stage. The energy is what's important.

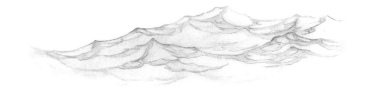

Drawing over the loose, naturally flowing energy of the rough sketch, the tighter details can now be added, keeping with the directional flow and fluidity of the rough drawing. All the details can be finessed and noodled with!

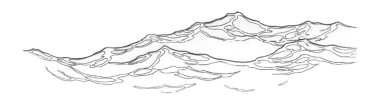

The final clean line can now be applied. The style, line quality and look of the drawing at this stage depends entirely on the look of the specific show the animation is needed for. But the steps leading up to this point should be the same.

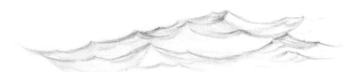

The "Whip" and "Wave" Effects

Whether you are animating smoke, fire, water, dust, snow, branches, leaves, a dangling rope, a fluttering cape, a curtain swinging closed, a dog wagging his tail, or a billowing dress, all of these effects have within them the basic whip/wave principle. It is a simple flowing, over-lapping action that occurs wherever energy interacts with matter which is not entirely rigid. Just take a piece of rope maybe a few feet long, or a garden hose, lift it up quickly and then snap it back down even quicker, and you will see a wave travel through the rope or hose, just like a wave travels through the water. We can move our arms much in the same way,

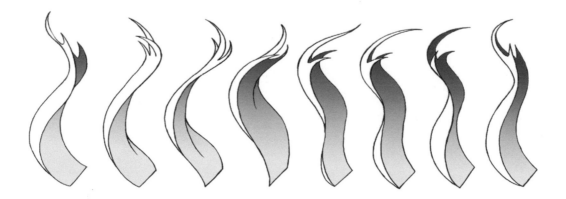

We've all seen those imitation flames made out of flimsy fabric, which have a fan blowing straight up from underneath them. This is a perfect example of energy, in this case wind, creating a wave effects in matter. Hot and cool air creates wind that creates the shapes we see in a real fire, which is why this illusion works relatively well. I have actually been fooled by one of these novelties (for a second or two!)

like the dancers who seem to be so rubbery and can make a wave appear
to travel across their body. Interestingly, even a perfectly rigid object
can appear to move with a wave action, as with the old trick of making
a rigid pencil appear to be rubbery and bendy. Simply by shaking a
pencil up and down, but also applying a rotational movement with the
hand and wrist, the rotation causes the illusion of a wave. Our eye sees
the circular motion of our hand transferred to the rigid pencil.

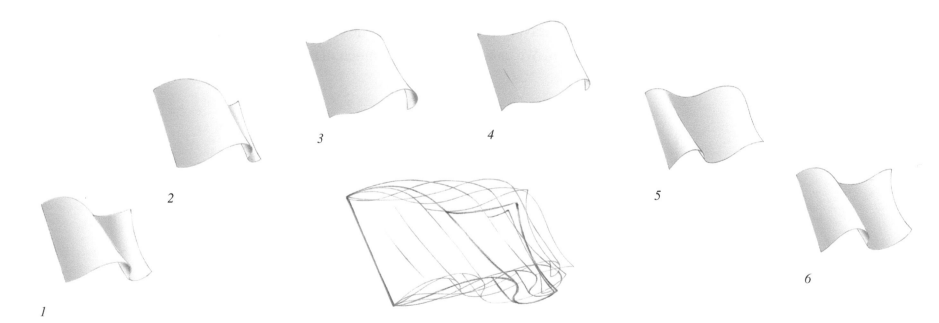

*This flag animation illustrates clearly how the energy of wind creates the
wave-like motion that causes a flag to flutter so elegantly. This animation is
actually a cycle; drawing #7 is actually a repeat of drawing #1, and the sub-
sequent drawings repeat throughout the remainder of the animation.*

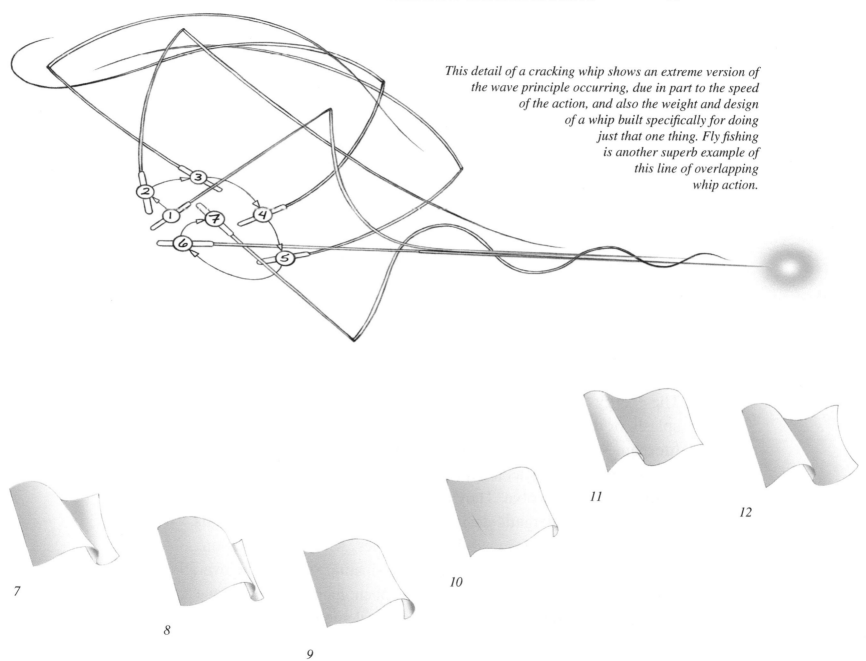

This detail of a cracking whip shows an extreme version of the wave principle occurring, due in part to the speed of the action, and also the weight and design of a whip built specifically for doing just that one thing. Fly fishing is another superb example of this line of overlapping whip action.

The energy that creates any elemental effect—the impact of a splash, or the sudden combustion of an explosion, has a finite lifespan. What starts out explosively, with very strong directional energy, loses energy as it expands. And as the energy dies out, the shapes it creates evolve. They change, interestingly enough, from sharp, angular, energetic designs to soft, flowing, languid designs. A sudden splash ends in subtle, soft ripples. A violent explosion ends with beautiful shapes of gently dissipating smoke. The overall design and dynamic movement of this phenomenon is the unique fingerprint that pure energy leaves on the elements that it moves.

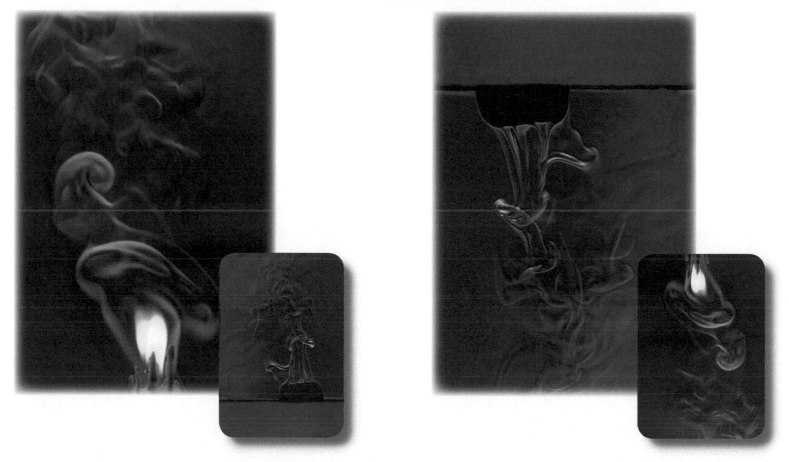

These two Schlieren photos, one of a candle flame, and one of an ice cube melting in water, show a remarkable similarity in the beautiful energy patterns that occur when hot and cold temperatures intermingle, regardless of the context. Rotating both photos 180 degrees and looking at them next to their opposites, shows us just how uncannily similar these patterns really are. We will find these patterns everywhere the various elements react to the cosmic forces at work in the world as we know it.

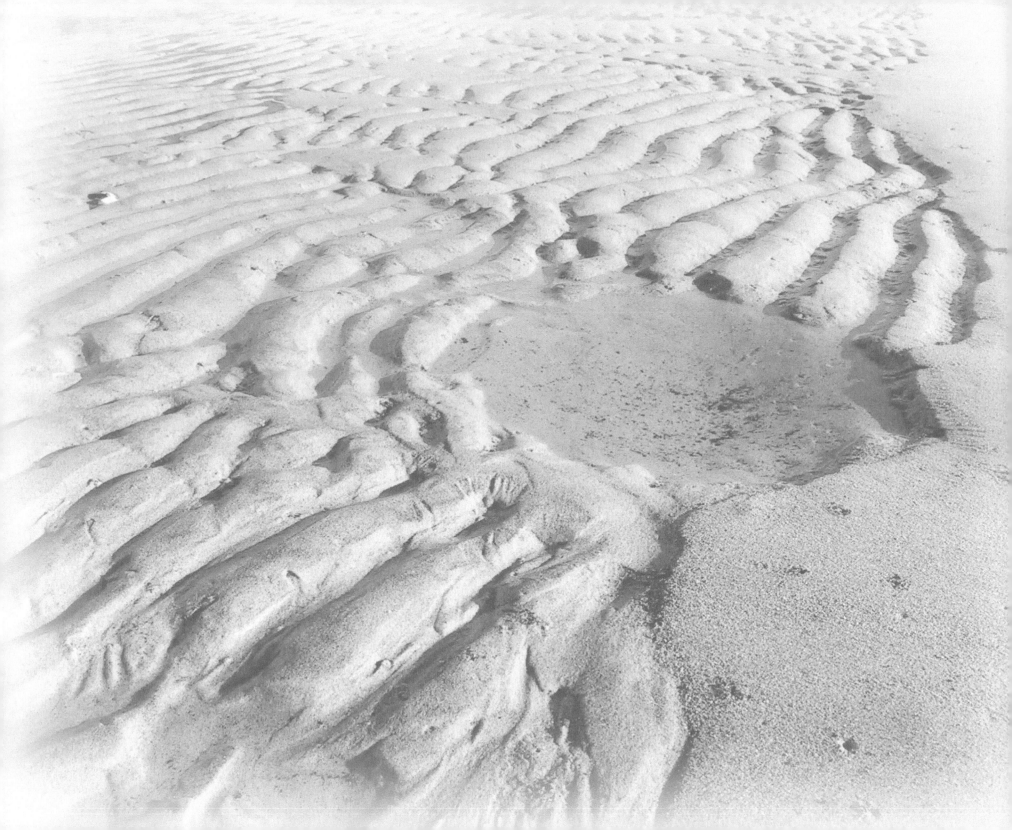

Into the Digital Realm of
Special Effects

Having looked at special effects animation from a classical point of view, what then can we bring to the table when we are animating special effects digitally in virtual 3D space using the incredibly powerful and versatile digital animation tools that we now have at our fingertips?

To begin with, taking advantage of the classical animation design principles contained throughout this book will bring a fresh new look to any and all effects that we endeavor to create digitally. I cannot emphasize this enough, the need for us as effects artists to understand and exploit what it is that makes classical effects animation so fantastic, no matter what element it is that we are animating, and no matter what technique we are using.

Special effects animation all too often (especially in this digital age) is treated as an afterthought, something that we simply have to add the fantastic environments and characters that populate our animated films to, in order to create a little bit of "reality" to a given animated scenario. But this book is all about the *exception* to that halfhearted

approach to animating special effects by default, and whether we are ani-
mating effects by hand, or digitally, we can take a cue from the masters
of the art and bring that extra magic to every little detail of special effects
animation that we create. Whether we have a tiny or massive budget, the
classical design and animation principles that drive the highest quality
effects animation can be brought into play and elevate our art form across
the board!

Indeed, the vast majority of special effects animation throughout our
history, has been for the most part an afterthought—"Oh yeah, we are
going to have to have some water in these scenes. Do we have anyone
around here who knows how to animate water?"

And so frequently some poor character animator (who might have a bit
of a knack for drawing splashes and such) would take on the task,
usually without a budget, or a plan, or any regard to design, or any
consideration of the actual intent or character attributes of the effects
animation in the scene. Interestingly though, before we were introduced
to computers and digital 3D effects animation tools, there were actually
some great advantages to drawing our special effects that are missing for
the digital artist today.

I believe that back in the days when our only tools were paper and
pencils, some special effects took on a stylized, more cartoony look that
worked really well as far as "fitting in" to their environment. In part it

was because the animators were originally character animators, already accustomed to drawing in a cartoony, highly stylized way. It was simply the natural thing for them to do, and as a result, the hand-drawn effects that they created were stylized and fit in quite well with their environments.

Another fact that worked to the art of animation's advantage was the animators' need to stylize and simplify their hand-drawn special effects in order to make it *possible* to draw them. Observing real natural special effects, an artist is overwhelmed with the complexity of even the simplest splash or small fire. To draw these things accurately is almost impossible. And so, by necessity, the earlier effects animators' drawings were simplified and stylized versions of reality that actually looked much more at home in a cartoon than something entirely realistic would have. And so there was a unified look and a more unified set of principles being applied to all the elements of a classically drawn, designed and animated cartoon.

I have puzzled a great deal over the apparent lack of attention that is given today to the importance of these classical animation techniques and principles as they pertain to digital special effects animation. I have come to believe that it is to a large extent the intoxicating power we have using digital tools, to closely mimic the overwhelming detail of natural special effects, that makes us tend to forget about the importance of stylizing, exaggerating and economizing our designs.

Today, the vast majority of young artists getting involved in the creation of digital special effects animation are not spending nearly enough time learning about classical design and animation principles. Although classical technique is emphasized quite a bit in any really good digital *character* animation school, young artists delving into the world of digital special effects are more often than not spending very little time learning about classical techniques.

The emphasis, more often than not, is put squarely on learning how to use the various complex software applications that are used to create digital special effects, and these young artists are missing out on an entire universe of classical effects animation knowledge that would elevate their special effects to a much higher level of artistry—if they were only given the opportunity to learn it. For these young artists, the natural thing to do is to look for the solution to their effects animation problems, somewhere in the highly complex 3D software that has been so heavily emphasized in their animation educations.

Keep in mind also, that digital tools open up a world of detail that was never possible for classical animators to draw by hand. Freed from these constraints of detail and complexity, today's digital effects artists are a lot less likely to even consider simplifying or stylizing their special effects. It feels good to be able to make cool effects that look realistic—but do they really look great in a highly stylized cartoon world?

In today's digital animation industry, when a young digital effects artist is asked to create a new special effect, he or she does not have a wealth of classical training on which to draw for inspiration. In most cases if any research is done, it will be through the observation of that effect in nature (which is great), or finding a similar digital special effect previously created in another film.

The emphasis is generally put on making the effect look as realistic as possible, and so the elements of stylized design that go into the environments and characters, and the exaggerated animation techniques that are taught to the digital character animators, are missing in the digital special effects that we all too frequently see. All too often, the results are cold, lifeless, and predictable digital versions of special effects reality superimposed into a highly stylized cartoon world.

So let's take a look at a hypothetical animation sequence in a computer-generated 3D cartoon, and see how we could approach such a task in a way that honors the legacy of special effects animators who pioneered these techniques, thus raising our art form back to the the level of artistic mastery that is its heritage.

If we have a sequence in a film in which a house is ablaze, the sets will be painstakingly designed, the well-designed characters will be animated doing whatever it is they have to do, and then usually, the fire and

smoke will be added—without any of the design considerations given the environment and characters. As long as it looks like fire (sort of), it can be approved by the director and pushed on through the production pipeline.

The same can also be said if the fire brigade arrives and begins hosing the fire down. The water, smoke and steam will probably be given just enough attention to ensure that they "work" adequately, and help to tell the story just enough. As long as the audience knows what they are supposed to be looking at that is probably going to be good enough for the special effects animator and the director .

But with an awareness of the classical special effects animation knowledge contained within the pages of this book, why not look at the design of the environments and characters in the film, and make at least some sort of attempt to design our special effects in a way that they integrate as well as possible into the overall look of the film? Animation is, if anything, the art of exaggeration and stylization, so why not apply those principles to not only the design and look of our environment and characters, but equally to our special effects animation?

Armed with the tricks of exaggerated animation timing and classical design principles, a digital effects artist can far better integrate his or her effects into a digital 3D or 2D world. (The term 2.5D frequently comes up in my conversations with animation professionals, as the vast majority of animation projects today utilize both 2D and 3D techniques, digital and hand drawn, intelligently integrated to best to realize a director's animated vision.)

Add to that a solid understanding of the underlying structures and energy patterns inherent in all special effects elements, and the well-informed digital effects artist of today does not have to lean on the computer for inspiration, but rather to bring the inspired imagination and vision of a classically trained animation artist to the computer.

We must never forget that the real *super computer* is our imaginations. The cold digital boxes in front of us filled only with plastic and wire, zeros and ones, and a bit of electricity, are really only information storage devices, like a blank piece of paper awaiting the stroke of a pencil. And our audiences around the world, the countless millions of people who are inexplicably drawn to and have been enormously entertained by the magic of animation for the past 80 years, need us to remember that.

Chapter 3

The Specific Effects Categories

Over the course of my career, I have animated an unbelievably broad range of elements, all of which fall under the umbrella of what can be considered "special effects". To best illustrate just how diverse this art form really is, let me share with you a short list of some of the things I have been called upon to animate over the years.

First of all—water. Lots of it! Splashes, ripples, waves, bubbles, fountains, white water, geysers, water hoses, raindrops, rivers, waterfalls, oceans, ice, snowflakes, avalanches, and slush.

And then there are all the other possible elements: Vapor, alcohol, and clouds. Gas, oil, syrup, oatmeal, mud, slime, and saliva. Chairs, cars, bags of flour, chains, whips, guns, spaceships, candle flames, campfires, bonfires, burning buildings, blowtorches, sparks, electricity, and lightning. Pixie dust and evil magic powders, flags and curtains, dust and dirt. Cigarette smoke, smoke signals, smoking guns, ray guns, exploding planets, bursting bubbles, laundry detergent, soup, salad, sandwiches, wine, whiskey, beer, coffee, bottles breaking, windows smashing, wood splitting, tires spinning, skateboards and running shoes.

Boats and bombs, ships and saddles, boots, pillows, handbags, chicken legs and tacton toes, forks and knives, cups and plates, tornadoes and whirlwinds, leaves and branches. Exploding houses, surfboards surfing, bicycles, motorcycles, water pistols, guitars, ukuleles and violins. Strings, ropes, threads, beds, and spider webs, just to name a few.

Some of the specific special effects categories are obvious, and will boast their own clearly delineated chapters, but even these main categories are mutable. If this seems confusing, let me give you a few illustrations of just how blurry the boundaries get. When water evaporates into mist and clouds, it begins to look a lot more like smoke than water. So which chapter does it fall into?

On the other hand, water that is frozen and forms glaciers, which then crack and break off in great chunks of ice, resembles rocks more so than a liquid. By necessity, we will have to cross-reference many of the effects elements we will be discussing, closely observing their similarities, but more importantly, pointing out the not-so-obvious differences.

Dust being kicked up by a galloping horse has the appearance of smoke rising up from the ground. However, smoke's informing energy is rising hot air, and it will continue to rise as it dissipates into the ether. The informing energy of the dust, on the other hand, is the pounding hooves of the horse and gravity; once the horse has passed, the dust quickly becomes a victim of gravity, falling back down to the ground as it dissipates.

As we touched on earlier, there is also a relationship between something as fluid and organic as a splash on a calm water surface caused by a falling rock and a glass bottle smashing on impact with a hard surface. The underlying energy pattern of the water being displaced into a splash, and the bottle's energy exploding outward, could be drawn or described very similarly, although there are other distinct differences in how the animation's energy patterns resolve themselves.

In some cases, where there is one type of effect, another closely related effect will commonly occur—the "Where there is smoke, there is fire" principle. Where there is fire, electrical activity or lightning, there will most often be some extra lighting effects on any objects nearby, even surrounding the effects themselves. Where there is an explosion, there is generally some flying debris or broken props to describe, as well as the various light effects within the explosion's core (and again, with light reflected on other objects).

Where there are splashes in water, there will need to be some bubbles and ripples as well. As you can see, effects is replete with cause-and-effect scenarios between inorganic and organic phenomena and the patterns of energy contained within them.

Imagine, for example, a person throwing water from a bucket on a campfire: The water will splash (some of it evaporating to steam, some of it creating overlapping pools of water on the ground), the smoke will become more thick, the flames will quickly dissipate, the embers will stop glowing, the light reflected on other objects will diminish, and the water droplets will run down the surface of the bucket.

This is only a description of changes in state; we haven't even addressed how the forces would interact. While the shapes of the elements themselves may appear random, if not scattered, as they change states, the main force in the scene will determine the path of that chaos. The water coming out of the bucket is the most forceful path of action, which will cause the fire and smoke to reverse arcs once the water hits them. Special effects animation is full of these kinds of forces of nature at work.

It is fascinating, frustrating, and challenging stuff to master! The categories I have committed to are not carved in stone, they are simply the fairest approximation of a logical categorical breakdown that I could imagine. Each animated film, and every special effects animation crew, will come up with its own effects language particular to the needs of the project they are working on.

In addition, artists discover their own unique solutions for problem solving regardless of how they initially learned to animate. This drive for innovation and exploration sharpens the craft and keeps us from falling into the artistic doldrums. I have never worked on two projects in a row, even in the same studio, without noticing a shift in both jargon and method.

The key to any animation project is always to communicate efficiently. When in doubt, draw a picture. The old adage, "A picture is worth a thousand words!" is probably the most accurate saying for our industry, (as well as "Back to the drawing board").

When attempting to describe an effects technique to someone using thumbnail sketches, there is nothing more satisfying than hearing someone utter the words, "Ah yes, I see what you mean!" I intend the most important element of this book to be its drawings, and I sincerely hope that you will see what I mean.

Each of the following categorical chapters will be broken down into roughly the same format: first covering design concepts, followed by a discussion of scale and perspective, then moving into a breakdown of the energy, path of action, and timing, and finally we will shape these ideas into clearly illustrated examples with accompanying notes. I will do my best to address both the scientific- or physics-based aspects of each category, as well as the more intuitive experiential aspects. I hope this book will flow like good effects animation does, so I'll make every attempt to keep it natural, fluid and dynamic, letting the book slip out of its structure from time to time. So without out further ado, let's get right into it!

Let's imagine a director decides he or she wants to see a character in his or her film pouring water out of a bucket onto a campfire. Sounds simple enough, right? But what sounds like a relatively simple scenario, can quickly turn into a great deal of work for a special effects crew. First of all, the effects artists might have to come up with a design for the wood on the campfire, as well as the bucket, depending on whether or not the layout department or a special props unit has already taken care of that.

Once a character animator has animated a character pouring the bucket, and the bucket has been carefully added to fit into the character's hands, an effects animator will have to design and animate the water flowing out of the bucket. Depending on the style of the film, this effect may vary greatly in complexity and detail, but even the simplest water design is an interesting challenge to animate! The effects animator also has to animate the fire and any embers, smoke and steam that will be needed to make the scene convincing. Depending on

artistic preference, an effects animator might decide to animate the water first, and then animate the fire and smoke reacting to it, but there is no particular order carved in stone that an effects artist must abide by. In this respect effects animation can be an inexact science, but it is a problem-solving riddle, and choosing which element to animate first can greatly reduce the difficulty of the task.

To best decide which element comes first, an animator needs to think about the cause and effect that these elements will have on each other as they interact. The fire may be burning placidly, when suddenly a bucket full of cold water hits it, causing total physics mayhem! Hot air and cold air collide creating vortexes of energy, water evaporating into steam, and embers flying everywhere! The energy released by this clashing of elements is chaotic and unpredictable, but at the same time it contains a marvelously designed energy pattern that is intuitive and natural.

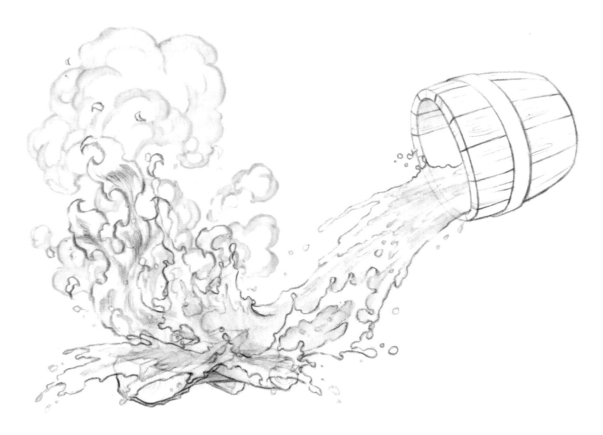

The final product, with all the elements working together, looks like a single event in time.
But the animator has had to take a lot into consideration to get to this point. Each element has
been carefully planned out and executed according to the laws of physics, and the needs of the
scene from a storytelling viewpoint. To better understand what's going on in this scene, we
can look at all of the forces at work on the next page.

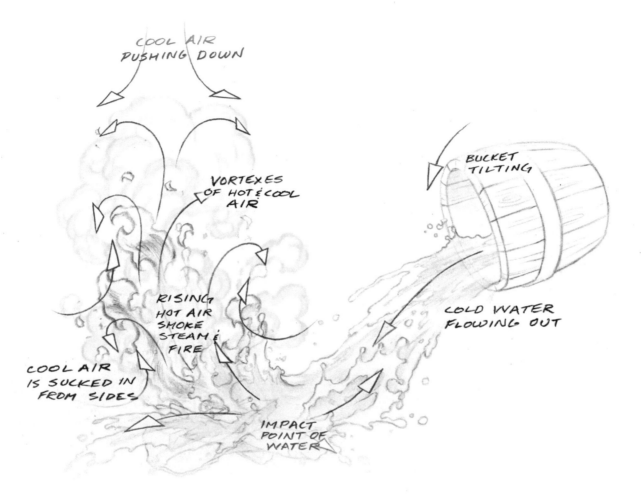

First of all, the bucket is tilted by the character. Then gravity sucks the water out of the bucket and it pours out onto the fire. On contact there is an explosion of water colliding with the firewood, and another explosion of energy released from the rapid heating up of the water, and the rapid cooling down of the fire. As the hot air, smoke, fire and steam, escapes and rises, it all collides with a layer of cool air above it, which causes the mushroom-cloud-like effect.

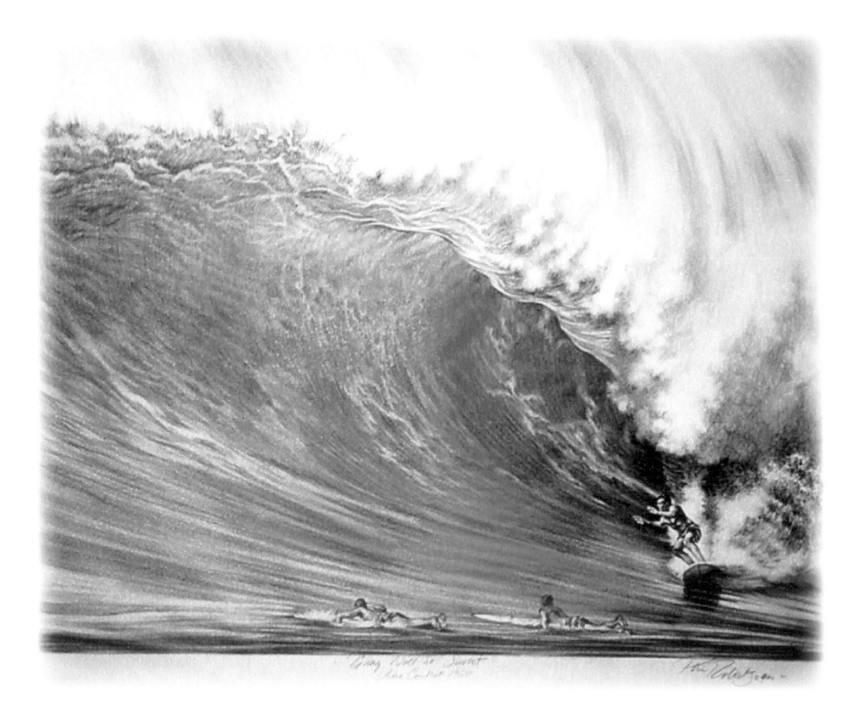

Chapter 4

Liquids

This is perhaps the most important chapter in this book. In the same way that Richard Williams spent much of his energy breaking down walking and running characters in order to best describe the basic principles of character animation in his cornerstone animation book, "The Animator's Survival Kit," I will focus a lot of energy on the design and physics principles that come into play when animating water and other liquids— principles which apply to some degree no matter what kind of effects you are attempting to animate, and no matter what medium.

A flapping flag, curling smoke, or a leaf flying in the wind—all of these effects contain principles that we will need to learn if we first master (or at least attempt to master) the natural principles of animating liquids.

Animating liquids, usually water, is generally considered to be one of the most complicated, difficult and specialized effects animation jobs. Water comes in a staggering array of shapes, sizes, and varieties, each one with its own unique set of physics laws, energy patterns and animation techniques. Splashes, ripples, waves, rivers or streams, waterfalls, containers filled with water or any other liquid, pouring liquids, fountains, rain, etc. And each one of these forms of water in motion has in

addition countless variations. A seemingly simple classification like "waves" for instance, can take on an almost infinite number of shapes and sizes. Surging, spilling, rolling and plunging waves, ocean swells, tidal waves, (tsunamis), or choppy water whipped up by a brisk wind. A wave kicked up by a boat or ship. Smaller waves may be traveling across the surface of a larger wave, and waves tumbling over on themselves create foam and bubbles. The wave variations go on and on.

The same can be said about splashes, which vary widely from a single small pebble or raindrop landing on a calm flat water surface to something as immense as a several thousand ton glacier calving and falling into the ocean.

After over two decades of animating water I am still learning every time I animate another splash, no matter how simple. Imitating and animating such a sublimely formed natural phenomenon is a process that never gets old for me. It is important as always, to remember the basic golden rules of effects design: avoid repetition, twinning, and symmetry, and keep your silhouettes dynamic and interesting.

Surging Wave

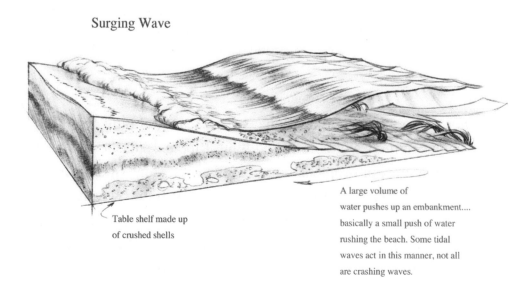

Table shelf made up
of crushed shells

A large volume of
water pushes up an embankment....
basically a small push of water
rushing the beach. Some tidal
waves act in this manner, not all
are crashing waves.

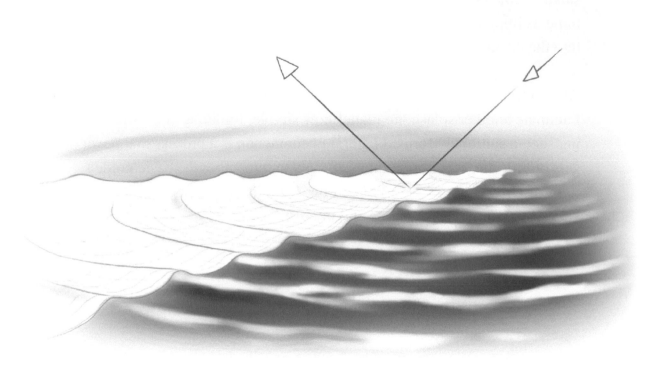

It is important to understand that what we are really looking at when we see shapes in the water is reflected light. Ripples, splashes, currents, bubbles formations, or droplets, do not really create any kind of lines in the water at all. If we learn to "see" water designs in this way, it is easier to understand how they undulate and move. The tiniest change in water surface shapes can radically effect how light bounces off of it. This is a big part of what makes water look so magical, ethereal, and difficult to describe.

1.) A simple drawing of rocks and the bottom surface

2.) Add refracted light

3.) Rocks and bottom with refracted light added

4.) Add water surface reflections

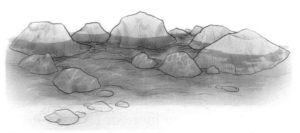

5.) Surface reflections added to overall composition

6.) Add refracted light on water surface ripples

Since water is essentially clear and colorless, what we are looking at when we see a water surface is a combination of reflections and reflected and refracted light. In this series of drawings, I have taken a piece of calm, rocky shore line and broken it down into four simple and distinct elements. The rocks and ground, the refracted light on the bottom, the reflective water surface, and the ripples reflecting light.

Here I have illustrated how the layers are sandwiched together to create the final image. This step of the process is what is referred to as "compositing." In the earlier days of animation, these levels were actual pieces of artwork you could hold in your hand; the process was much as it is illustrated here, the layers were more or less simply laid over the top of one another, although there were tricky camera techniques to achieve certain transparencies and glowing effects. The same is true today, although the artwork is either scanned or is computer-generated and then the layers are sandwiched together using software specially designed for this task.

THE FINAL COMPOSITION OF COMBINED ELEMENTS
CREATES A SENSE OF DEPTH AND REALISM USING
ONLY FOUR RELATIVELY SIMPLE LEVELS OF ARTWORK.

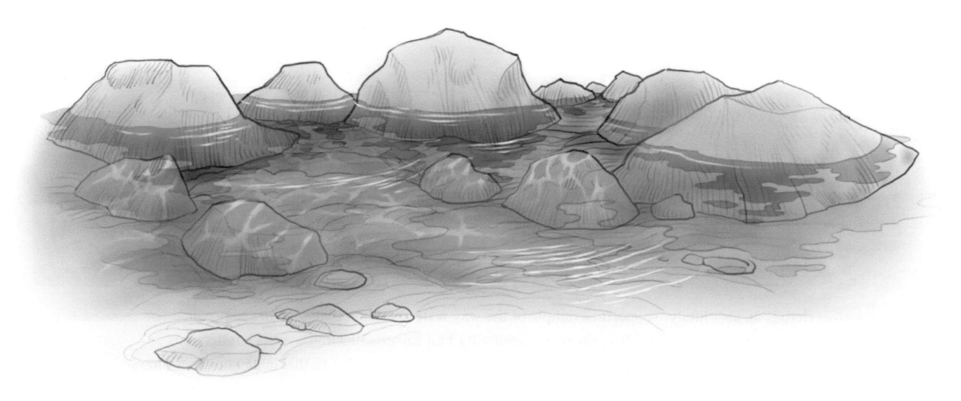

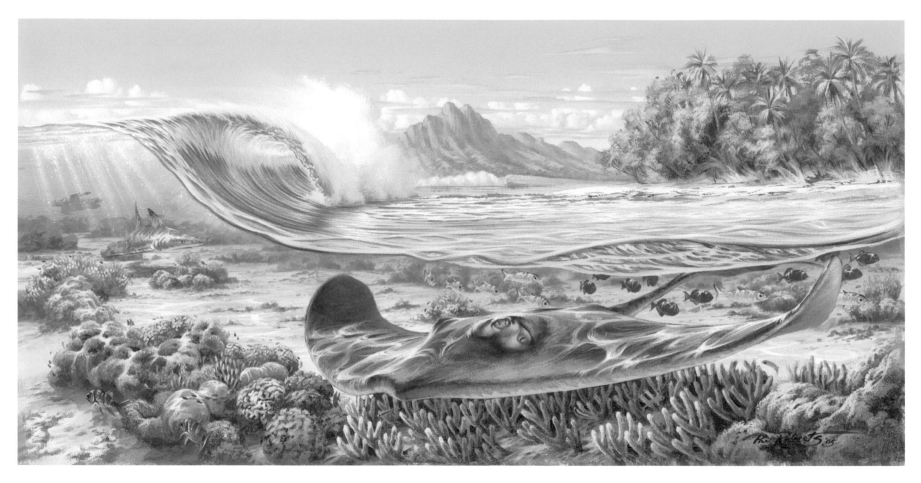

Here is an absolutely wonderful example of the way water and light play together to produce incredible visual effects. This gorgeous painting by Phil Roberts illustrates surface reflections and underwater lighting effects superbly. Of course achieving a look like this in an animated film would be quite a daunting undertaking, but by breaking it down into the relatively simple elements described in the preceding pages, we can build an animated scene like this step-by-step.

It is extremely important when attempting to draw water, to learn how to break down the shapes we see in natural water formations into much simpler shapes and designs. The amount of detail in even the smallest, simplest splash is intimidating.

Just tossing a medium-size stone into a swimming pool will generate hundreds of droplets breaking up off of the main mass of displaced water, with an extremely complex design of over-lapping ripples radiating outward, as the hundreds of droplets all fall back into the water. If we attempt to draw all of it, we will quickly be overwhelmed by the details.

Even the most complicated water animation is highly simplified compared to the real thing. This can be said of most effects elements we will be discussing in this book, so watch out for it. Very, very important to simplify and stylize!

Perspective is extremely tricky to master when animating water. Such apparently abstract shapes don't at first glance appear to fall under the rules of perspective as they are generally taught, working with vanishing points and a predetermined perspective grid against which a given image is constructed. However quite the opposite is true. I have seen a lot of fantastic water animation that is plagued with fundamental perspective drawing mistakes, in high-quality animation films.

How a splash integrates with the perspective of its environment is extremely important if we expect our animation to feel natural. We must determine our perspective grid before attempting to animate any water surface or splash, and then determine how the circular or elliptical shapes that underlie the structure of our water designs sit upon that perspective grid. Our effects must always integrate themselves credibly with their environment, or else the viewer will feel that something is amiss, and their attention will be drawn away from the story. Properly executed special effects should not draw undue attention to themselves.

A perspective grid must be established when animating effects which occur on a surface. The ellipses of ripples caused by a splash must always conform to this perspective grid.

DON'T DO IT THIS WAY! *DO IT THIS WAY!*

If we animate ripples expanding uniformly in every direction, we lose the correct angle of the perspective.

Ripple ellipses must expand farther horizontally than vertically, in order to stay true to the perspective.

Ellipse 1 is quite narrow vertically, and describes a sharp perspective on which the ellipse is sitting. Ellipse 5 has expanded incorrectly and now sits on a much flatter perspective.

Here we have the same ellipse 1, and ellipse 5 has stayed true to the perspective, and is simply a larger version of the exact same ellipse as the smaller one.

Also extremely important to remember is that as our elliptical shapes animate—the perspective must be retained from drawing to drawing. This is where the mistake is often made, even by some of the best effects animators in the business. It is incredibly easy to allow our ellipses to flatten out in perspective, as they expand away from the center of a splash, if we don't pay attention to the underlying perspective grid and follow some basic principles of how ellipses expand in perspective. Now let's look at the forces at work in the anatomy of a splash, and break it down into simple steps.

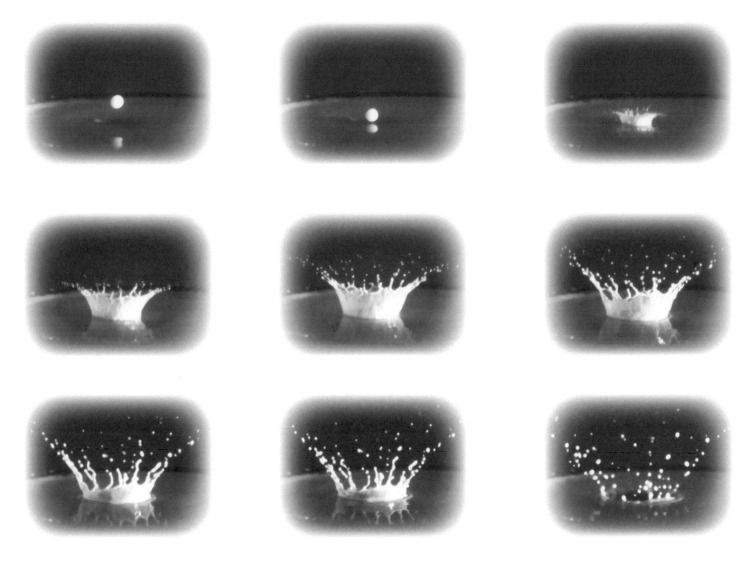

This high-speed photography sequence of a drop of milk landing in a bowl of milk, illustrates very well just how complex even the smallest splash can be. In order to draw this phenomena, we need to stylize and simplify. At the same time the effects animators have an advantage, because they can also exaggerate the design and physics of a splash, to make it more snappy, flashy, punchy, and dynamic!

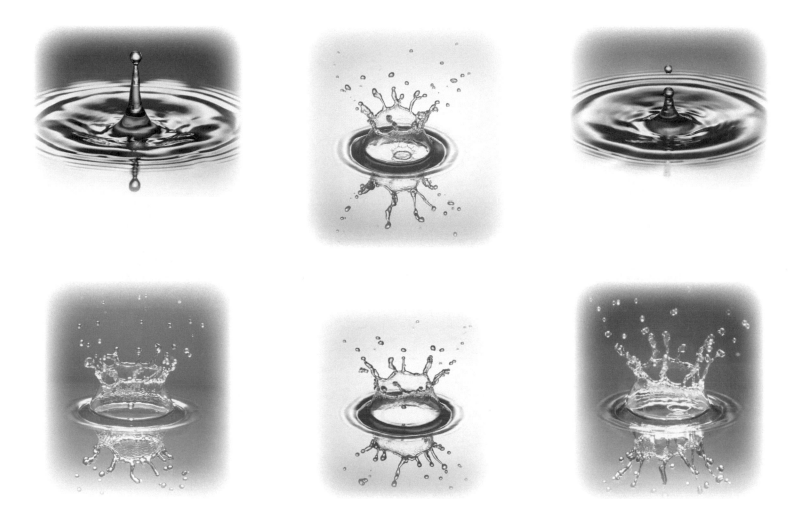

In these beautiful high-speed water droplet splash photos by Andrew Davidhazy, we see a brilliant array of perfect designs. These photos are random and do not represent a sequence of action. Each splash, either the initial splash or the secondary splash, is as unique as a fingerprint! It is important to keep in mind always, that while we do learn a great deal from observing reality, it is the special effects animator's magic to be able to exaggerate and thus almost improve upon nature's staggering beauty.

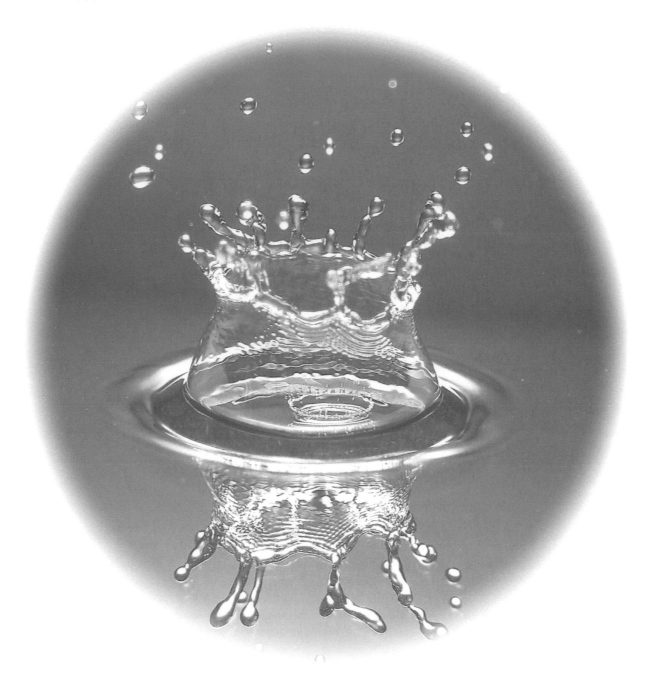

Raindrops are the simplest, shortest splashes. In these sequences, only four drawings are used. In some cases only three or even two drawings can work reasonably well. Personally I always like to go a little bit farther even with something as simple as a raindrop. This is a straight on side view. The drops on this page would be hitting a solid surface.

It is plain to see, that these are much simpler designs than something like the photos of the milk drop on the previous pages. This is especially important when you are animating lots and lots of raindrops, but it also looks cleaner and neater than getting too detailed with your splashes. This is a slightly downward view of a raindrop.

This is a straight down shot of a raindrop splashing on a solid surface. Again, this formula is not carved in stone. If I am animating a lot of raindrops I might do the majority in three drawings, some in four drawings, and the occasional one in five or even six drawings. This would introduce a nice amount of variety to the look and implied scale of the raindrops.

A splash's proportion, or size, is a very important thing to consider when animating a splash. The #1 splash here is roughly the size of a big raindrop splash, or a small pebble being dropped in the water. It should only last about half a second, or 12 frames of film and the ripples resolve almost immediately. The secondary splash of this tiny splash, is no more than a tiny droplet on top of a little jet, shooting up for 4 to 6 frames. The second, splash #2, is about the size of a splash created by a baseball or a fist-sized rock. It should last about 24 to 36 frames, or a little over a second, and its ripples could carry on as long as two or even three seconds. Its secondary splash should be substantial.

The #3 example is a medium to large splash, as might be created by a basketball-size rock. It should last about 2 or 3 seconds; its ripples could carry on outward away from the point of impact for several seconds before resolving, and its secondary splash might be as big as its initial splash. The key to the size and duration of a splash, is how much water is being displaced.

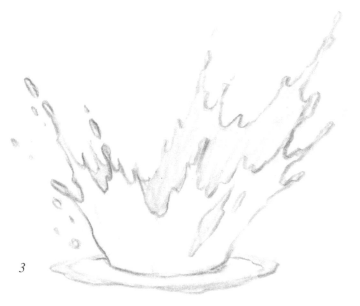

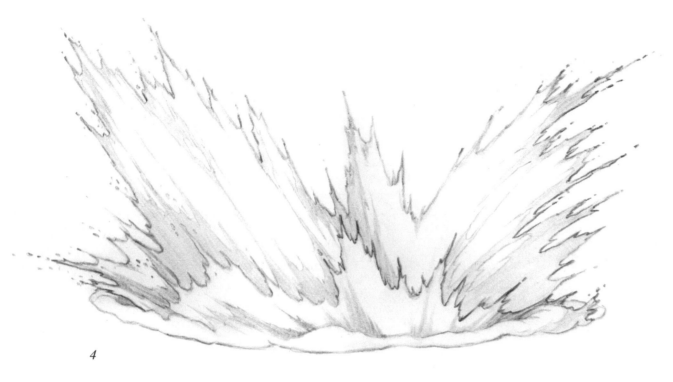

4

The #4 splash is absolutely enormous—the kind of splash that might be created by a breaching whale or a chunk of glacier ice falling into the ocean. The sheer volume of water being displaced is tremendous, and to really get that feeling of immense volume across to the viewer, the effects animator needs to make this splash move relatively slowly after the initial explosive impact. The secondary splash will also be huge and a splash like this doesn't just generate ripples, it generates waves, which can follow through for several seconds. This kind of effects animation takes a great deal of finesse, labor, and patience to do properly. There are no fast easy ways to make something this big look convincing.

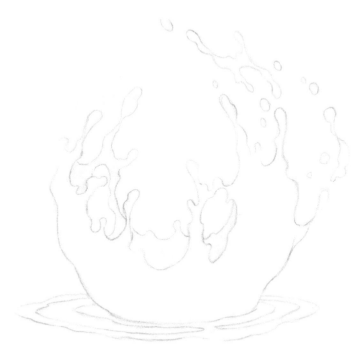

A splash's design is a wonderful thing! One of my favorite aspects of animating special effects like water is that there is always room for quite a bit of personal design interpretation, even if you are bound by a film's design to stay within some fairly strict design parameters. It is interesting to note that after working with certain highly talented effects animators over the years, I am able to recognize their effects drawings with only a cursory glance. A bit of an artist's personality can go into every effect. All of the splashes on these two pages are roughly the same size. The first one on the left here, is somewhat

bowl-shaped, and fairly realistic. The splash to the right, is almost the opposite shape of the first one, and its details are far more globular and slightly less realistic. This is similar to the style of effects drawings that we designed for the feature film, "Lilo & Stitch", at Walt Disney Feature animation in Florida. Not only is it pleasant to look at, it is also a far easier style to animate, and therefore cheaper to produce. Less full, "cartoony" animation might go even farther in this direction, simplifying water design to its most basic forms, in the best interests of economy—both visual economy—and fiscal economy!

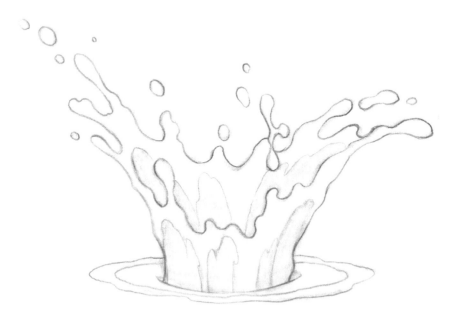

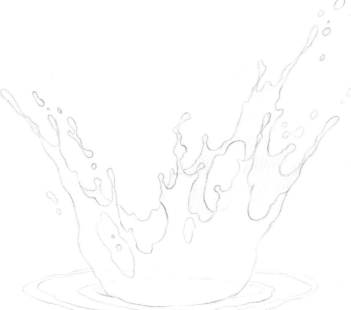

This splash is a far more elegant and less cartoony approach to designing a splash. This style might be more suitable to a more dramatic, stylistically sophisticated film, like Walt Disney's "Mulan" or Dreamworks "Prince of Egypt." Being more realistic and far more detailed, naturally is also more time-consuming and expensive to produce. With effects this realistic looking, it is almost a given that the director is going to want additional

highlights and transparencies to heighten the sense of realism (and the film's budget!). The edgy design on the right, is very similar to the effects I designed on a television show called "Silverwing." The overall design of the show was very angular and hard-edged, and I designed all the effects, water, smoke, fire, etc. to reflect that design hook throughout the show. Designing effects is a lot of fun! Every scene is a new design challenge, and it never gets old.

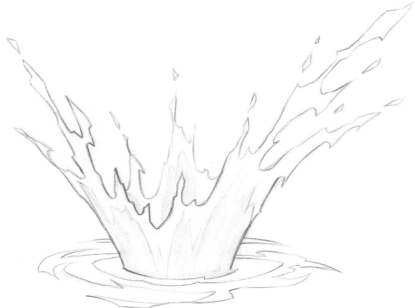

The primary force at work in any splash is generally an object entering and displacing the water, forcing it to move out of the way, or pushing it aside. The energy of the object entering the water, its size, shape, density and velocity, all contribute to the splash's attributes, as well as the tendency of all liquid to displace itself on a molecular level quickly and efficiently as governed by its viscosity and the forces of gravity. In the case of a medium-size splash, let's say a baseball landing in the middle of a swimming pool, there is actually quite a violent reaction by the water as the baseball collides with it.

First we'll run through the process in words, and then we'll look at the all-important visual diagram of what happens, starting on page 104.

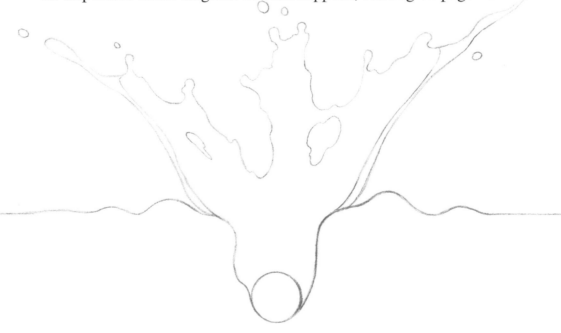

Initially, the energy and mass of the ball entering it forces the water
forming the actual splash violently outwards and upwards (Fig. 1).
The ball drags a bubble of air underwater with it, which breaks apart
almost immediately into smaller air bubbles. Waves or ripples emanate
outward in a circular pattern from the point of impact. As the main body
of the splash, the water that was first displaced continues its trajectory
up and away from the point of impact (Fig. 2), it begins to succumb to
gravity, and at the same time it begins to be pulled apart by the effect
that movement and energy have on its ability to hold its viscosity to-
gether (Figs. 3 and 4). Initially it may take on a sheet-like form, which
will then break up, first forming holes in it, and then ultimately breaking
up into much smaller droplets of water.

During this process, the mass, sheet, or droplets of water will reach an apex in their trajectory path, where they will slow down before beginning their continued path of motion downward, back toward the water's surface (Figs. 4 and 5). We refer to this slowing in and out at the apex as "hang time." It is a clear illustration of the force of gravity at work. This hang time is an important aspect of any splash animation, and will largely determine the scale and dramatic effect of our splash. As this apex hang time is occurring, ripples continue to emanate outward from the initial point of impact, slowing down and diminishing in size and intensity as they go. During this mere fraction of a second, water also rushes back into the air hole that was punched into it by the ball in the first place; this often creates what we call a secondary splash or jet, as the water fills the hole and is propelled upward, however, this secondary splash does not always occur and is generally much smaller than the initial splash. Its timing will also differ from and overlap the timing of the initial splash (Figs. 5 and 6).

The main body of the initial splash then finally succumbs fully to gravity, and falls back into the water surface as sheets blobs, droplets or spray with different parts of the main body of the splash falling at slightly different intervals depending on their original trajectory. These will create another secondary set of ripples, which then need to emanate outward from their individual points of impact (Figs. 7 and 8). Finally this last set of ripples runs out of energy and subsides, and the water's surface goes back to its original, flat, calm, undisturbed state (Figs. 9 and 10). Sound complicated? Well, it is, but broken down visually into clearly defined and separated stages of a splash, it is much easier for an animator to manage all of this fantastic information.

(This is a straight-on horizontal side view of a splash as if it were cut in half)

Fig. 1

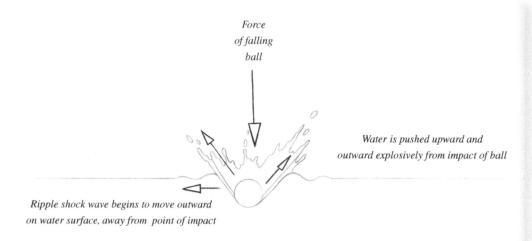

*Force
of falling
ball*

*Water is pushed upward and
outward explosively from impact of ball*

*Ripple shock wave begins to move outward
on water surface, away from point of impact*

Fig. 2

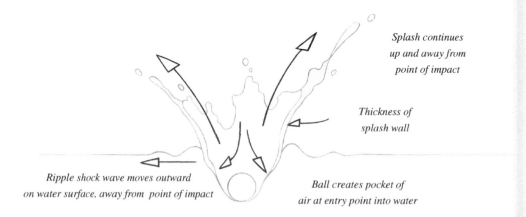

*Splash continues
up and away from
point of impact*

*Thickness of
splash wall*

*Ripple shock wave moves outward
on water surface, away from point of impact*

*Ball creates pocket of
air at entry point into water*

Fig. 3

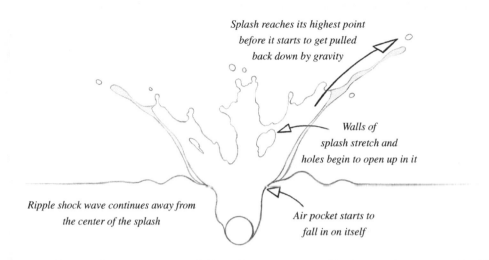

Splash reaches its highest point
before it starts to get pulled
back down by gravity

Walls of
splash stretch and
holes begin to open up in it

Ripple shock wave continues away from
the center of the splash

Air pocket starts to
fall in on itself

Fig. 4

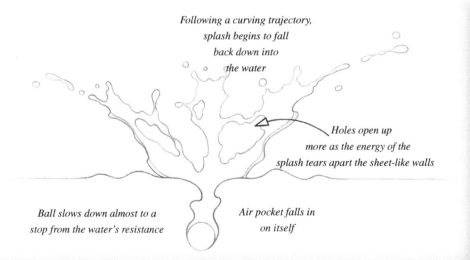

Following a curving trajectory,
splash begins to fall
back down into
the water

Holes open up
more as the energy of the
splash tears apart the sheet-like walls

Ball slows down almost to a
stop from the water's resistance

Air pocket falls in
on itself

Fig. 5

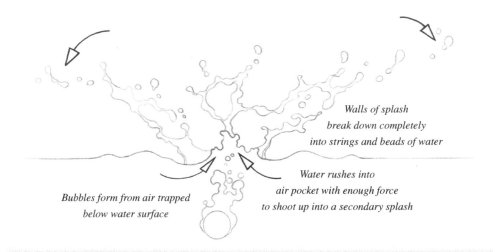

*Walls of splash
break down completely
into strings and beads of water*

*Water rushes into
air pocket with enough force
to shoot up into a secondary splash*

*Bubbles form from air trapped
below water surface*

Fig. 6

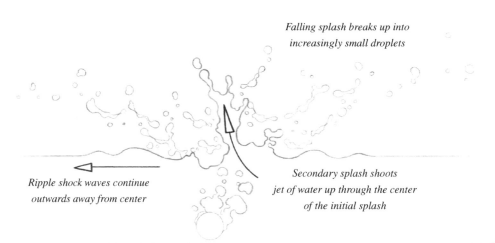

*Falling splash breaks up into
increasingly small droplets*

*Ripple shock waves continue
outwards away from center*

*Secondary splash shoots
jet of water up through the center
of the initial splash*

Fig. 7

Secondary splash water jet reaches its
apex (highest point) before gravity
pulls it back down

Another set of ripples
begins to emanate outward
from the secondary splash

Air bubbles trapped under water
continue to rise as they break up
into smaller bubbles

Fig. 8

Water jet falls,
highest droplets hang a little
longer before falling

Some of the falling droplets create
small secondary splashes

Ripples from secondary
splash overtake initial ripples
that have lost their momentum

Fig. 9

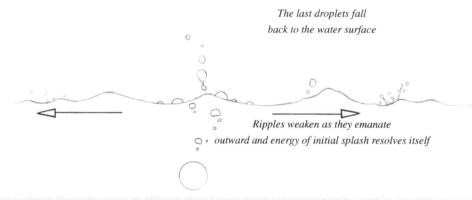

*The last droplets fall
back to the water surface*

*Ripples weaken as they emanate
outward and energy of initial splash resolves itself*

Fig. 10

*Ripples finally die out completely and water
surface returns to its calm flat state*

*Ball continues to sink.
Its speed and trajectory will vary,
depending on the speed of its
entry and its density*

Here is a photo of a well-developed secondary splash, or jet, at its highest apex. You can see the leftover ripples from the initial splash, still emanating outward. Depending on the size, shape, weight, trajectory and entry angle of the object that caused the splash, the secondary splash can vary greatly in size relative to the initial splash. In some cases it is much larger than the initial splash, but it is generally a much smaller splash.

Here's a real splash that was created by tossing a rock about the size of a baseball into a river. The walls of the splash are breaking up, and the secondary splash, or jet, is just starting to shoot up the center.

1

2

3

4

5

6

7

8

9

*A small water or soap bubble bursting creates its own tiny splash.
A bubble can form extremely quickly, suddenly appearing on a
water surface, or it can expand slowly as it reaches its breaking
point. When it does reach critical mass, a tear first appears on the
top of the bubble, bursting outwards very suddenly (4, 5, 6). After
the initial tear in 4, the bubble breaks down very fast as in 5.*

10

11

12

13

14

15

16

17

18

As the bubble breaks down completely, the force of its bursting creates a unique little splash, which then resolves itself much as a larger splash created by an object which has been thrown into the water, just on a much smaller and lighter scale. In this bubble animation, I added a secondary splash caused by one droplet which lands after the main splash has resolved (15 through 18).

This splash is very similar to the more technically drawn diagram of a side view of a splash on the preceding pages. A splash of this size and intensity could have been created by an object about the size of a golf ball being thrown into a calm pool. In drawing #1 we see the initial impact, which should have an explosive energy to it, appearing as an already well developed little splash shape. If this stage is animated too slowly, with the splash growing gradually in the first 6 to 8 frames, it will not have the necessary impact, it will look slow and unreal. As the splash continues its trajectory upward, its wall begins to become too thin for the

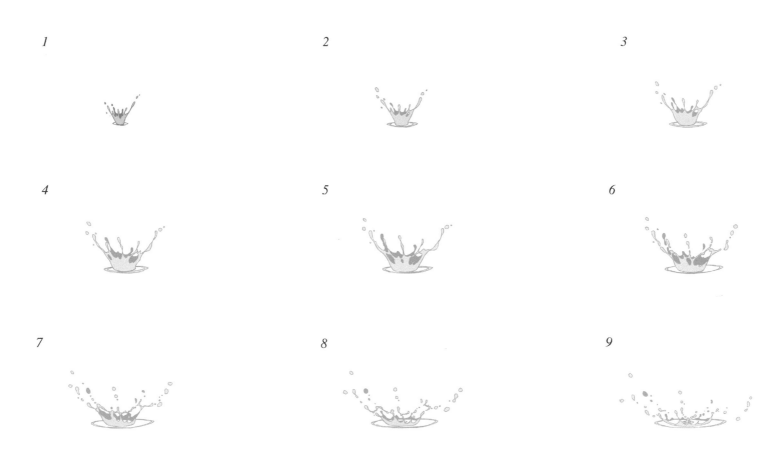

1

2

3

4

5

6

7

8

9

water molecules to hold it together, it begins to stretch and tear, and we see holes begin to open up in the thin sheets of water. Always keep in mind the directional energy that originally created the splash! As the walls of the splash tear apart into drop- lets and fall back to the water's surface, we see a secondary splash, or water jet, shoot straight up the middle of the splash's point of impact, as water rushes in to fill the hole created on impact. Drawings #10 through #15 show the secondary splash shooting up and falling back down, creating yet another tiny splash. The overlap- ping timing of these different splash elements is what gives good splash animation its dynamic and entertaining quality.

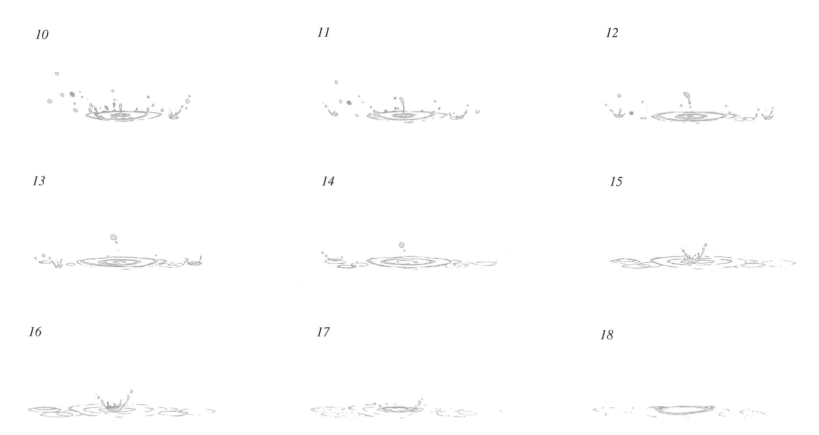

10

11

12

13

14

15

16

17

18

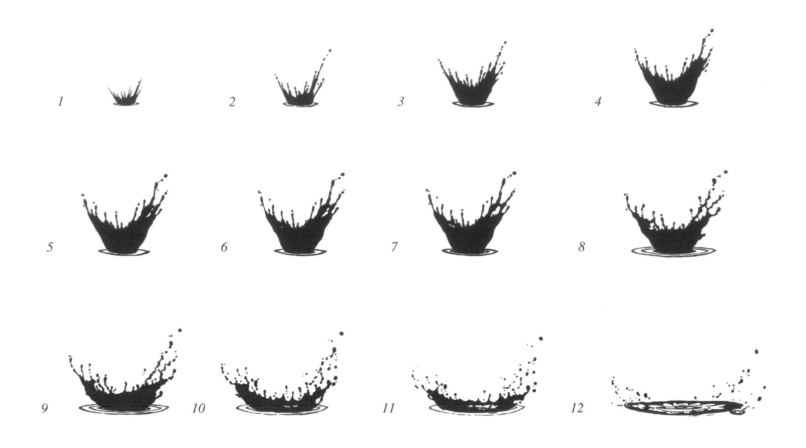

The splash on these pages is a medium-size splash, as if we dropped a baseball in the water. I have silhouetted this animation to show more clearly the importance of asymmetry when designing a splash. The sequence of separate events that make up this splash are basically identical to the smaller splashes in the preceding pages. The initial impact, drawings #1 through 4, in which the shapes are most pointed and directional. This must not be too slow or effect will lack impact.

The next stage is the apex, or highest point that the water will reach as it shoots upward. The drawings get closer and closer together as the splash slows to its highest point in drawings #5 through 7. The walls of the splash stretch and begin to tear. From drawings #8 through 12, the splash falls back down, continuing to tear apart, accelerating as it goes the drawings getting farther and farther apart as they get closer to the surface. From drawing #12 through #18, the splash does its final resolve, with the main ripple that was caused by the initial impact slowing down as it spreads out.

Care must be taken to assure the elliptical perspective is kept consistent. Several droplets create tiny secondary splashes as they land, giving a nice overlapping feeling to the overall timing of the splash. Although there may have been around fifty droplets visible around drawings #9 through 12, only four or five actually splash down, but that is enough to suggest that they all landed. Adding too many landing drops will just make your animation overly busy!

13 14 15

16 17 18

Here is the same splash from the preceding pages, in full color with reflections, bubbles, and additional secondary splashes. We can see clearly here, how overlapping actions moving at different speeds and directions add to the dynamics.

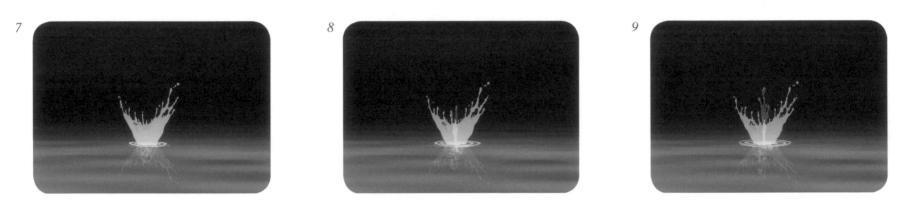

As the splash reaches its highest point and begins to fall, a secondary splash shoots up, creating overlapping action. The pocket of air that was pulled underwater by the rock, breaks up into individual bubbles.

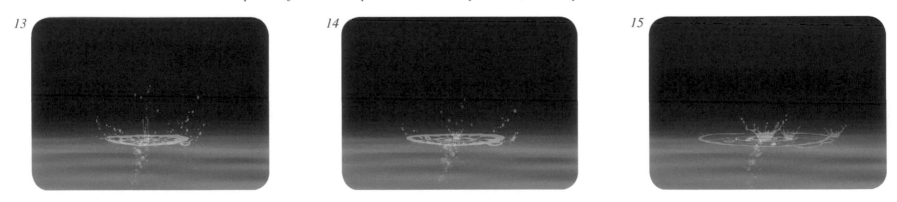

The final droplets from the initial splash reach the surface, and the droplets from the secondary splash accelerate downward. There are small additional splashes from the falling secondary splash, and the bubbles reach the surface, popping as they hit the air.

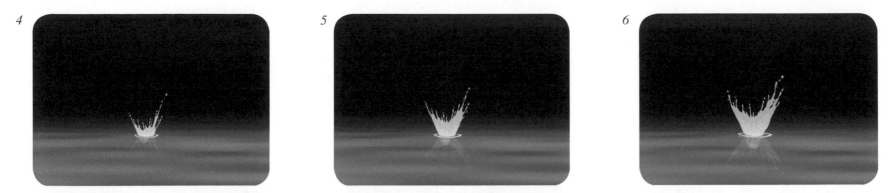

As the rock hits the water, it pulls a pocket of air under the water. The initial splash is very spiky and explosive, but it begins to slow down quickly at it shoots upward, taking on softer, more liquid shapes. Holes begin to tear in the walls of the splash.

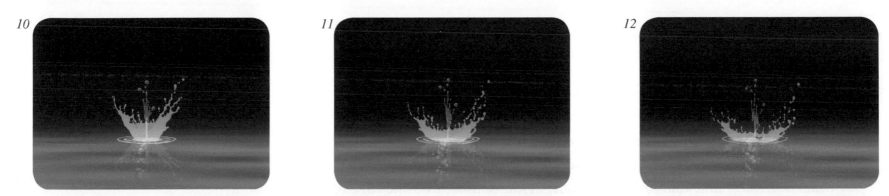

Now the walls of the splash really tear apart, as the the initial splash accelerates downward, and the secondary splash reaches its highest upward point. The bubbles from the rock make their way wiggling to the surface.

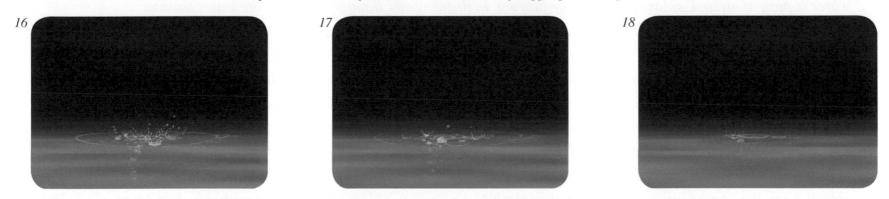

The ripples of the initial splash and the secondary splash fade away as the last bubbles to reach the surface pop and leave tiny ripples that resolve quickly.

*Here is a sequence of a typical drip like we might
see coming out of a tap that isn't quite turned off.*

1 2 3 4 5 6 7 8 9 10 11 12 13

*To really get a good feel for the way
a drip behaves, we need to understand how
water tension works. This is the way in which water
molecules cling together, and fight the effects that gravity and
other forces have on water. We have all seen how an overfilled glass
of water will bulge and kind of hang in there, before spilling over the edge of the
glass. That is water tension, and it is responsible for all the fascinating shapes that occur when
water is pushed around, splashed, falling or flowing. In drawings #1 through 9, we see the water tension
holding a small volume of water together as it builds up and increases in size, until the effects of gravity on
its weight are stronger than the water tension holding it together. It stretches and strains to the breaking point in draw-
ing #10. Immediately upon snapping, the effects of water tension take over again, pulling the molecules together to form
a beaded string of droplets. It is important to vary the size of these droplets, for a more dynamic-looking effect. As the
largest droplets falls first, it stretches and then squashes as it falls in drawings #11 through 17. If we were to watch this
sequence in slow motion on live action film, we would see that the droplets jiggle like jello as the water tension attempts
to pull them back into a perfectly spherical shape, and they recover from the snap of the stretching water breaking off. The
splash when the droplet hits is exactly like the splash of a raindrop, although the droplet probably didn't have the velocity
that a raindrop does, thus its splash is somewhat more subtle and globular than that of a raindrop.*

14 *15* *16* *17* *18* *19*

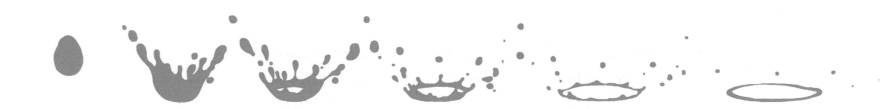

In the following splash sequence, the splash is roughly the size that would be created by a small cannon ball, or a rock about the size of a small coconut, being dropped into the water. This approach to drawing/ animating a splash, is clearly not an attempt at realism. This particular design and approach owes its look and physics to the Disney effects animator's animation of the 1930s, 40s and 50s, and is very similar to splashes seen in films like Dumbo and Peter Pan.

Of course, the first thing an animator must do, before forging ahead with animating an effect, is have a plan. The very first step in this plan is a simple perspective grid, inside a frame, or field. This is the stage on which the animation is set, and it needs to work with whatever other elements there are in the scene's layout.

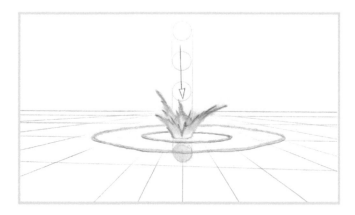

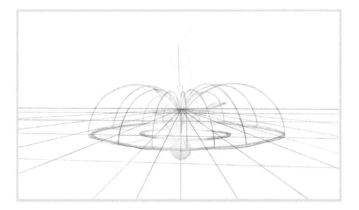

The next step is to begin considering the parameters of the shot. What is causing the splash? How fast is it moving? What is it made out of? Is it light or heavy, dense or porous? How much water would this object displace, and how big will the splash have to be? How much of the frame should it fill up as it dissipates?

A path of action for the effect should be established before we begin animating. This serves as your guide as you animate, and can be very helpful in keeping the proportions of the effect accurate. Always consider as well, what the intention of the effect in the scene is. Is it the star of the scene, or does it only have a supporting role? Know what the scene requires in every way before starting!

There are as many subtly different approaches to animating a special effects scene, as there are animators. There is not necessarily a right or wrong way, as long as your final animation looks good! But there are fundamentally sound ways to proceed that will give you the greatest chances of success. By far the most tried-and-true technique for hand-drawn effects animation, is to roughly animate to begin with. Avoid thinking about the details of your effect until the overall motion is working well. Draw with a loose hand, think of the energy rather than the design, and push your drawings dynamically as if they were actually moving on your page. Don't be tentative at this point! The finely detailed and clean splash drawings on the following pages, got their energy and direction, from dynamically drawn, rough preliminary drawings.

There are several things to always consider when you are animating a splash. What is causing the splash is one of the most important. That factor alone will have a lot to do with how much water will be displaced, how high the splash will shoot up before it succumbs to gravity, and how big its secondary splash will be. Always remember to think about what else is going on in the scene. Is the effect important to the telling of the story? Is there another action going on in the scene that is more important? Knowing what is causing the splash, what the splash's role is, and then integrating the effect with the overall style of the film is a great recipe for successful splash effects animation!

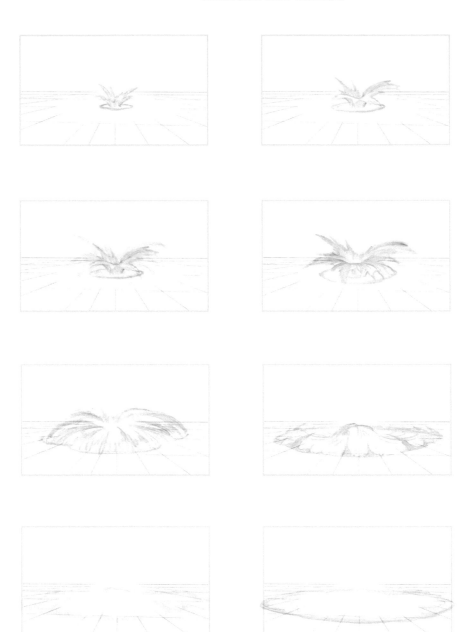

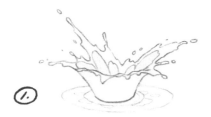

This is a very classical, stylized approach to animating a splash. The initial splash shoots up and outward, like a blossoming flower.

The walls of the splash fold over at the highest point of its trajectory, or the "apex", of the splash's path of action.

As the walls of the splash stretch outward, away from the point of impact, holes begin to open up, as these sheets of water "tear" apart.

The leading edges of the initial splash fall back to the surface first, and are absorbed into the surrounding water surface, creating a new set of ripples.

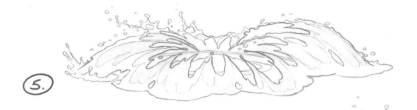

The *"sheets"* of the splash fold over at the
apex as they stretch and tear, and they are
finally absorbed back into the surrounding water surface.

At this point we begin to see the
"secondary splash" forming at
the original point of impact.

In this case, it is not so much a *"splash"* as a huge
swelling bubble bursting back up to the surface,
which is often the case when the object causing the
splash is very heavy, or dense.

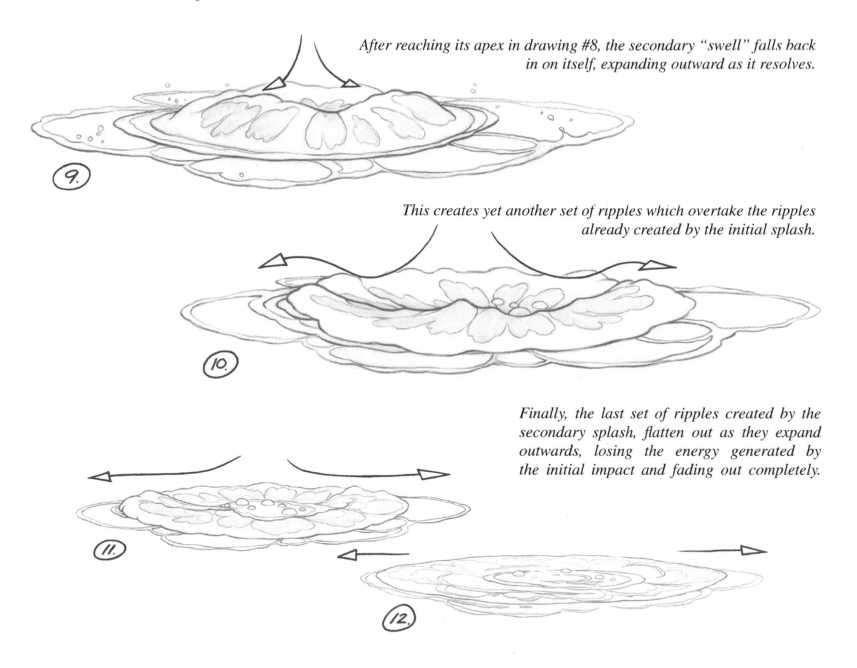

After reaching its apex in drawing #8, the secondary "swell" falls back in on itself, expanding outward as it resolves.

9.

This creates yet another set of ripples which overtake the ripples already created by the initial splash.

10.

Finally, the last set of ripples created by the secondary splash, flatten out as they expand outwards, losing the energy generated by the initial impact and fading out completely.

11.

12.

Wave action is another very commonly seen water effect, the basics of which are relatively easy to master once the underlying principles of wave motion are understood. There are some fun, easy tricks that can be used that mimic the principles of wave motion without the need to really get deeply into the actual scientific physics of wave movement. Understanding displacement, how a water surface always displaces itself as it moves from place to place is extremely important. Imagine tubular

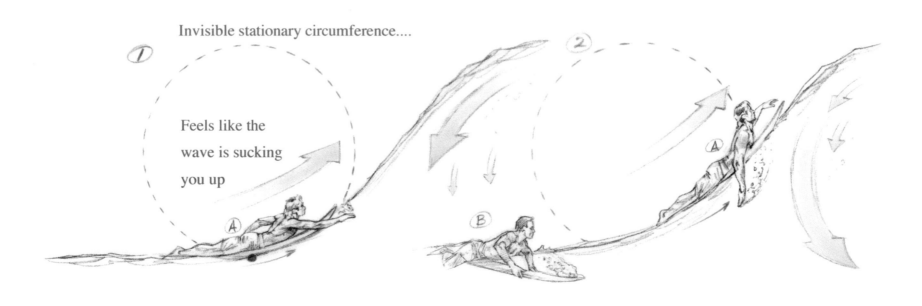

Surfer A : Paddles over the top of the wave.
Surfer B : "Duck dives" under the wave and is lifted to surface by wave's turbine.

shapes of energy moving just under the surface of the water, which displace the surface textures as they roll underneath, allowing the details to fall back into their original place as they pass. The simplest way to illustrate this is the image of a tiny boat, bobbing up and down and to and fro as a wave passes under it, but winding up in the exact same place it was after the wave has passed. Whether a water surface is moved by

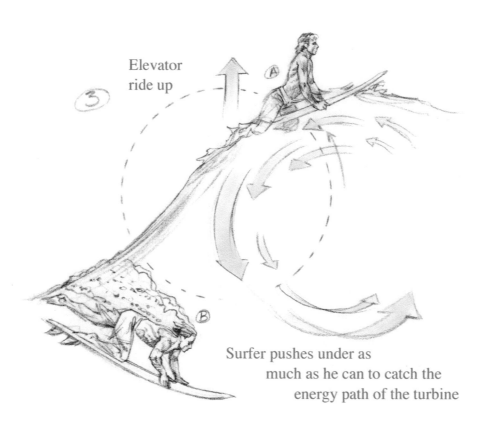

Elevator ride up

Surfer pushes under as much as he can to catch the energy path of the turbine

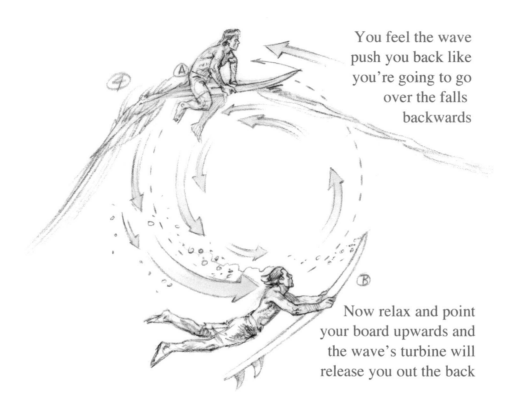

You feel the wave
push you back like
you're going to go
over the falls
backwards

Now relax and point
your board upwards and
the wave's turbine will
release you out the back

wind, the moon's gravity, a boat pushing through it, or an explosion that
has caused its movement, waves all behave similarly once they get their
initial directional movement. When attempting to animate more than
one wave at a time, especially a water surface covered with waves, it
is easy to get overwhelmed and find that the drawing is controlling us,
rather than us controlling the drawing. Remember to keep your drawings
as simple as possible, at least until the initial ruff animation is working

Note that Surfer A simply rolled around in a circle as the wave passed underneath him. He ends up in almost precisely the same spot he started in. If you follow his movement through this sequence of drawings, you see the classical rolling wave physics at work!

Spray from wave's crest feels like rain

You can still feel yourself being pulled back

⑤

⑥

Surfer A pulls his board up to put on the brakes and keep himself from going any further backwards

Surfer A returns to his original spot

Surfer B gets shot out of the back of the wave (That's what it feels like!)

Surfer B emerges well in front of Surfer A

well. Then we can add details, and add the overlapping actions of different sized waves. It is extremely important with good effects design, to vary the size and shapes of our waves and their surface details—and their movement as well—to create believable, natural feeling water animation. Remember also, to always *push your drawings*. Always exaggerate, as animation needs that extra information to work well!

In this next wave sequence, we'll look at some of the tricks of the trade to consider when animating rolling waves, including overlapping our action and using counter action. These drawings are key poses about eight frames or one-third of a second apart. This entire sequence would last roughly 2.6 seconds, and it is a cycling wave action, with pose 8 hooking up and continuing through with pose 1. I have labeled specific wave

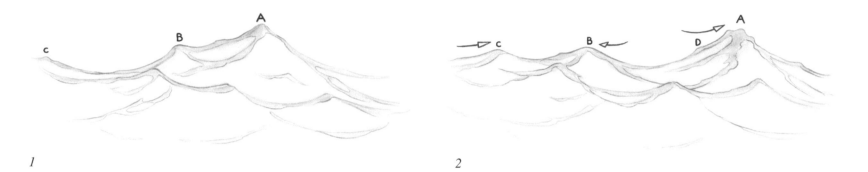

1 *2*

peaks with letters, as we often do in the business, so that an assistant animator can follow which wave is going where, especially when there are counter-acting waves. The main direction of these waves is from left to right. In pose 1, we see wave peak A figuring prominently. Imagine it is traveling from left to right, and wave peak B is sliding down the back of wave A in the opposite direction, from right to left. This action can be seen clearly in pose 2. Wave C has just entered screen left and is traveling toward the right, along with the general flow of this water surface. The larger waves might be big rolling swells that may have been created by a storm a thousand miles away, while the smaller counter-acting

waves could be a smaller, choppy type of wave caused by a local breeze. In pose 3, we see wave B and wave C converging on each other, moving in opposite directions and building up into a larger wave, as wave A rolls away to the right, with much smaller waves D and X rolling down its back much as wave B did. In pose 4, waves B and C have crossed over each other, with the much larger wave C pushing right through

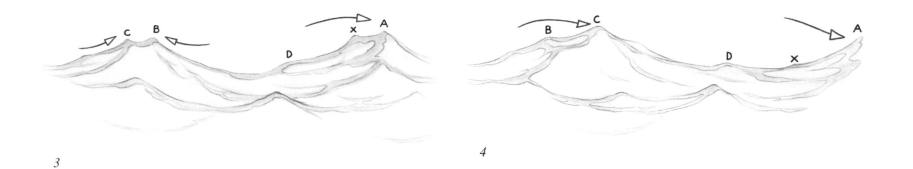

3 4

wave B, building momentum as it goes. The smaller waves D and X are still moving right to left against the larger waves, and wave A is rolling right out of frame right. It is important to keep in mind, if the camera and therefore the horizon line is fixed, our water will always displace itself evenly in frame. If we push it down on one side, it must rise on the other side. Water always displaces itself perfectly, as its molecules rush in to fill any space vacated by whatever energy is moving the water. It is always attempting to move back to its flat, even self, as it is held earthward by gravity. In pose 5, we see secondary wave B still

moving right to left, counter to the overall thrust of this water surface, while wave C has built up in size and continues left to right. All the smaller secondary waves, D and X and another unnamed ripple, are moving counter to the main wave, now moving toward the left, up the face of wave C as it rolls to the right. In pose 6, we see waves C and D converging, while wave X has been absorbed completely, and the

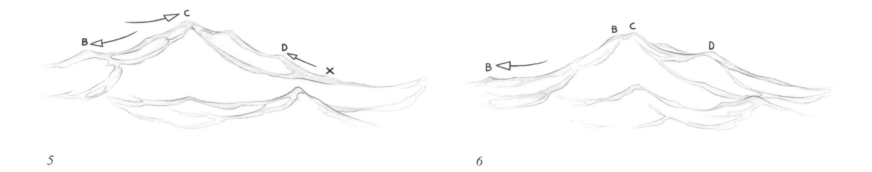

5 6

unnamed ripple gets pushed back and away from us as C and D converge. Behind wave peak C, I have reintroduced secondary wave B, as the original wave B continues of screen left. This is where this wave action begins to hook up with the original action in pose 1, so that it can be cycled over and over. In pose 7 we see wave C and D continue to converge and build up, approaching the size and weight of wave peak A from pose 1. The smaller secondary wave B is starting its way back down the backside of the larger more powerful wave.

In pose 8, secondary wave D is swallowed up by the strength and momentum of wave C, which I have also labeled (A) as this is where the cycle hooks up with pose 1. If you look back at pose 1 now and imagine it is the next pose, you can see how A continues its way left to right, as wave B slides down its back. This is a very stylized approach to animating wave action, with larger swells pushing against the smaller

7 8

secondary chop moving in the opposite direction. The smaller waves in the foreground demonstrate the same type of wave action, and if you analyze these actions, there are some very useful techniques and tricks for successfully animating waves. Always keep overlapping counter-action and volume displacement in mind when you are animating a water surface. It's also very important to keep in mind that water is constantly morphing, and many wave shapes can and do disappear and appear mysteriously.

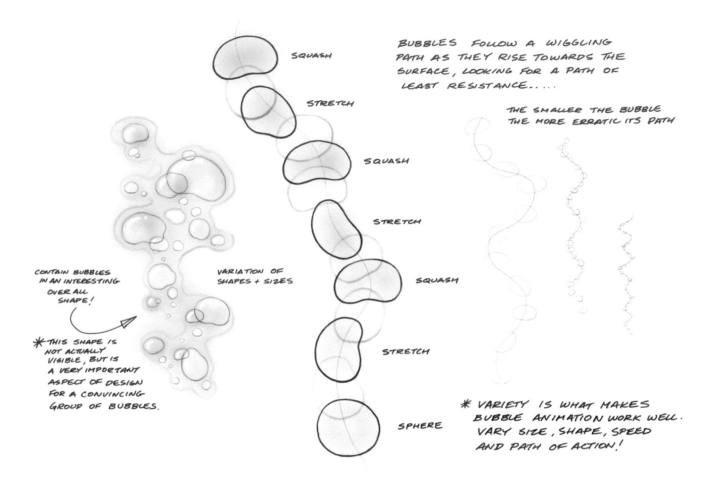

Bubbles are really fun, fascinating elements, little pockets of water pushing their way to the surface, looking for the path of least resistance, and just wobbling around madly in the process. They can take on an incredible variety of shapes, and they stretch and squash delightfully. When animating bubbles, remember to exaggerate the stretch and squash, and have fun with them!

Earlier on in this chapter we looked at how a splash looks, from a cut away side view. Here is a more detailed look at what happens underneath the water, as the object punches a pocket of air into the water. The initial air-filled hole gets pulled downward by the momentum of the object, and in the process it stretches into liquidly oblong shapes. Then as gravity continues to pull the object down, the air begins its wiggling journey back to the surface breaking up into smaller pieces in the process.

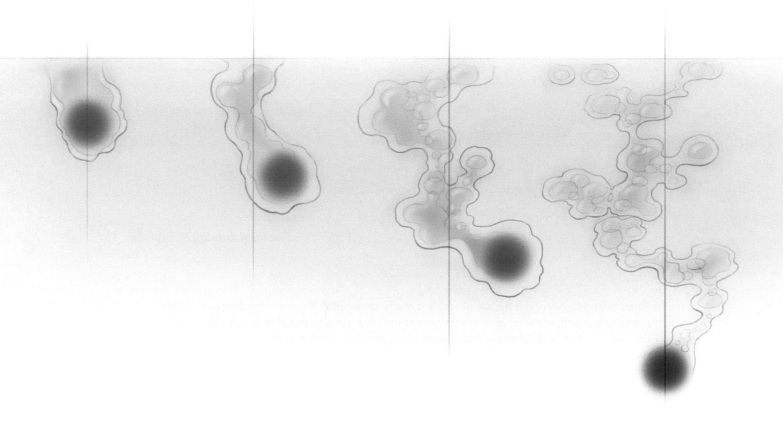

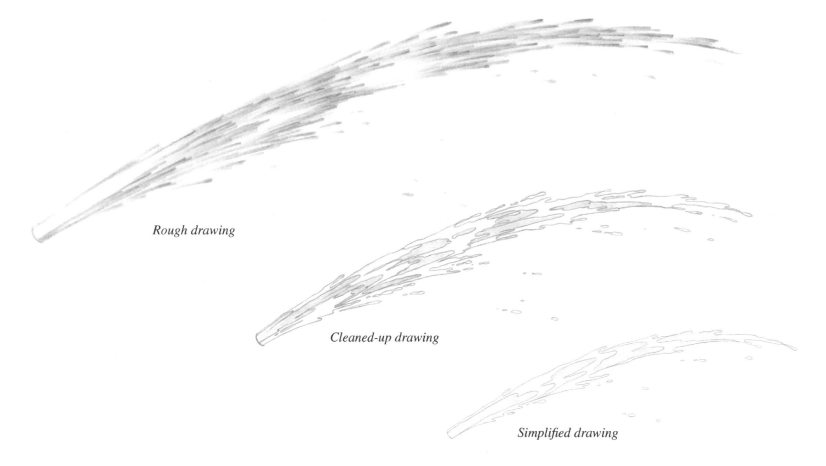

Rough drawing

Cleaned-up drawing

Simplified drawing

Water shooting out of a hose, should have a really strong directional energy flow to it. When drawing it rough, use fast, energetic strokes to create good directional movement to each drawing. If the rough drawings have energy in them, the shooting water will retain that when the drawings are cleaned up. Even if it is a very simple cartoon style, with far less detail, as in the third example drawing here, if the rough has good energy so does the cleaned-up drawing.

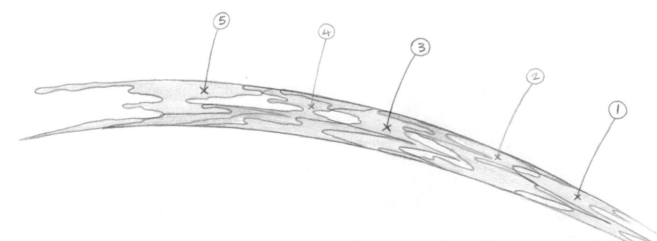

The detailed shapes inside this shooting water, should be moving very fast, in the direction of the water's flow as in the diagram above. These shapes should overlap slightly, and change shape quite radically from drawing to drawing. The overall shape of the shooting water should have a very subtle waving action to it, as illustrated in the drawings below. This undulating action should be very fast as well, and it can also be somewhat erratic, as water shooting out at high speed does have a very active randomness to its movement. These principles can be applied to many water elements, such as waterfalls, fountains, or water running out of a tap.

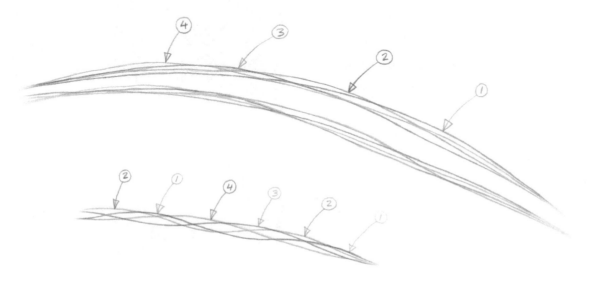

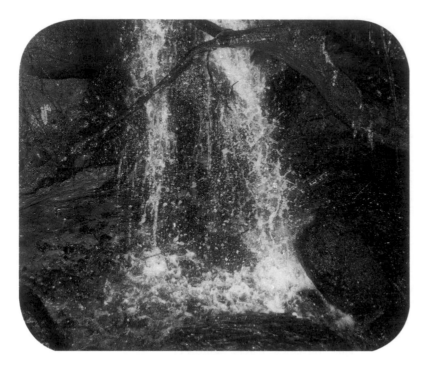

Animating waterfalls by hand can be a daunting task, given that even a very small waterfall, like the one in this photo, is an extremely complex element to illustrate. It is imperative to find a more simplified, stylized design in order to make the level of detail manageable to draw. This photo above was taken with a very fast shutter speed, so there is no motion blur whatsoever.

When designing a hand-drawn waterfall, we should add a certain amount of directional energy and motion blur, which not only helps to simplify the animation process, but can also add the all-important energy which I emphasize so much as an integral part of all effects animation. The photo of the exact same waterfall on the right was taken with a much slower shutter speed, so you can see the directional flow of the waterfall far better.

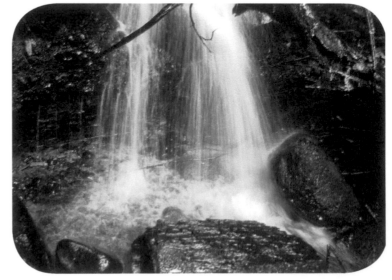

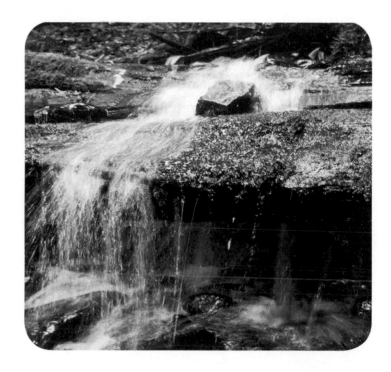

Simplifying something as complex as even a very small, relatively simple waterfall is no easy task. There are so many overlapping shapes happening at once to describe the water's path of action. My drawing here is still extremely complex, even though I have reduced the amount of detail at least 50% compared to the photo.

Taking the first waterfall photo from the preceding pages, I have illustrated how, by simplifying the shapes and stretching them out, we can illustrate the directional energy of the waterfall at the same time that we simplify it enough so that we can animate it without too much detail.

Even with a great deal of simplification, the drawing on the right is still a very detailed and difficult design to animate! Animating waterfalls is another area of special effects animation that can be much more "effectively" done with the aid of digital technology, and still retain a hand-drawn look.

When drawing and animating a waterfall, the details can get way out of hand. To consider animating each little droplet and water shape as it descends is out of the question. If one must animate such a thing, keep in mind that if the general flow of the shapes is moving in the right direction, the illusion that every drop is moving in that direction will succeed. Some of the details can be followed through, but it is not necessary to animate all of them! Keep it as simple as possible! When deciding which details to

focus your efforts on, choose the parts of the effects design that make the strongest silhouette. These are worth detailing as the viewer's eyes will see these shapes more easily than shapes that are inferior to the effect. Choose your battles carefully, and you will save much time and your effects will be more powerful. I must emphasize once again, that waterfalls are one effects element that can be beautifully done digitally, even in a 2D environment, so considering their inherent complexity, animating them by hand is not always the best way to go!

Of course not all liquids are water. In the course of my career as an effects animator I have had to animate alcohol, oil, salad dressing, mucus, lava, mud, blood, gasoline, milk, oatmeal, and other liquids, and I handled every one slightly differently. Most important is to establish the viscosity, or thickness of the liquid we are attempting to animate. The higher the viscosity, the thicker the liquid. Suppose water is our standard for average viscosity as it is the most commonly animated liquid.

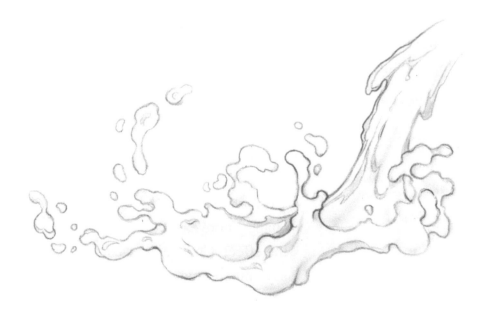

If we are animating motor oil, or cooking oil, which has a far greater viscosity than water, our shapes need to be more blobby and rounded, and our animation has to be somewhat slower as well. Greater viscosity means the molecules of the substance cling together more stubbornly, thus it is thicker and moves more slowly.

Thus gasoline has a very low viscosity, it is thinner than water, as are paint thinner and pure alcohol. These liquids will displace themselves more quickly and break up into beads much more easily than water. On the slightly thicker, higher viscosity side, something like milk, which is only slightly thicker than water will displace and break up slightly slower than water. Thicker still are all types of oils, thicker even more are mud, lava, tar, molasses, etc.

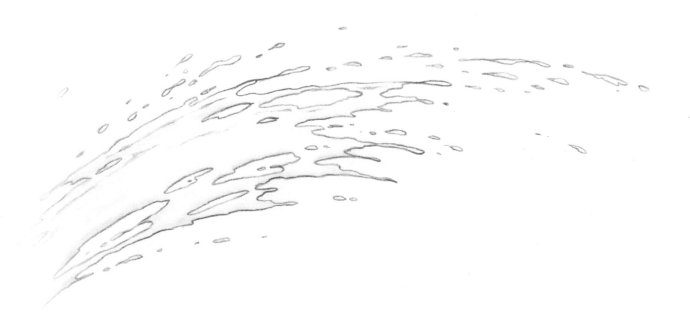

If we are animating gasoline, paint thinner, or kerosene, the opposite principles apply, as these liquids have less viscosity, and therefore are thinner and break up more easily than water. So keeping that in mind, gasoline will break up into thin sheets and tiny droplets much quicker than water does. In a puddle it would spread much faster as well.

As viscosity increases, our animation must slow down appropriately, and our designs become more rounded and blobby, as these thicker liquids hold together much better than water, and resist the forces that move them a lot more as well. Research and observation are very important when tackling these liquid elements. Many have been beautifully animated in films like Fantasia, and observing the design and animation timing in these films is extremely valuable, especially for the beginner.

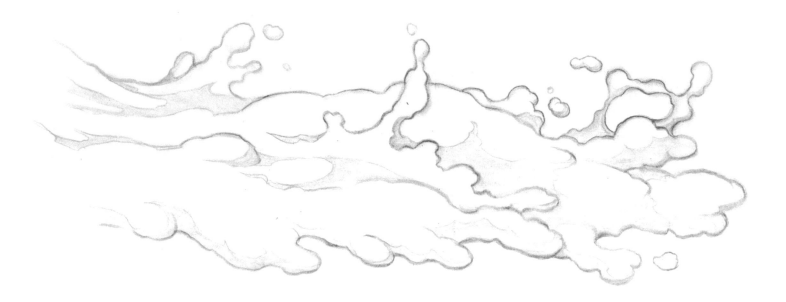

If we are animating lava, which has a far greater viscosity than water, oil or gasoline, our shapes need to be even more blobby and rounded than our oil, and our animation has to be slower although it depends on how quickly lava is being ejected from a volcanoe, it can be moving very fast. Lava is very challenging to animate, as it is usually cooling quickly, and the cooler lava is thicker, therefore we need to deal with different viscosities at the same time.

This lava splashing up out of a fissure is a beautiful example of how the initial force behind the movement of any liquid creates a flowering, spreading design that has a logical path of action. As this lava is thrust upward, it is also spreading and rotating as it stretches and breaks up into smaller and smaller pieces. In the illustrations on the following pages, I have found the essential energetic design of this spewing lava and drawn it clearly. This flowering, fractal design can be seen in all dynamically moving liquids, as well as in fire and smoke, dust, dirt, gas, and vapor, etc. It is the cosmic design behind everything.

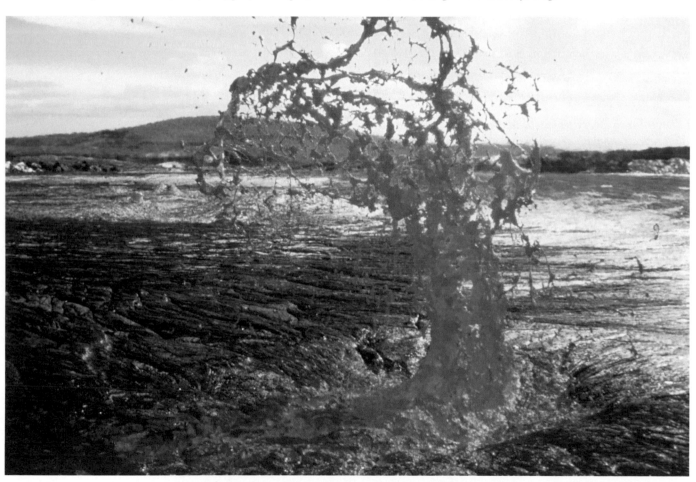

Spectacular lava fountain, Hawaii Volcanoes National Park.

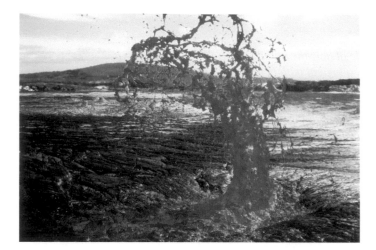

This photo of spewing lava really caught my eye, because it illustrates beautifully, the directional energy and the arcing and sweeping lines of its trajectory. As it spews upwards, it also fans out and away from its source, a direct result of the pressure below, being released into the air above. It is like a blossom opening up! Pure energy unleashed.

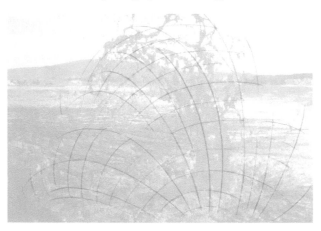

First I have drawn a very technical-looking grid over the splashing lava, that reflects the path of action and underlying structure of the splash. This kind of grid can help us to see the structure that every little droplet and detail of the lava is attached to as it spews, seemingly into abstract shapes, up and out of the volcano below.

Here is a simplified, stylized, slightly "cartoony" looking drawing of the splashing lava. I have drawn it with very clear elliptical shapes in order to point out a very important aspect of special effects design. Frequently I see attempts to draw this sort of effect, having a very unorganized and non-energetic feel to them, and that is because they are missing this all important principle. These shapes and lines may appear to the untrained eye to be mostly abstract in nature, but they are in fact extremely structured. Let's look at how and why.

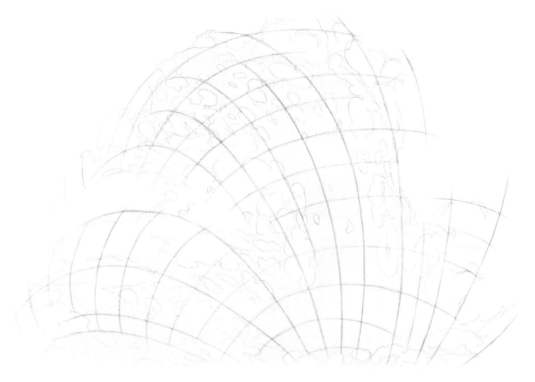

When we superimpose the stylized drawing over the rigid, technical-looking grid that I drew, we see how structured the cartoony looking splash really is. Note that every single ellipse "fits" into the grid, much like the simple ellipses I drew earlier in this chaper to describe how ripples adhere to a perspective grid. This is what makes good special effects of any kind look fantastic and filled with energy. The blossoming energy that has initiated and drives the element's action, informs every aspect of its design and movement. This is an essential principle underlying all special effects animation.

To further illustrate this principle, here are sets of arrows describing both the upwards energy of the splash and the outward fanning-out motion of it. There are many subsets of energy in a splash as energetic and complex as this one, and I could draw hundreds of little arrows to describe them. Most importantly, they are all connected to the main driving force behind this splash. Think of the energy of a flower or a tree, the veins in our arms, a fireworks display, or a river delta fanning out into the ocean. Driven by a force of nature, or by artificial intervention, all elements move with this universal energy.

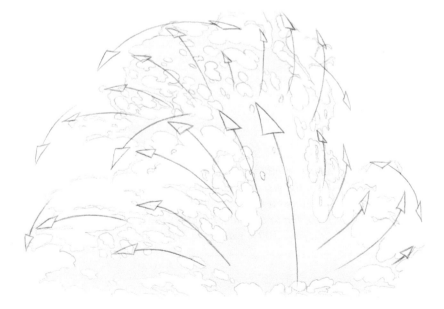

Experimentation with the actual substance we are trying to animate and shooting reference photos or footage can be enormously helpful, and is also a great deal of fun. Remember to have fun whenever you get the chance, because the sheer volume of work involved in animating liquids can be daunting, and it's not all fun and games. Play when you get the chance!

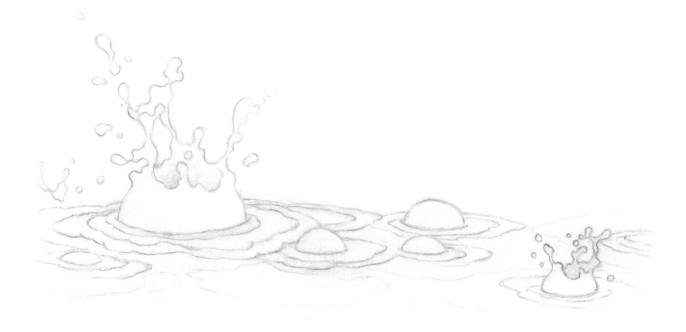

When animating mud, the viscosity is somewhere in-between that of oil and lava, and like lava, the viscosity can vary depending on the temperature or water content of the mud. As mud dries it may become brittle and form chunks and strangely shaped blobs. It can be a lot of fun to animate, as it may have an extremely wide variety of thicknesses, or viscosities, from 100% watery, to brittle dry clay.

Digital Waves

How do all of these classical effects animation principles come into play when we are approaching animating water using today's C.G.I. technology, which is more often than not the way animation is being created these days? Well, if we want our water to look and feel really fantastic, understanding what makes water animation look great from a hands-on approach can help us create far better CGI water effects.

Let's consider the design principles that we have discussed in this chapter, and in Chapter 2 as well. Using what we know about strong classical design, we always strive for striking silhouettes in our animation, an absence of repetitive shapes, or too much symmetry, and in our action we also strive to overlap and offset our timing as much as possible, exaggerating these principles to make our animation more dynamic and alive.

This approach to animating water digitally, can immediately set our work a cut above the rest. This is particularly important in the world of CGI cartoons. Do the same, photorealistic effects simulations that we see in big budget science fiction thrillers really belong in our animated films? The answer is an emphatic no! Animation is a world of imagination, where *all* of the elements should have even more life, character, pizazz, and zest than they do in the "real" world.

That is what sets animation apart from other mediums, our ability to exaggerate reality, to push it farther, into a more fantastic, and ultimately entertaining version of reality.

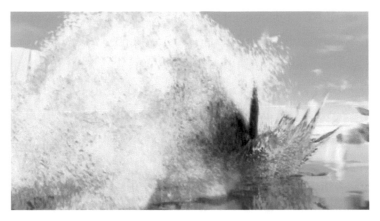

CGI effects animator John Thornton at Blue Sky Studios has taken 3D effects to a whole new level, using innovative CGI rigs to animate water effects.

The majority of 3D programs have preset effects simulations, which we can of course alter and manipulate in a variety of ways. Whether it is an undulating water surface, or an enormous splash that we are animating, if we approach our computer with the knowledge that natural elemental energies contain within them a great deal of randomness and chaos, we can, with patience and technical know-how, imbue our digital effects with that fantastic aliveness that sets great effects animation apart! If we are content to set up a fully simulated effect, one that runs on its own, flowing with preset behaviors such as weight, velocity, viscosity, collision parameters etc., what we will end up with may be a

convincing enough-looking liquid simulation, but in the context of animation, is that all we are looking for? Can we not, armed with our imaginations and the knowledge of the elemental magic at work in the universe, add something to our computer animation that will honor the art form, and bring it to a higher level of artistry?

Approaching the same CGI simulation I described above, if we consider the "intent" of the effect, and the design of the film, particularly if it is a CGI animated feature, we should immediately see that a mere computer simulation lacks character and design, compared to the fanciful characters and environments that populate today's CGI animated features.

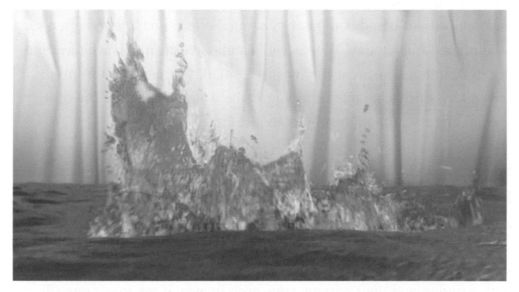

The CGI water special effects in Blue Sky's "Ice Age, The Meltdown" have a fantastic, 'stylized' look. Effects artists there are able to create dynamic shapes with their 3D effects rigs, and to manipulate the effects manually to give them more life.

The same wild, imaginative design principles that drive the rest of the elements that make up an animated film, must be applied to our CGI effects animation as well. And too often, that is simply not the case.

There are, here and there in the industry, effects artists pushing the envelope of digital effects animation in a direction that honors the unique ability of animation to be more entertaining than reality. Not coincidentally, many of these artists have extensive classical animation backgrounds. At studios like Sony and Blue Sky, old-school effects animators are rolling up their sleeves and working with savvy technical directors to create digital special effects that really stand apart from the vast majority of bland computer-generated effects that we too often see in animated films today. Whether it is a massive curling wave threatening to devour a hapless surfer, or just a small, whimsical little splash created by a tiny character jumping in the water just for the fun of it, special effects animation should be just that. *Special!*

So to each and every one of you special effects animators out there, regardless of the tools you choose to use, or need to use in order to create your effects—remember the spirit of animation. Learn how to *feel* what a good effect *feels* like. Remember that is is our responsibility to give the audience more than just enough. We can make children's eyes grow with wonder, and their parents jaws drop in awe, if we inject our effects animation with that awe and that wonder!

It is through innovative and creative application of the classical principles that have always made animation such a magical art form, that we can always improve on the new effects we create and carry on the legacy of animation greatness.

Animating water is like trying to catch the wind. Try this someday. Just sit down by a pond or a lake or the ocean, and pay attention to the way the shapes undulate and morph into each other wildly and unpredictably. Find a few stones and throw them into the water, and observe the shapes of the splashes they create. Although each splash may resemble the next, each is more different than we can possibly imagine. There is an entire universe of uniqueness and natural perfection in every drop, every bubble, every ripple, every wave.

Water reacts to every force
exerted upon it, with the absolutely
perfect defense mechanism of displacement.
If you push it here, it expands over there. If you rob it of
its space, it seeps into the adjacent one. If you heat it up, it flies aways, if you throw a rock at it,
it swallows it up instantly and seals the hole as if nothing ever happened. If you scream at it,
it absorbs your sound waves. If you thrash at it wildly, it just moves out of the way and
regroups elsewhere. Hurricanes can move it into mountains that shape our
shorelines, but after even the most violent storm, it simply returns
to its flat, calm, perfect self. Water is perfect design,
the fluid of life in motion, the very
building blocks of
our essence.

Being drawn to the water,
be it a small waterfall in the woods
or a raging Hawaiian seashore, I find myself
completely mesmerized by its continuous restless movement, and its
indescribable perfection. To attempt to know it, and capture the magic of its movement,
has been a lifelong learning experience for me. And it will continue to be. Every
time I attempt to animate a splash, it draws me into the perfection
of nature's cosmic design. As it catches light like a mirror,
and reflects everything back at me, it swallows my
imagination like an enormous blue whale,
and swimming in its darkness,
I touch infinity.

Chapter 5

Fire, Smoke, and Explosions

When attempting to animate fire or smoke, the importance of understanding the underlying forces of energy cannot be understated. Without this core energy, fire and smoke animation will simply not ring true. Animating fire and smoke is far more about understanding the energy that is in play than moving pretty shapes around in random ways, as we so often see artists do when attempting to animate these sublimely beautiful elements.

Without the forces of gravity, wind, hot and cool air currents, or excess fuel being added to a fire, a fire will actually burn as a perfect featureless sphere! (As was discovered when conducting experiments in zero gravity aboard a space shuttle.) When we look at a fire's flame, we are actually seeing luminous gases being released and rising quickly from their former state into the air as a given material is heated to its point of combustion.

Fire can be drawn in any number of styles. There is no right way to draw fire. What is absolutely essential though is that the drawing contain the right *energy* and *flow*!

The fire on the left is drawn in a highly detailed style, slightly stylized, with a combination of smooth flowing lines and angular corners combined. The fire above is drawn with a very smooth and liquid style. Next to that we have an extremely stylized angular style of drawing fire. Finally on the right is a very smooth, swooping style of drawing fire. All of them are perfectly valid styles, depending on the style of the animated film you are working on. Anything goes, as long as the energy is in the drawing!

First let us analyze a small flame like we might find on a candle or match. Its shape is a simple tapering affair, fatter at the base and tapering off to a dull point. In a sheltered setting, with little or no wind, its movement will be a subtle stretching and squashing.

There should be no extra shapes emanating off of or breaking away from a flame this small and simple. To add detail would suggest a much larger fire. In a relatively calm setting, the small flame throbs and bobs gently as it subtly gains on and then loses against the cooler air surrounding it.

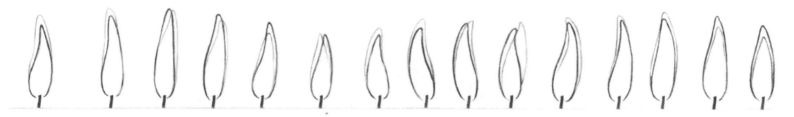

In the series of drawings above, I have animated a candle flame behaving as if it is in a room with very little turbulence in the air. The flame simply grows taller, and then shorter, weaving with an extremely subtle wave action as it stretches and contracts. The simple graph on the right shows the highest and lowest points of the tip of the flame. There should be a slowing-in cushion as it reaches its highest and lowest points, with the drawings being much closer together. The lighter part of the drawing is the subsequent position, to illustrate the movement more clearly.

I am always on the lookout with my camera for good special effects reference material. It is one of the greatest ways to observe and keep engaged with the effects learning experience.

If we add a small amount of wind to the scenario, which also adds oxygen, or fuel to the fire, our candle flame will stretch out in the direction of the wind, and pieces may break off at this point. It becomes slightly more violent and reactionary to the outside forces. Extremely subtle turbulence occurs, introducing opposing curves, billows and flickers.

If the wind gets any stronger, a candle flame is quite easily extinguished. In its last dying breath, the flame may momentarily flare out with a burst of oxygen, become larger for one or two frames, stretching out to maybe three times its normal length, and then snapping off a little flicker before ultimately dying. This will usually be followed by a small puff of linear smoke, which appears two to six frames after the flame is extinguished, and is generally very short-lived, maybe a second or two at the most.

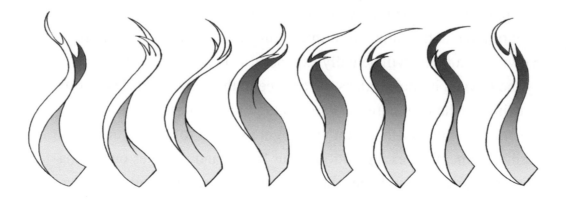

Remember those imitation flames made out of flimsy fabric in Chapter 2 with a fan blowing straight up from underneath them? This is a perfect example of how fire animates. Hot and cool air colliding causes the wind and turbulence that creates the shapes we see in a real fire, which is why this illusion works so well.

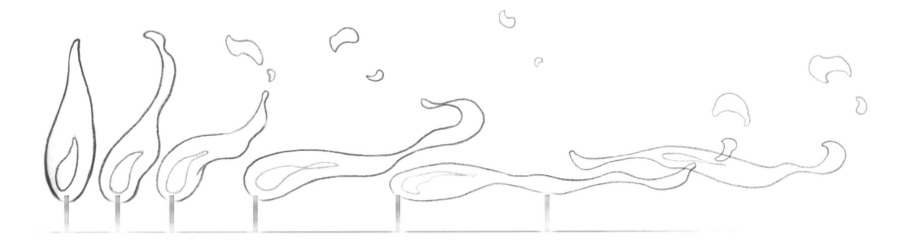

In this sequence of drawings, we see a candle flame being blown out.
It doesn't take a very big breeze, or blow, to extinguish a candle flame,
except of course when it's your birthday and you're trying to blow out
a lot of them at the same time! Interestingly, before actually getting
blown out, a flame will actually expand in volume a little bit, fueled
by the oxygen in the wind, as we can see in the second, third and forth
drawings. When animating a flame being blown out, it is a good idea
to stretch it much further than you might expect it to actually stretch in
reality. Remember, exaggeration is our friend, and it makes our anima-
tion more punchy and believable! It would be feasible to add one more
drawing perhaps of the dissipating pieces of the flame, but it works well
if it simply vanishes quickly!

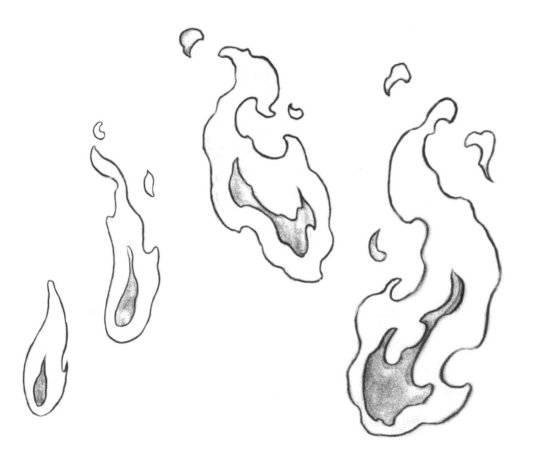

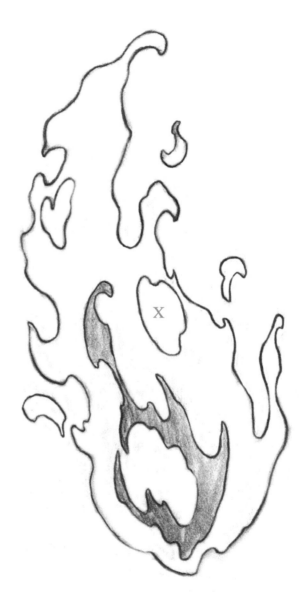

Here are five different sized flames, from the size of something slightly larger than a candle flame, to something around the size of a medium campfire. Notice how each larger fire has slightly more pieces, or details, than the one before it. The campfire on the right is starting to have holes break open inside of it as well. It is very important to understand the scale of the fire you are attempting to animate and to add the appropriate amount of detail.

As we advance to a larger fire, as in a campfire or a burning torch, the bobbing motion will become more pronounced, as will the reversing internal arcs, which undulate from side-to-side. This motion is caused by one side of the fire cooling faster than the other; the hotter side will then rise faster, rolling upward and over, causing a flame shape to break off of the main silhouette. This series of events repeats itself as forces interact with it, especially wind—even an imperceptible current can give fire this undulating action.

Before any interior details can be considered, it is best to construct
the basic flow, or gesture, of the fire. On the second pass, the primary
interior shapes can be conceived as sections of spherical masses mov-
ing upwards, which then diminish in size. We build the silhouette with
sharper edges, connecting these spherical masses. The over arching idea
of a fire is a triangular shape, or a series of triangular shapes feeding
one another. These quickly unite into larger silhouettes, depending on
the severity and frequency of the forces (wind, gravity, pressure) and the
amount of available fuel from the material that has been ignited (paper,
straw, wood, gasoline, etc.).

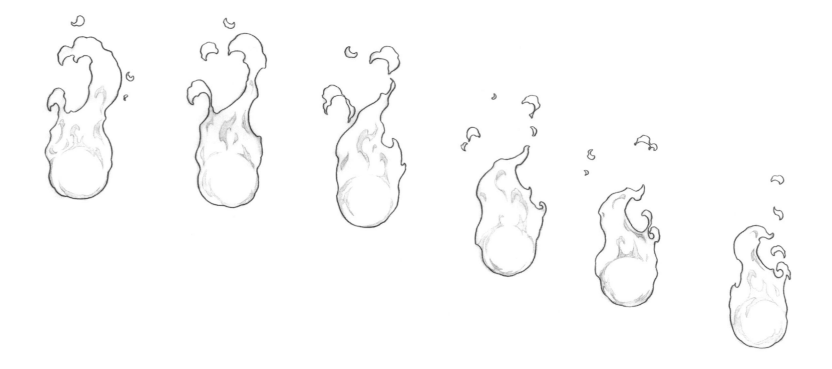

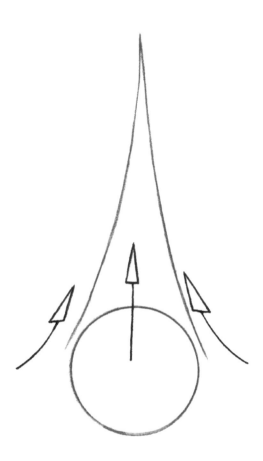

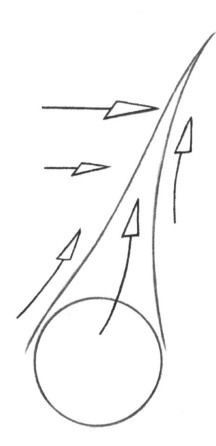

1. Hot air rises from a fuel source, drawing
in cooler air in from the bottom.

2. Add a small breeze, pushing the flame
to the side. It begins to arc.

This simple yet effective formula for animating a medium-size fire was originally designed by
a colleague of mine at Walt Disney, David Tidgwell. I have never found a better explanation!

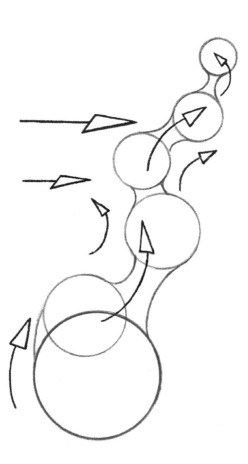

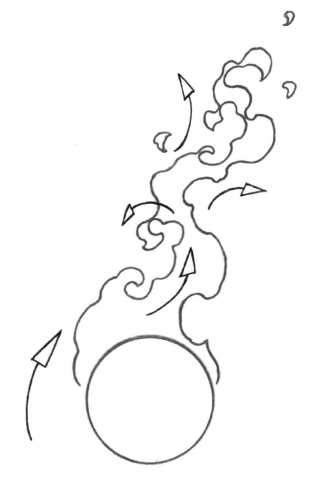

3. Add turbulence. As the cooler air interacts with the rising hot air, it creates alternating eddies of swirling air.

4. Add details. The energy pattern is simply and clearly described within the details.

1

Here is another approach to "building" a fire. I have started with basic triangles—note that they are different sizes. Because of the repetitive nature of fire shapes, it is important to always vary your shape sizes.

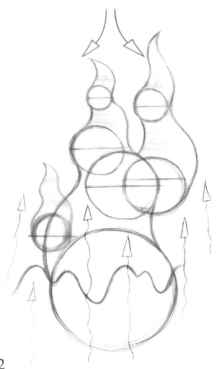

2

Now I have treated each of the individual triangles as if they are flags being blown from below. I have added the curving bottom line shape of the fire, and indicated the directional flow of the air currents causing the flags to flutter and wave. Note that there is cooler air pushing down from above the fire as well, that causes additional turbulence.

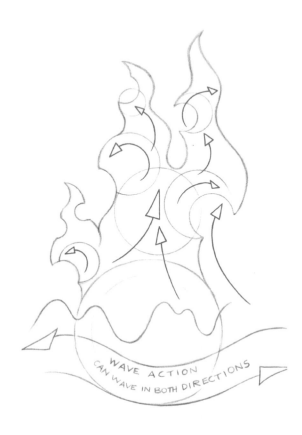

WAVE ACTION CAN WAVE IN BOTH DIRECTIONS

3

Now things start to get a lot more dynamic, as turbulence is added to the picture. This turbulent energy creates small spiraling eddies of air that twist, pull, and squeeze the triangular shapes, causing the familiar arcing shapes that we see so frequently in fire. Note that on the left side of the fire the twisting currents rotate counter-clockwise, while those on the right revolve in a clockwise direction. Opposing arcs become very apparent at this stage, and are an outstanding feature of almost all good, elemental effects design.

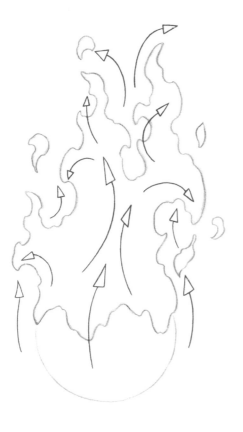

4

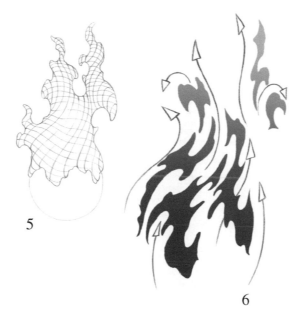

5

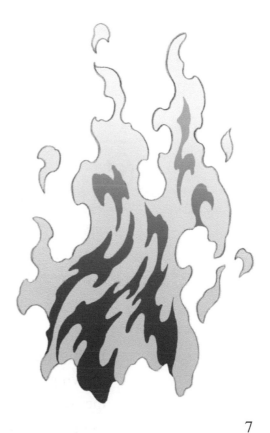

6

7

At this stage in the drawing, the same air currents and turbulence that came into play in Figure 3 are now used to add the more detailed, wavy, wiggly shapes that really start to describe this shape as a fire. Opposing arcs are always a very important aspect of these designs. As always, make sure that the size and positioning of these shapes avoid being overly repetitive.

At this point, we must think of our two-dimensional diagram as a three-dimensional object. I have illustrated, first with an overly technical wireframe drawing, one way of approaching this stage in our drawing. We can then add our interior shapes which do much to describe the volume and directional energy of the fire. With more experience, one would generally begin a fire drawing with a very volumetric sketchy approach, skipping the more technical process shown here in the first four examples. But this is an excellent foundation for beginning to understand the principles at play in a fire.

Finally, we can add our elegant touches to the fire design, tweaking and pushing our design to make it as dynamic as possible. The final outline, combined with the interior shapes, makes for a pleasing (in this case relatively simplified and stylized) rendition of a typical campfire-size fire.

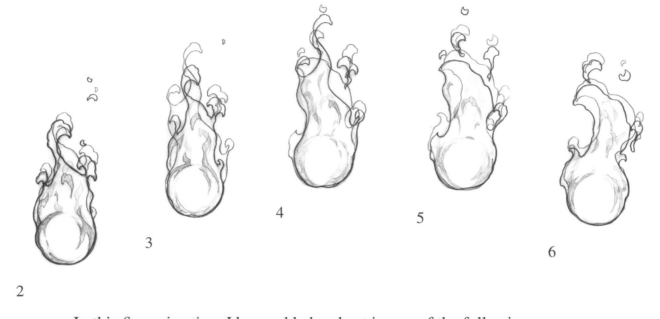

1

2

3

4

5

6

7

In this fire animation, I have added a ghost image of the following drawing, so that you can see clearly how the motion progresses. As the overall shape of the fire undulates with the familiar, whip/wave motion, smaller pieces emerge from the bottom sides of the fire and react to the turbulence being created by the hot and cool air currents colliding as the fire sucks in cooler air from around it, in order to fuel itself with oxygen. This animation also shows clearly how large pieces of the fire are pinched, or squeezed by the cooler air as they rise, causing them to break off as they rise. Note that the small shapes that break off from the main body of the fire do not last more that two or three drawings. Larger pieces may last longer.

Another fire animation trick, clearly illustrated here, is how a curling shape that is breaking off and rising quickly away from the main body of the fire will invert its curved shape from one drawing to the next. This gives these little pieces of flame the appearance of flickering and behaving like a real fire. I animated this fire as if it is a well-fueled "ball of fire" so the shape of the base of the fire is much more stable and static than a camp fire would be. Note too, how the secondary inside shapes enhance the overall shape and volume of the fire, working as a sort of shading tool. This animation is a cycle of thirteen drawings, with the last drawing hooking up seamlessly with the first.

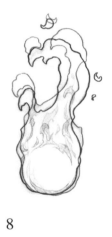

8

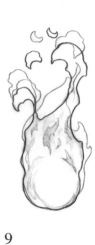

9

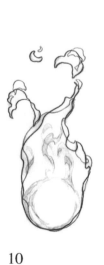

10

11

12

13

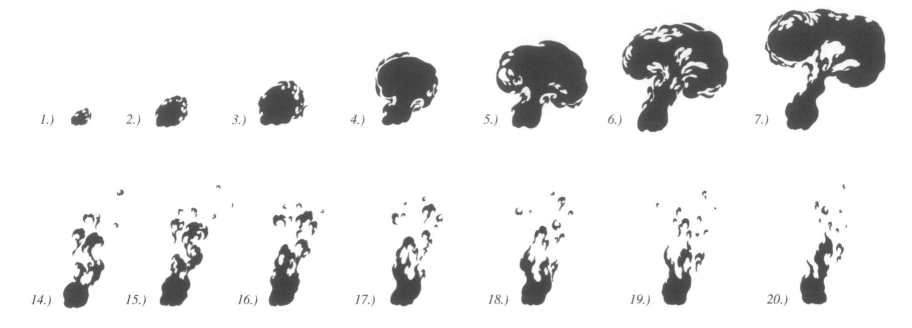

1.) 2.) 3.) 4.) 5.) 6.) 7.)

14.) 15.) 16.) 17.) 18.) 19.) 20.)

Here I have animated what a fire might look like ignit-
ing, as if from a pool of a highly flammable substance like
gasoline. Initially, in #1 through 3, the fire simply blossoms
quickly upward and outward. It is well fueled with a flam-
mable substance and plenty of oxygen. Outside forces have
not yet come into play, but immediately in #4 and onward,
we see the familiar mushroom phenomenon beginning to
take shape. In this clearly illustrated enlarged view of #7.
we see the force of the initial ignition still shooting upward.
(A) As the cooler air surrounding the fire pushes it down
from above, (C) and the hot fire sucks cool, oxygen-filled
air into itself from the air surrounding it, (B) it pulls the
cooler air inward and upward, and the collision of these
forces creates the mushroom shape.

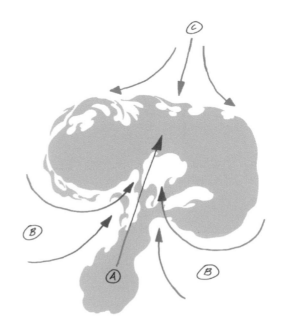

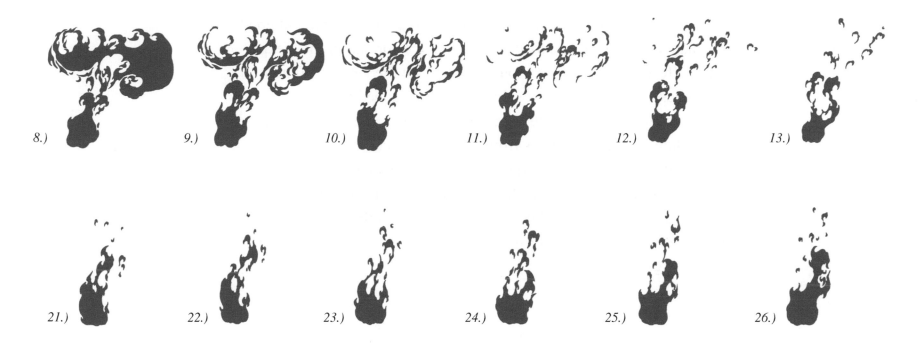

8.) 9.) 10.) 11.) 12.) 13.)

21.) 22.) 23.) 24.) 25.) 26.)

As the fire continues to rise, the intense heat, with no place to go but up, has to push its way through the layers of varying temperatures of cooler air around it. As the hot and cool air interact, spiraling eddies and twisting currents of air are formed, which give the fire its distinct shapes. Every smaller shape of the fire that is created (as outside forces tear it to pieces) takes on a somewhat similar form, as the cooler air above it, and its natural trajectory upward continue to create fascinating and beautifully shaped air currents. Keep in mind always fire is pure energy being expended—and seems to have a life of its own. Its shapes are created by hot and cool air reacting to each other. If the physics of your fire animation don't follow these natural laws of nature, it will look unnatural and strange.

It is important to note that a fire should not increase in size without good fire dynamics being taken into consideration. It's normal for the inexperienced effects artist to unconsciously expand the fire's mass. Without certain tricks under your hat, it's difficult to keep a medium-size fire from expanding as a fire scene progresses. We can achieve consistency in the volume by opening holes from the middle section (as we did previously with water); these will quickly meet together and help to break off large sections of flame. The holes should reflect the direction of the force through their elongated negative spaces. Be careful not to make these negative spaces too water-like! Keep the shapes working with the overall design.

I have indicated X's where there are holes breaking open in this fire. This is a way that we actually mark up our production effects drawings, so that our assistant effects artists can tell the holes from the interior shapes. This is common when animating water and smoke as well.

Fire is filled with similar-looking shapes, so vary them as much as possible into big, medium, and small shapes to avoid twinning and buzz-saw silhouettes. We can also break flames off of the main body of the fire by "pinching" it in the middle, then "twisting" the fire as one might wring out a washcloth. The most interesting way to resolve a broken-off section of flame is to reverse its arc from one drawing to the next. Do not make the bits stay on screen too long, or shrink predictably into a direct center point … in fact, once a flame breaks off a medium-size fire, its life span is very short, maybe three or four drawings.

Here is another approach to how to start drawing and animating a fire. As with all special effects, start out with the most basic shapes as in this example on the left. If you turn this drawing on its end, it looks like five flags. Approached with this technique, you can now animate the fire, just as if it was a group of flags, using the basic flag-waving motion, and not having to worry about all the difficult little details of the final fire drawings.

The drawing to the right, shows the underlying geometric structure of our "flags." While I would never go to the trouble to illustrate this when actually animating a fire, it is important to understand the fundamental structure of what you are working with! With time and practice, an effects artist intuitively feels this underlying structure within every drawing he or she creates.

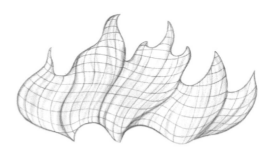

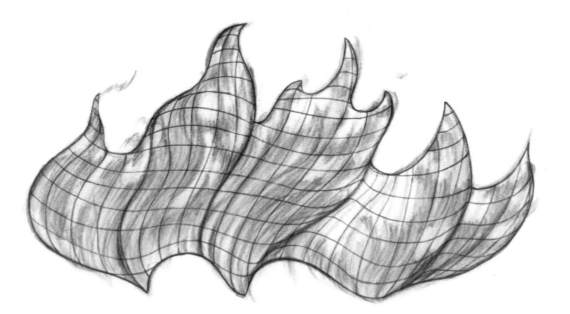

The really "fun" part of the effects drawing experience is the sketching in of the intricate details of your effect. It is important in the case of fire, as it is with water, smoke, etc., to make sure that every detail follows closely the overall flow of the underlying structure. The smaller shapes you see breaking off of a fire will just look like bizarre disconnected shapes if they do not adhere to the natural "flow" of the drawing. When these shapes are drawn with the directional flow of the energy driving the effect, the results are fantastic. This is a very key point to understanding and drawing all effects animation—as I emphasized so emphatically in Chapter 2! Understand the energy behind the effect, and stick to it with every stroke of the pencil.

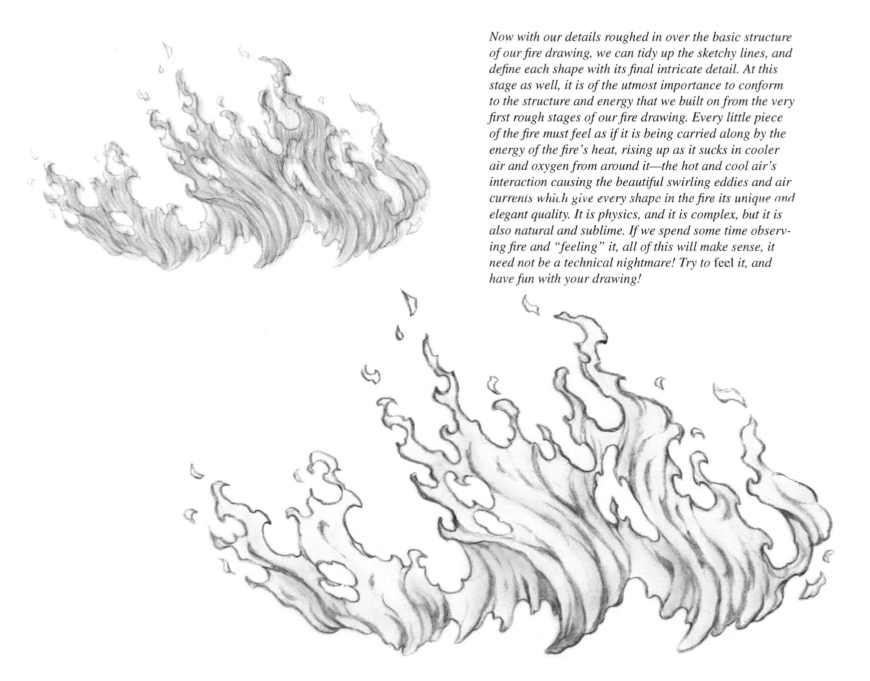

Now with our details roughed in over the basic structure of our fire drawing, we can tidy up the sketchy lines, and define each shape with its final intricate detail. At this stage as well, it is of the utmost importance to conform to the structure and energy that we built on from the very first rough stages of our fire drawing. Every little piece of the fire must feel as if it is being carried along by the energy of the fire's heat, rising up as it sucks in cooler air and oxygen from around it—the hot and cool air's interaction causing the beautiful swirling eddies and air currents which give every shape in the fire its unique and elegant quality. It is physics, and it is complex, but it is also natural and sublime. If we spend some time observing fire and "feeling" it, all of this will make sense, it need not be a technical nightmare! Try to feel it, and have fun with your drawing!

Now that we've worked out the basic mechanics of the main silhouette, let's investigate what happens with the interior details. While there will be overlapping shapes within the fire, never forget that these details cannot act independent of the timing or direction of the main body. These details delineate the core—the hottest part of the fire—from the rest of the flame. The core design can be complex, but it must integrate with the whole mass. Now the spherical shapes will come into play, our interior designs describing their geometry. They will roll clockwise and counter-clockwise—again, make sure these spirals and eddies integrate logically with the main animation.

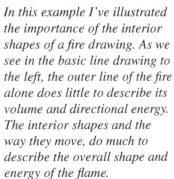

In this example I've illustrated the importance of the interior shapes of a fire drawing. As we see in the basic line drawing to the left, the outer line of the fire alone does little to describe its volume and directional energy. The interior shapes and the way they move, do much to describe the overall shape and energy of the flame.

The quickest way to build in these designs is to suggest a basic tonal mass with the side of your pencil—you articulate the drawings more fully on your third pass. Earlier we mentioned dragging the candle flame, but not too fast lest the flame go out. Now imagine we are dragging a torch to and fro. There is sufficient mass and fuel to keep the flame going, so these shapes will stretch and follow the path of motion of the physical torch. The shapes won't have a long life span, but they will stay on screen long enough to register in the viewer's eyes as they resolve upward and simultaneously along the arc of the torch.

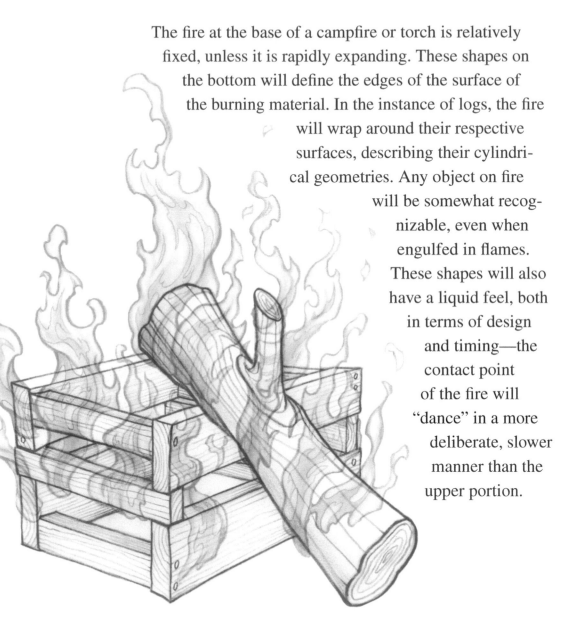

The fire at the base of a campfire or torch is relatively fixed, unless it is rapidly expanding. These shapes on the bottom will define the edges of the surface of the burning material. In the instance of logs, the fire will wrap around their respective surfaces, describing their cylindrical geometries. Any object on fire will be somewhat recognizable, even when engulfed in flames. These shapes will also have a liquid feel, both in terms of design and timing—the contact point of the fire will "dance" in a more deliberate, slower manner than the upper portion.

Before we move onto large-scale fire, we'll touch ever so briefly on a
couple of other important additional fire elements. Once we get to any
fire mass beyond a candle flame, we will begin to see cinders rising with
the fire. These particles will have some randomness, but their direction
will be dictated by the structural arcs and forces that move within the
main fire. We should also be aware of the spacing of these
elements, and course, vary their sizes.

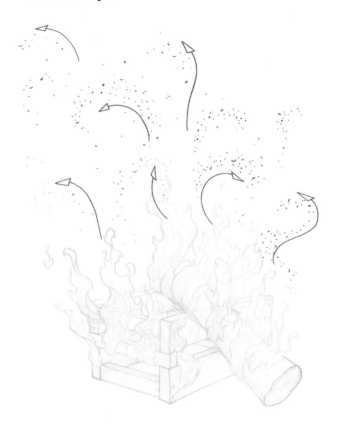

When fire is eventually colored, there are ways to reinforce the idea of "heat." The fire can be given a glow, a soft outer lighting achieved by copying the artwork, blurring it heavily, then giving it a transparent appearance. "Warp" and "turbulence" can be added after the elements are composited in a computer giving it the finishing touches.

If you're having a hard time visualizing what "warp" or "turbulence" may look like, imagine the way the air is distorted when heat rises off of a desert highway, or the turbulent air patterns generated by a 747 engine as it revs up. Intense heat can be suggested off screen by adding a warp and turbulence to a character, as well as a strong rim light. We'll leave it at that, as this book is less about camera effects and production tricks and more about the mechanics of drawing and animation.

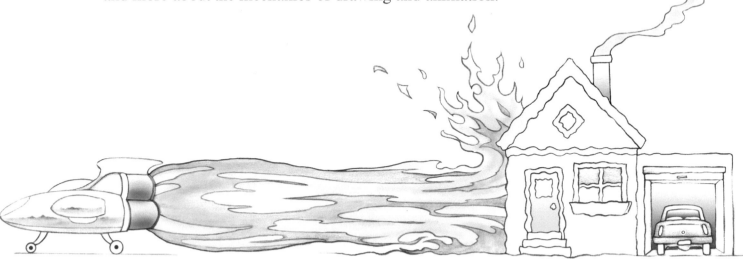

Here is an example of a jet engine causing some heat turbulence. Of course the house would also be reduced to ashes in pretty short order!

Almost everything we mentioned about medium-size fires—can be applied to large-scale fires. As with water, the larger the fire, the more ponderous its timing becomes. Adding extreme amounts of details will also suggest a larger conflagration. By the time a fire reaches to the mass of a large bonfire, there are more smoke-like shapes that need to be integrated into the overall design. Also there are more powerful forces of wind within the fire, which will cause a more violent agitation of the cinders, as well as the flame shapes themselves.

The number of these shapes will increase exponentially with the spreading of the fire, particularly in a forest fire where there are copious amounts of flammable material. With fire this uncontrollable, there will be multiple instances of overlapping actions as shapes violently twist, curl, and roll into themselves; however, the driving direction of the mass will stay constant.

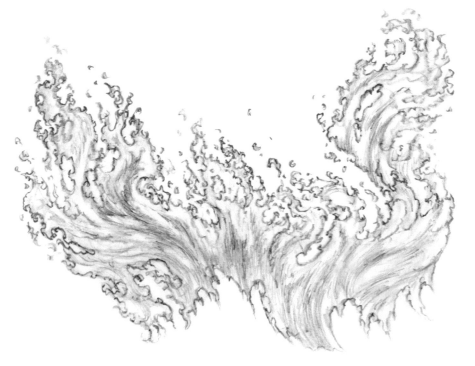

This rough drawing of an enormous fire shows how freely and energetically one must draw in order to describe this firey mayhem. You can see clearly the directional energy of my pencil strokes that helped construct the shapes in a way that clearly conveys the violent turbulence of the fire.

This smaller drawing to the right, has exactly the same underlying structure as the huge fire above, but by simply leaving some of the details out, it ends up looking like an average-size campfire. This illustrates perfectly the fractal nature of all pure elemental energy. Whether at the macro- or microcosmic level, the same patterns are apparent.

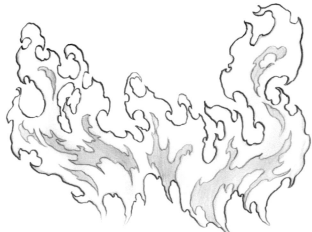

In this drawing I have illustrated some of the directional energy of this fire with a series of elegant plant-like strokes, rather than textbook type arrows, to better emphasize the natural aspect of this energy. Again pointing out the relativity of all nature's design, whether it is a fern unfolding deep in the forest, a raging forest fire, or an elegant lily in a garden.

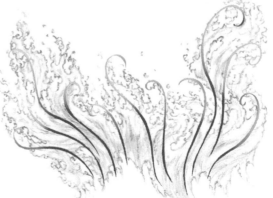

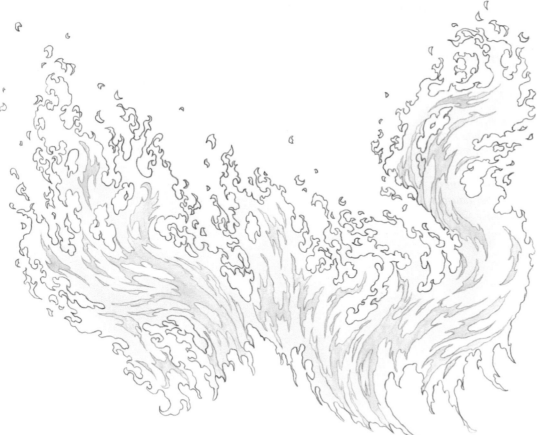

In this clean version of the rough sketch on the preceding pages, I paid more attention to the inside shapes, which help describe the volume of the fire, the actual three-dimensional shape of it, while at the same time accentuating the directional energy. As in the earlier examples in this chapter of a medium-size fire, to animate something of this level of detail we must start out with the simplest of shapes, and apply the simple rolling wave and whipping flag animation principles before adding the more intricate and tiny details, each of which must animate with that same whipping, curling motion.

We can't finish this discussion until we address the fire's by-product—smoke. When we mentioned the linear variety, we were talking specifically about small-scale smoke. This design is seen briefly after candles are snuffed out, yet lingers longer in the case of cigarette or incense smoke. The life span of such smoke is determined by its density, which in turn is determined by the type of fuel being ignited. Linear smoke is fun to animate, it shares the same principles as torch flame when it's being "dragged." The main difference is that flame dissipates much quicker, whereas smoke will follow the arcs of the source and stay on screen much longer.

Ah, the abhorrent cigarette smoke, so often associated with evil, especially these days! It is fun drawing and animating linear smoke like this, and there is an interesting combination of the smoke reacting to the subtle air currents as it rises, as well as the movement of the cigarette. Cruella De Vil is an excellent example, with her nauseating and intrinsically evil green cigarette smoke writhing and curling menacingly.

In Disney's "101 Dalmatians," Cruella DeVil's infamous green
cigarette smoke is very dense, which is why her frenetic paths of
action are reinforced by it. This is a clear case, too, of an effect
integrating into the psychology of a character. Hades, in Disney's
"Hercules," is a composite character, whose hair is made of fire and
whose robe is made of smoke—and therefore, both character and
effects animators must work in concert to achieve a fully integrated
result. All of his effects elements reinforce his paths of action,
as well as his emotional state. The incense smoke in Disney's
"Mulan" is a more subtle example of linear smoke, which takes
on very particular design motifs inherent in the background and
character designs, yet it never becomes too agitated. Again, her
psychology is more graceful and mannered, and as such, so are the
smoke shapes she generates by moving the wick.

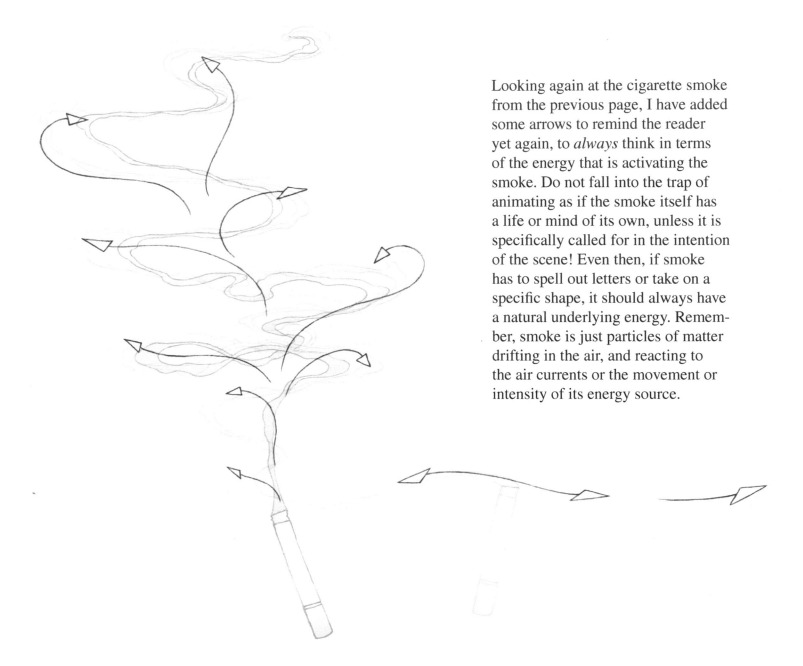

Looking again at the cigarette smoke from the previous page, I have added some arrows to remind the reader yet again, to *always* think in terms of the energy that is activating the smoke. Do not fall into the trap of animating as if the smoke itself has a life or mind of its own, unless it is specifically called for in the intention of the scene! Even then, if smoke has to spell out letters or take on a specific shape, it should always have a natural underlying energy. Remember, smoke is just particles of matter drifting in the air, and reacting to the air currents or the movement or intensity of its energy source.

And here, just in case I haven't emphasized it enough, I have illustrated yet again, the forces of energy at work which must inform our smoke animation. I was deeply inspired by the "schlieren" photography of J. Kim Vandiver, whose wonderful photos show us clearly how the hot and cool air currents intermingle and create swirling eddies of energy above a small candle flame.

COOLER AIR PUSHING DOWN

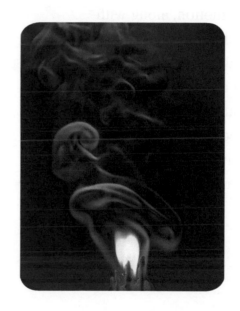

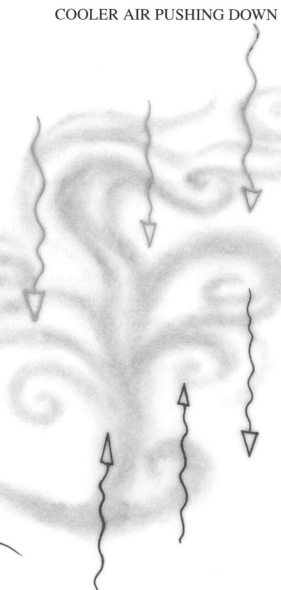

MOVEMENT OF ENERGY SOURCE

HOT AIR RISING

The drawing sequence below illustrates one of my simplest formula for animating smoke. I have numbered each drawing with the actual frame numbers, and this sequence would represent 74 frames, or just over two seconds of animation. This simple formula can be applied to fire animation as well, as I will illustrate on the following page.

I have combined the classic upward flag-like wave motion, along with an emerging ball shape, that kind of "rolls" upward through the volume of the smoke in time with the wave action. This ball continually expands as it rises as smoke will in relatively calm air with a hot source pushing it upward, and cooler air above slowing it down and pushing it outward. Variations of this simple approach can be combined with a far more complex smoke design as well, but this is a great little exercise to get a good feeling for how a simple column of smoke can be simply but well animated.

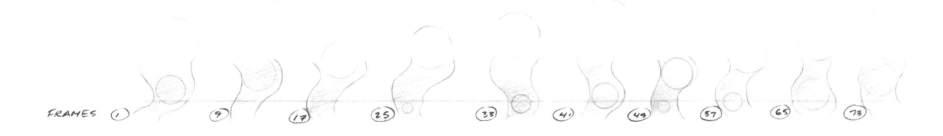

FRAMES 1 9 17 25 33 41 49 57 65 73

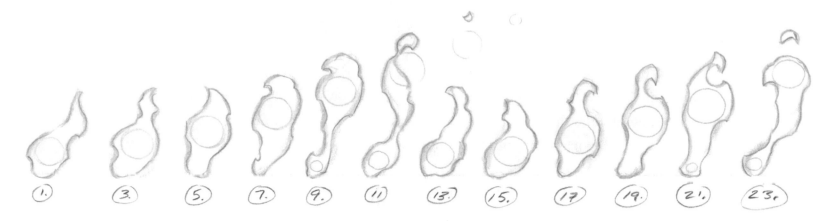

This sequence is very similar to the smoke sequence on the preceding page. This time I have combined the upward flag-waving motion with the rolling ball, and worked it all into a fire design. This sequence would represent approximately 24 frames, or only one second of animation, so it is moving much faster than the smoke on the last example—as fire does.

Note that, as the large piece breaks off the main body of the fire, the shapes almost wrap themselves around the ball shape as they break off and then dissipate. In the more detailed smoke animation examples that follow, we will look at how the hot and cold air currents that collide around smoke and fire's perimeter shapes create additional vortexes and swirling eddies of energy that influence the velocity, shape, and the paths of action of the smoke. Starting out with simple, stylized, medium-size smoke and fire like this is a great way to understand the fundamental principles of animating energetic and convincing-looking smoke effects.

What we are seeing when we look at a plume of smoke above a flame is actually the shapes of moving air currents which are filled with smoke particles—the waste by-product of a material reaching its combustion point. So the temperature changes, air currents, availability of fuel in the air, and the nature and amount of the material being burned all conspire to create the particular fire and smoke that we're observing.

In the case of explosions, the central driving force is from a given fuel being very rapidly ignited, whether it is a nuclear bomb or a firecracker. This force is initially very straightforward, traveling directly outward from the fuel source, but as an explosion expands it becomes prone to secondary forces like wind, obstacles, or secondary explosions.

- ROLLING -
MUSHROOMING
PATH OF ACTION

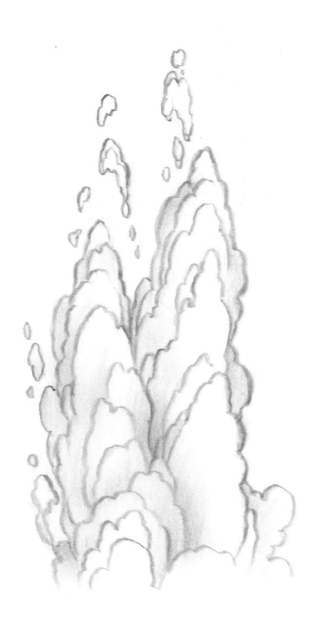

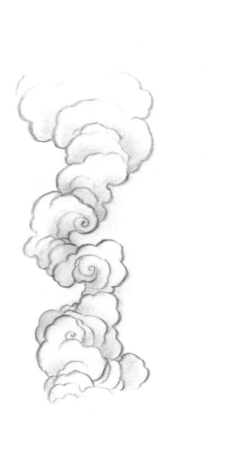

Smoke comes in a staggering variety of shapes. On the left is an explosive blast of smoke, as if shooting from a volcano. In the center is a billowing, stylized smoke, like we might see from a campfire. On the right is a whispy, more delicate style of smoke, like we might see coming from a cigarette or stick of incense.

The best way to really understand how these forces move in time and space is, as with all natural phenomenon, through observation. Staring fascinated into a pile of burning leaves, watching a building burn, or observing a simple candle flame, we can observe how the subtlest change in wind direction or intensity greatly affects smoke and fire's behavior. The more we observe, the more we can absorb the very essence of how fire and smoke work. Of course there is also a wealth of wonderful reference material available in movies, particularly in the case of enormous violent effects like massive explosions, which can be found in any number of the big action "effects" films.

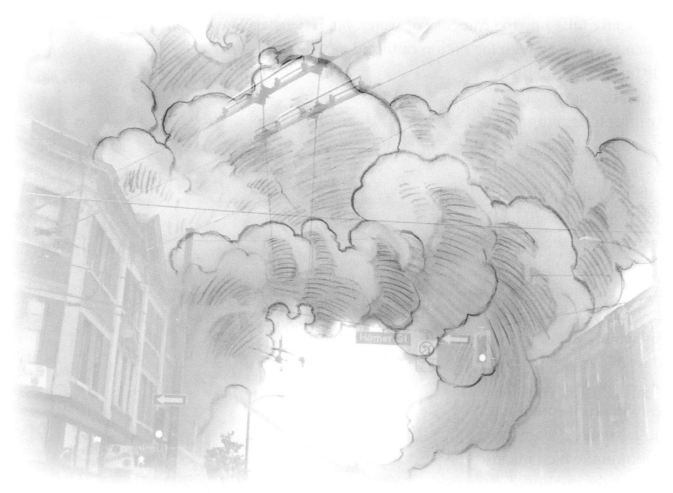

Anyone keeping his or her eyes open for great reference material will be
rewarded with a wealth of fantastic stuff. With persistence, hard work,
and lots of drawing, we can translate this reference material and our
understanding of it, into beautiful special effects animation.

Steam technically falls into the category of water, but it behaves like smoke in many ways. As with the notion of turbulence and warp to indicate distortion, steam initially behaves the same way, eventually morphing into more discernible cloud-like shapes. If steam is being generated by a teakettle, there will be very little tonal variety within the silhouettes. However, once we get to the steam created by a nuclear power plant, it is virtually indiscernible from large-scale smoke (except the color is white). The steam generated from our mouths is a small-scale event, therefore the silhouettes will seem somewhat "flat." Unlike smoke, steam is water evaporating, which means that it can have the quality of "disappearing" as it resolves.

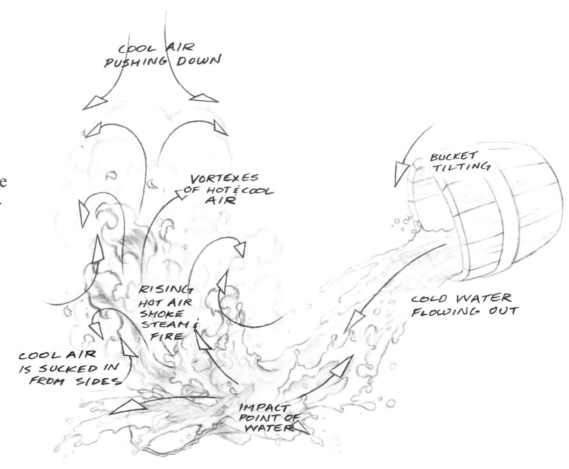

This illustration that I created in Chapter 3, could be smoke, could be steam, or both. In an actual scenario like this, there would probably be a great deal of smoke and steam at the same time. The steam would dissipate and disappear much faster than the smoke. The smoke would continue to rise and spread out into the air above. Often when driving in a rural area, you can see smoke from relatively small campfires or brush burn-offs, from miles away!

Smoke can dissipate also, but it is prone to breaking down into smaller shapes. We must be vigilant in small-scale smoke to keep these shapes from looking like popcorn, where the shapes are uniform in size, design, and spacing. Bilateral symmetry is the kiss of death in organic effects. If you can draw a line bisecting a path of steam or smoke into two similar halves, you are approaching the Rorschach inkblot test phenomenon. Try varying the primary path of action so that it makes the direction less straight-up-and-down. Like fire, pinching shapes can add more interest in the design of the silhouette.

In medium-size smoke, we should always be aware of the rolling direction, which is determined by the energy of the forces at play. As with fire, smoke rolls in clockwise and counter-clockwise directions, but it does so very specifically. For instance, if a model rocket is set off in your backyard, the energy is pushing the smoke down and out on both sides; this means the right side will roll counter-clockwise, the left side will roll clockwise, as all the shapes roll from "underneath," generating from the bottom in the center. Yet while the interior shapes are moving up and curling over, the main "idea" of the burst is outward (like the ripples in a splash).

The smoke trailing the rocket will follow the energy of the rocket's path upwards, quickly slowing in, then drifting as a dissipating trail, finally disappearing altogether. The smoke on the ground will also slow in very quickly, but it will retain its mass longer than the stream of smoke. The contrast between the two overlapping smoke reactions creates visual interest. If the smoke is coming from a campfire, it will be rolling outward from the center—the left side will now roll counter-clockwise and the right side will roll clock-wise. That's because the force is now pushing the shapes up and outward, instead of down and outward. In both instances, there will be overlapping smoke shapes that morph into one another.

1. ANIMATE RUFF EFX WITH SIMPLE VOLUMOUS SHAPES

-ESTABLISH TIMING AND PATH OF ACTION

2. ADD SHADING AND DETAIL TO RUFF KEYS.

3. CLEAN-UP

When animating smoke (or just about anything for that matter) it is best to start out with the most basic shapes and get the action and timing working first, before adding detailed shapes and lighting. In the upper left-hand corner, you can see the subtle wave action lines in the drawing.

To animate smoke that is rising up from a fire, one needs to be very aware of the physics involved in order to give the animation a nice, believable energy. In this diagram, we see that initially the smoke rises up very fast, driven upward by the intense heat of its source fire. As the heat begins to subside, the smoke slows down, reacting to the cooler air it is running into. The warm and cool air colliding will cause the smoke to meander and twist slightly at this point. As it rises further, it spreads out, moving slower and slower. The cool air above forces the smoke back on itself, creating a slow rolling effect as the smoke being pushed down gets sucked back into the rising warm air once again. It is a beautiful movement to see when we are watching real smoke, and if animated well, it is also a thing of beauty!

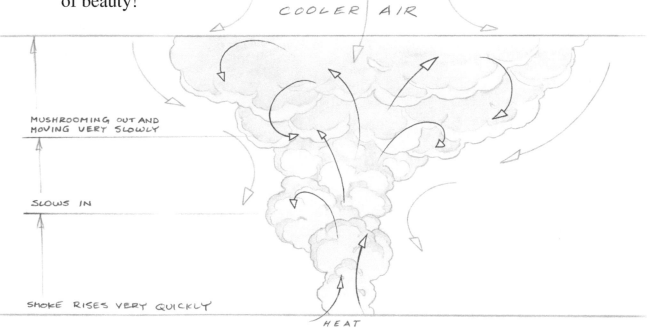

In Chapter 2, we spoke of "implied geometries," how a tone describes the internal structure of a lit object. Smoke is generally one-third shadow and two-thirds light. This tone will accurately delineate the interlocking spherical shapes and suggest how they fit together, even where there is no drawn line to connect them. Be careful not to make your smoke look like a bag of marbles—vary the shapes! Often, the bigger shapes will be the ones containing the most energy, and therefore, they will consume some of the smaller shapes as they roll upward and around.

The initial sketchy smoke drawing below shows the loose drawing style that is best to "sculpt" and construct smoke designs, well describing the internal masses.

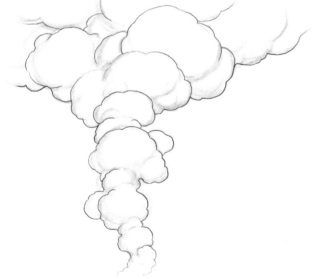

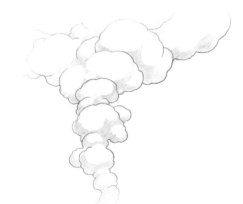

In the drawing below, I have added shadows to the smoke as if it was lit from above. The shadow areas, or "tones" as we call them, do much to describe the underlying geometry of the smoke. 'Implied geometry' through lighting the form.

In this drawing, we see how I have applied a clean line over the initial rough drawing, keeping it simple, yet describing the most important shapes clearly defined.

Be careful also, not to literally think of smoke as rising circles; there is an element of "fluid randomness" which must play out in the animation. Drawing with the sides of our pencils, we can define these internal masses quickly, without getting mired in details. The line quality of smoke is a series of "shaky" lines falling about a rounded edge, whereas fire has fluid lines accentuated by sharp points. Smoke is "married" to the forces generating it, whether its from a long-burning source or an explosive event. This means it will be affected by the same forces of hot and cool air, wind and gravity.

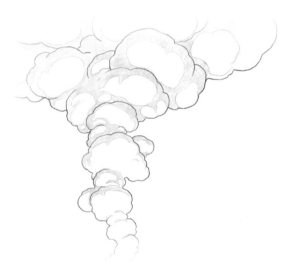

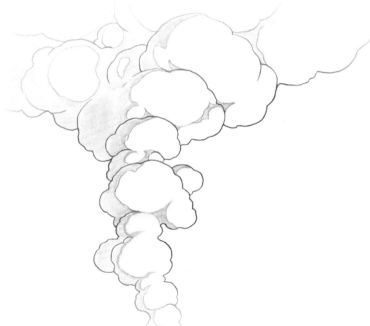

Here the smoke is lit from below, and the "tones" still do much to describe the inner implied geometry of the smoke. The final example on the right, is lit from the right, again, clearly describing the underlying shapes elegantly.

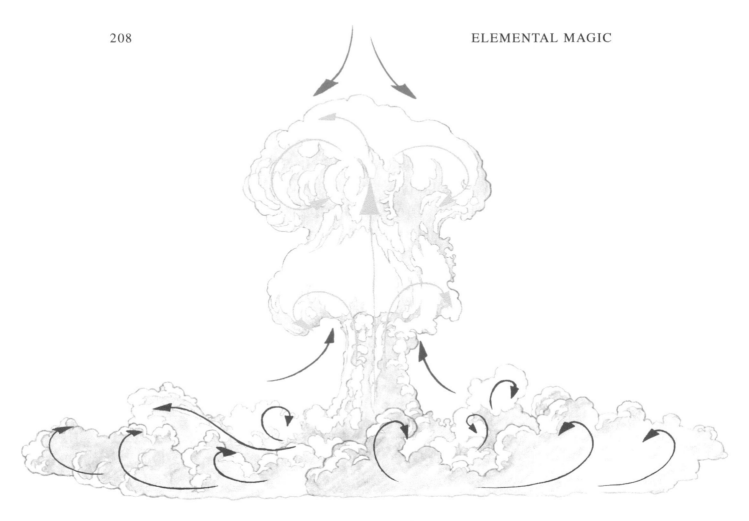

By the time we attempt a large-scale plume of smoke, we've already learned that slower timing plus extra detail equals a greater scale (and lots more drawings!). We can achieve this by adding more internal, churning and rolling shapes (with a finer articulation of tone as it describes them), as well as a more particular refining of the smaller "shaky" shapes as they wind around the rounded edges.

Let's take our model rocket example and find a similar large-scale version. A nuclear blast comes to mind. Think about it—there is a strong directional force moving upward, which causes a reversed series of explosive plumes on the ground. The only difference is that a nuclear explosion then hits a ceiling of cooler air as it rises, which makes it roll out into that iconic mushroom shape. The internal rolling of such a massive blast is exceedingly violent, yet the movement is still extremely slow. A volcanic eruption is very similar, with enormous amounts of internal overlapping shapes rolling into themselves as the overall mass gains volume.

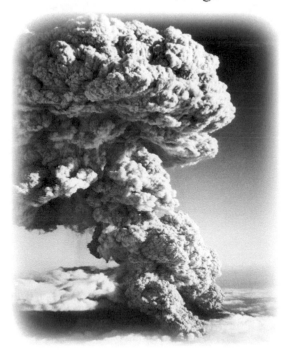

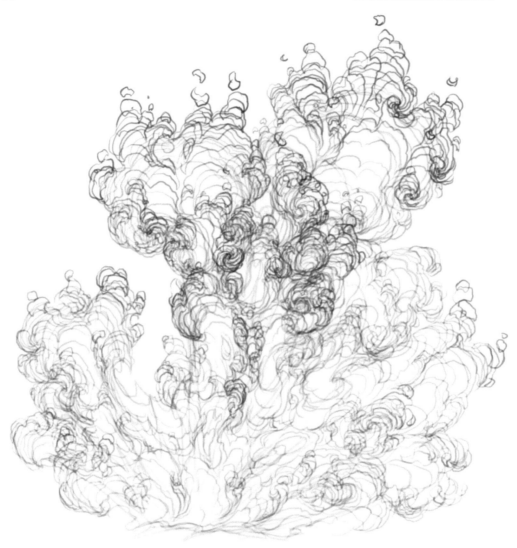

This is a series of drawings from an animation sequence of a fire-based explosion,
superimposed over each other. This reveals the shapes of the underlying energy of
the explosion, an almost flower-like, blossoming shape.
Elegant forms of pure energy.

And so we arrive at explosions, which, while being a necessary topic of discussion in this chapter, can fall into several different categories, as not all explosions have an igniting fire at their core. Explosions can be caused by any sort of pressure building up within a space that can no longer contain that pressure, such as steam pressure building up in a pressure cooker, or a river swollen with rainfall pressuring a dam. Explosions can be full of liquid, gases, or any variety of natural or man-made elements.

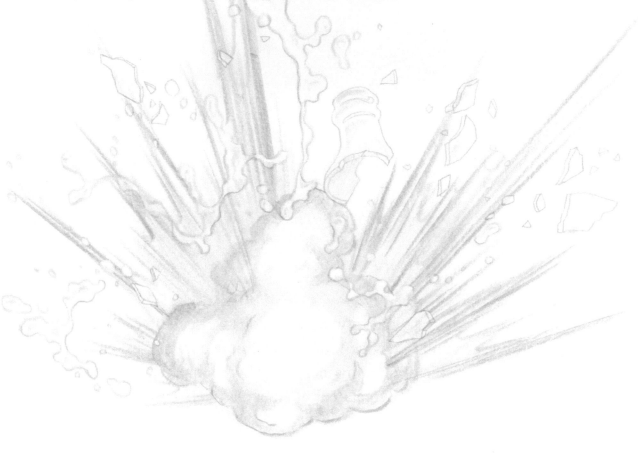

Or an explosion can be caused by an extremely abrupt and violent impact of two or more objects, like a comet colliding with the earth's surface, a car crashing into a telephone pole, or even something as simple as a glass bottle or a teacup, falling and exploding on impact with a tile floor. And of course there are all kinds of fantastic explosions caused by the imaginative devices of our science fiction and fantasy worlds that drive the animated special effects we see in films today.

Explosions come in an infinite variety of sizes, shapes and materials!

However the vast majority of explosions we see, are caused by heat and/or incendiary devices, and at their core contain vast amounts of energy capable of creating incredibly high temperatures, and subsequently, fires and a great deal of smoke as well.

Regardless of the cause behind them, the anatomy of all explosions is very similar. The initial action is an extremely abrupt outward burst of energy from the source of the explosion, which then collides with the resistance of its surroundings—be it air, water, or objects with which it collides. This slows the initial outward force of the explosion substantially, and then as the explosion continues to expand outwards it eventually slows down completely. Its shapes are completely affected only by the surrounding atmosphere, air or water currents, and to some degree the material that initially caused the explosion.

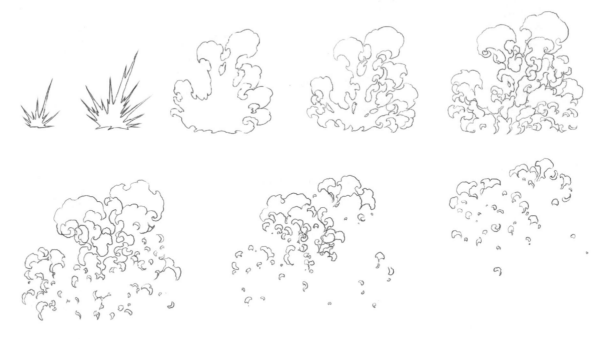

1 2 3

7 8 9

This absolutely fabulous explosion from Michel's Gagne's classic "Prelude to Eden" is a perfect example of Michel's unique design and approach to special effects animation. Starting with the spinning nucleus, this explosive birth of a small planet begins with a bright white central design, almost abstract, growing quickly as it shoots out random beams of light. There are only 6 frames of this initial animation, a quarter of a second, bringing us to frame 8 in this image sequence. Frame 8 is an anticipation frame, with no central light at all. Frames 9 to 16 of this sequence represent a full 150 frames of animation—over 6 seconds! This is a fantastic formula for dynamic explosions of all kinds. The initial explosion is extremely sudden, only 3 to 6 frames, and then the explosive shape forms in 3 to 6 frames. From that point on it settles and expands extremely slowly. This particular scene is a pretty subtle explosion, not really a large-scale cataclysmic event, but the timing dynamics could apply to any size of explosion.

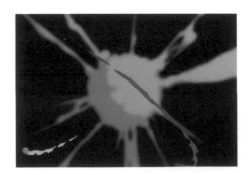

13

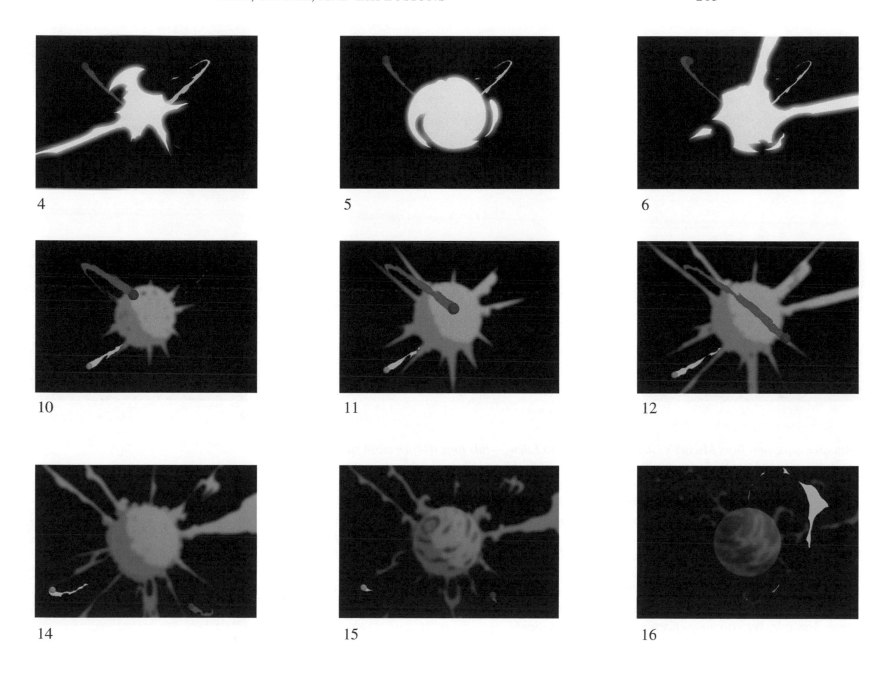

4

5

6

10

11

12

14

15

16

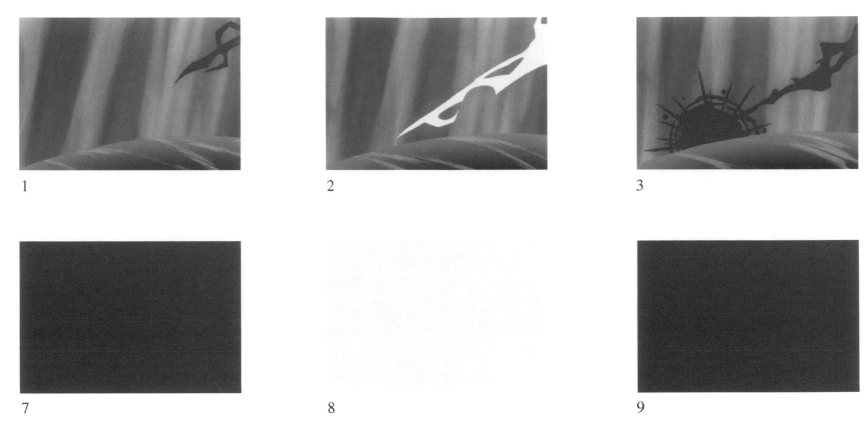

1 2 3

7 8 9

Another explosion from Michel's Gagne's "Prelude to Eden"—this time a much more violent and dynamic style of explosion—with fantastic use of "flash" frames to shock and jar the viewer's eye. In frames 1 and 2 we see a bolt of energy enter from frame right. Frame 3 is the initial explosion, which expands extremely quickly through to frame 6. Michel has used alternating frames of off-white and bright red to create a strobing intensity in the scene. Then there are five frames of alternating red and white frames, which create a powerful sense of the explosion having filled the frame entirely, blasting our eyes with impact! From frames 12 through 16 we begin to see the edges of the explosion flickering and lessening in intensity. This carries on for about 8 frames past the final frame of this sequence. These frames are the real-time actual frames of this scene representing two-thirds of a second of animation screen time. A simple, yet extremely effective, animated explosion!

13

Turning Up the Digital Heat

Having looked at fire, smoke and explosions in a great deal of detail from hand-drawn point of view, what have we learned that can breathe new life into the fire, smoke and explosions that we animate digitally?

As I have explained in previous chapters, the most important things we need to consider when animating elemental effects using any technique, is what I call the *classical* animation principles of strong design and exaggerated dynamics. And I feel that nowhere are these principles more important than with fire and smoke.

When we approach fire digitally, our starting point is very often a preset or "canned" fire effect that has been created already by the software manufacturer, using particles or points in our virtual 3D space that are emitted or shot out of a particle generator. The generator, is usually a simple geometric volume that serves as the birth place for our particles. This particle-emitting software will have various forces of energy that we can bring into play to make the particles move. Sometimes they are called "fields," which is a physics term, but I like to think of them as forces of energy. There are things like wind, gravity, vortex, turbulence, and then there is usually a baffling array of newly invented terms— many that are unique to whatever software package you happen to be

using. There are no real standards of terminology from one software package to another, so we very often need to learn a whole new set of descriptions to understand the forces that we are working with. I would love to have an opportunity to plea with the brilliant folks who create these software interfaces, would it be too much to ask of you just to use simple English terminology, like, just speak to us in the same language that we all speak to each other in? That would make some of these software packages learning curves a lot less steep!

But let's move on. The computer-generated fire that we usually end up seeing is usually moving quite simply straight upward, with some added back and forth movement, or turbulence, to give the fire that twisting and curling look created by hot and cool air that I described earlier in this chapter. A lot of computer-generated fire looks pretty darned good, and there is no mistaking what we are supposed to be looking at. This is helped of course by its color. When we see yellow and orange flame-shaped objects shooting upward, it tells our brain "fire" pretty easily.

Some of the computer-generated fire I have seen is downright amazing to look at. With things called "expressions," a kind of code that can introduce a variety of variable mathematical equations to our animations—computer programmers are able to add wildly variable dynamics to any given effects simulation, adding chaotic and unpredictable turbulent forces that whip and curl the fire effects in a pleasantly random and realistic way. In

may cases, the fire animation that we get right out of the box, using software packages like Maya, Particle Illusion, XSI, or RealFlow, looks good enough to simply add to a scene and leave it at that.

However, if we bring to the table our knowledge of how classical animation actually improves on nature—by exaggerating and pushing the dynamics both in the design and the timing of our work, we can take our fire animation to a much higher level and make it stand apart from the standard, out-of-the-box computer-generated fire that we generally see in CGI cartoons today.

Once again, dare I emphasize that if our environments and our characters are designed imaginatively, why not our special effects elements? Of all the elements, I find that fire truly lends itself to being treated like a character. It is an observation that all of us may have had as children while watching a campfire that fire does indeed seem to have a life of its own. It crawls, creeps and devours, leaping and shooting, curling and flipping around, seeming to taste things and caress them as it advances and grows. Fire drives our imagination powerfully, as an elemental force, wild, dangerous, unfathomable in its mysterious nature. It consumes things and spits them out as an empty, spent, and lifeless shell. So if we are animating fire, we have an opportunity to tap into that mesmerizing living energy. We can breathe even more life into it, by going back to the classical animation principles we have learned, and injecting that energy into the mathematical equations of our digital fire.

From a technical standpoint, that can be easier said than done, most particle-generating computer programs are wickedly complex affairs, and learning how to tweak the inner workings of a particle simulation can be daunting. But there are easier tools to use as well. Simply by adding more dynamic key frames and a more dynamic scale to our fire animation, begin to add to its dynamic appeal. Exaggeration is a key principle to remember and turn to every time we animate. Always exaggerate your animation, unless the scene specifically calls for a very subtle and understated effect. It helps to understand that exaggerated images or poses in animation may be only a frame long and are "felt" more than "seen." They serve to help the viewer feel the energy in the effect. The exaggerated image is visible for too short a time for the viewer's mind to isolate and concentrate on it, but as part of the stream of images that make up the full event, they add a great deal of dynamic energy to the overall animated effect.

When a fire ignites, push the size of its shapes as it mushrooms outward, scale it way up and then back down again. In the case of a character holding a burning torch, vary the volume and size of the flame as it is moved around. A torch being moved sometimes will create a burst of energy to the fire as it gets more oxygen, and then it will simmer down as the action slows. There are countless ways to improve on any fire effects animation, simply by adding to its dynamic interface.

Smoke also can benefit enormously from our understanding of dynamic design and animation. All too often I have seen 3D computer-generated smoke animation that is extremely uniform and uninteresting looking even in very big budget live-action films. It seems that as long as it sort of *looks* like smoke, nobody seems to care if it doesn't really *act* like smoke. Long columns of smoke rising in the distance after a battle has been waged frequently look like perfectly symmetrical columns rising upwards, as if there is no hot and cool air to create more interesting shapes as would invariably happen in reality. And as animators, we need to exaggerate even reality and push the design and movement of our smoke animation even farther.

I have been warned repeatedly as an author to avoid repetition as much as possible. Good advice for animators too! But repeating my message of exaggerated dynamics, is a cornerstone of this book. I don't think it can be over-emphasized when it comes to animation. Do not let the computer do your thinking or animating for you! If you do, the results will be mediocre, lifeless and uninspired. Bring your imagination, and your knowledge of what makes great animation great, to every element that you create.

Fire and its smoke is wildly exciting, incredibly dynamic and unpredictable stuff. And if if we inject the power of our imaginations into it, it can be *even more* exciting for our audiences to watch!

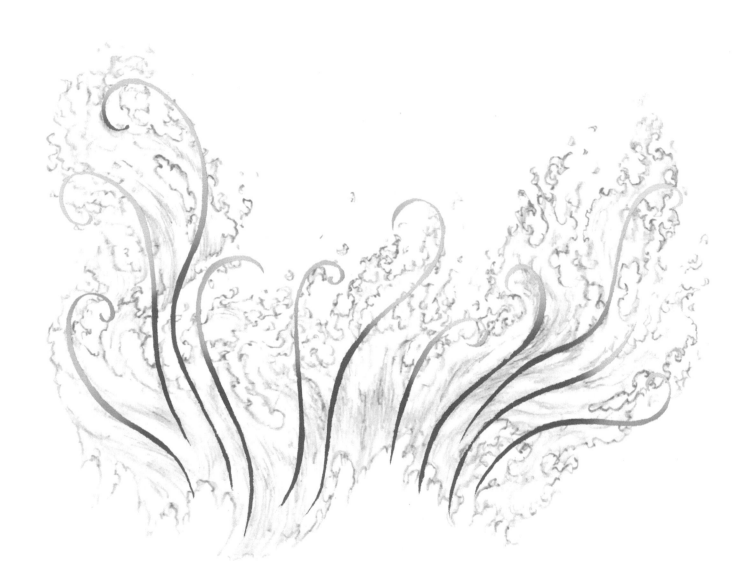

Chapter 6

Magic

Often when I try to describe special effects animation to my friends who are not in the animation business, I will mention "pixie dust" as one of the common effects elements that we deal with. This inevitably brings oohs and aahs of familiarity, enchantment and curiosity. Humankind has always had a love affair with magic and it seems to transcend the humdrum routines that we've mostly come to accept as reality. In the world of special effects animation, it is no different. I have yet to know an animator who doesn't feel a wonderful creative release when working on "magic" effects.

With magic we are able to shed the rules of physics that govern most effects animation, and invent our own set of physics or lack thereof. Magic sets us free on the page. Free to defy gravity and transform objects at will.

We are free to conjure up visions from our subconscious, free to break out from the boundaries of what is possible in our mundane day-to-day life! Magic is by far the most open-ended category of special effects animation. An entire book could easily be written about this fascinating artform.

Sometimes what helps something to appear magical is the simple fact that it does not follow the same set of natural principles that govern the physics of our material world. For instance, any object that appears to defy gravity immediately appears magical. All we have to do is make a chair float several inches above a floor, and our rational minds assume that magical forces must be coming into play.

This is the same drawing from the preceding page. Here it is right side up, as it was originally drawn. I flipped it upside down on the previous page to illustrate just how well it can work, to break the rules, and defy all natural physics, when we are creating magical special effects.

However, the physics governing the movement of elements like water, fire or smoke can and should be brought into play when animating any kind of magical effect. Just as we can lift visual design cues from natural phenomena when designing the look of our magic effects, so can we pull from our arsenal of natural effects physics and energy patterns when bringing those designs to life.

For instance, pixie dust emanating from a magical wand can incorporate many of the same energy dynamics as a plume of smoke coming off of a stick of incense, or it could take on the look and dynamics of a water skier's wake as he carves through a lake's surface.

Where magic is involved, a director frequently won't really know what he or she is looking for until they see it! That is when a special effects artist with a good knowledge of elemental energy, and a loose drawing hand, can come up with something fresh to spark the director's imagination.

The difference in the dynamics is that when we are animating pixie dust, we can depart from the worldly physics of elements like smoke or water at any moment in our animation and create a magical dynamic of our own. This is of key importance when animating magic effects. To invent and describe our own set of dynamic rules, so that whatever the magical effect we create, no matter how bizarre or unusual, it will appear to have an internal logic of some kind governing its design and movement.

One of the best ways to proceed when animating something that you want to feel magical, is to start out with a solid design based on what you know about creating good organic special effects elements. Then, animate it in a completely different way, giving it a life of its own. I used this smoke elsewhere in the book to illustrate linear smoke design. But if we animate this smoke as if it was rising up like a snake out of a basket, pausing, hesitating, shooting forward and such, it would not feel like smoke at all, but more like a self-willed spirit rising up out of the cauldron.

This can help our effects appear to have been created by a higher intelligence, as in the case of an alien abduction, or a fairy godmother granting a wish, or a burning bush in the desert. Even though we are creating something completely outside the normal sphere of natural phenomena, imbuing our magic effects with a look and feel of internal dynamic logic helps us to make the unbelievable, believable.

In these colored key frames of animation, we can see that the "smoke" rising up out of the cauldron does not behave like real smoke at all, but instead has somewhat of a mind of its own. Simply by breaking the rules of what smoke does naturally, we can immediately give this effect a magical feeling. It can shoot up quickly out of the cauldron, and then pause, almost as if thinking, and sniffing the air before continuing upward. It can even recoil, and pull back at certain points. Any departure from normal smoke physics will help the audience know that this is an element of magic.

Magic effects can be represented in an infinite variety of ways.
Defining and categorizing them is impossible in a way, and its
infinite nature discourages me every time I try. So I'll touch on the
few definable principles that make magical effects animation look
magical, and from there, perhaps this most ethereal and mysterious
form of special effects animation elements will reveal itself to us.

Let's begin with the design aspects of magic effects. While the parameters may be less restricted than those of a naturally occurring physical phenomenon, we really need to keep in mind all of the design principles which apply to other more natural types of effects. Good design is good design after all. Watch out for the tendency to create repetitive or twinning shapes. Always avoid perfect symmetry (unless of course it is specifically called for by the director). Keep your silhouettes dynamic and interesting to look at, play inventively with positive and negative spaces, and always think of the core energy underlying your designs.

Here is a concept drawing that I did for directors Aaron Blaise and Bob Walker for Walt Disney Pictures feature film, "Brother Bear". The idea was that a beam of liquid light would shoot down from the sky and create a pool of magical liquid with a beam of light in the center, that the film's hero, Kenai, would then wade into. This was the beginning of the film's "transformation" sequence in which Kenai in transformed into a bear.

Here we see frames from the transformation sequence that ended up in the film, very similar in look to the original concept drawing. The liquid tendrils in the first frame were created entirely in 3D CGI, and then as the beam became more intense and focused, as we see in the second frame, additional hand-drawn elements were added around the CGI element. Many tests and months of development went into making the CGI and hand-drawn effects integrate together to achieve the look of the original concept sketches.

As the beam impacts the ground, the splashes that explode outward were entirely hand-drawn effects animation. This helped to keep the overall look of this magical effect very well integrated with the art direction of the film. It was felt that an entirely computer-generated magical element would have lacked the organic feel that we were able to achieve with hand-drawn effects. But no matter what technique is used for the final effect, great effects animation still depends on a fertile, well-informed imagination and a skilled drawing hand at the stage of the initial concept.

Even when we are creating shapes that are intended to look repetitive, an effort should always be made to inject some variety into our shapes. We find that the shapes inherent in the natural phenomenon we study can adapt well to the world of magical elements.

A wizard conjuring up some sort of a spiritual entity from a bubbling cauldron magical brew may very well produce a shape that is very much liquid-like in its appearance, and might resemble a waterfall falling upwards! A common dynamic of many magical effects is a spiraling vortex of energy, much as we might see in a small whirlwind or a mighty tornado.

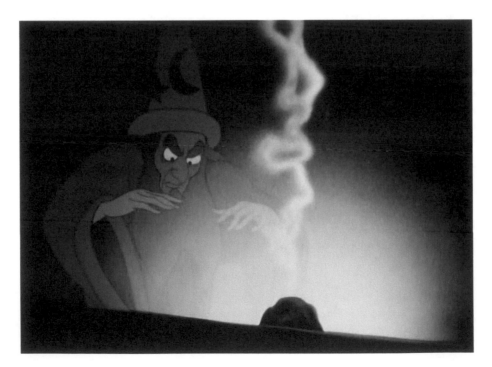

© Disney Enterprises, Inc.

In "The Sorcerer's Apprentice" segment of Walt Disney's classic Fantasia, the wizard conjures up a fantastic bat-like demon creature that then morphs into a beautiful butterfly. This is magical animation at its best, starting out as simple rising smoke, but then taking on a very magical life of its own.

© Disney Enterprises, Inc.

This energy vortex could very well be added to our magical wizard's apparition. This spinning vortex of liquid magical energy might appear to be filled with smoke or steam, or pixie dust behaving much like snowflakes. The possibilities are endless, fantastic, challenging and fun! We can imbue our effects designs with visual cues lifted from all the other natural effects elements, and add our own twists and turns wherever we please.

Attempting to imply scale and perspective in our magic effects can be extremely difficult because we don't have any of the normal reference points that we do when we are creating effects elements which commonly occur in real life. So we need to exaggerate our scale and perspective even more than we do with special effects in general, when we are animating magic.

We can approach this in a number of ways. In order for our magic effects to appear massive, we can add a great deal more detail, which can be an effective way of suggesting scale. We can give our animation even more scale by slowing it down a great deal, almost making it slow-motion.

In cases where magic effects are moving in perspective, it is important to really exaggerate our drawings as much as possible, pulling closer effects out toward the viewer, and pushing and pinching into forced perspective the effects which are farther away. Don't forget, we can always push our drawings a little farther!

This pixie-dust sequence is from the Don Bluth film, "Thumbelina" that was released in 1994. As a directing special effects animator, I was given the task of animating a great deal of pixie-dust. At the time, CGI animation was still very much in its infancy, and creating pixie-dust like this using 3D particle emitters, as is frequently done today, was not yet an option. This scene in particular was extremely difficult and painstaking, as it was over 30 seconds long and all of it had to be

drawn on one's, that is to say, 24 drawing per second, because the artwork was panning and would strobe disturbingly if not done this way. In the last couple of decades I have had the opportunity to work more and more often with computer-generated special effects, and in particular, on pixie-dust. When I was special effects director at the Walt Disney Animation Services department, one of my tasks there was to digitally create pixie-dust that looked exactly like classically animated

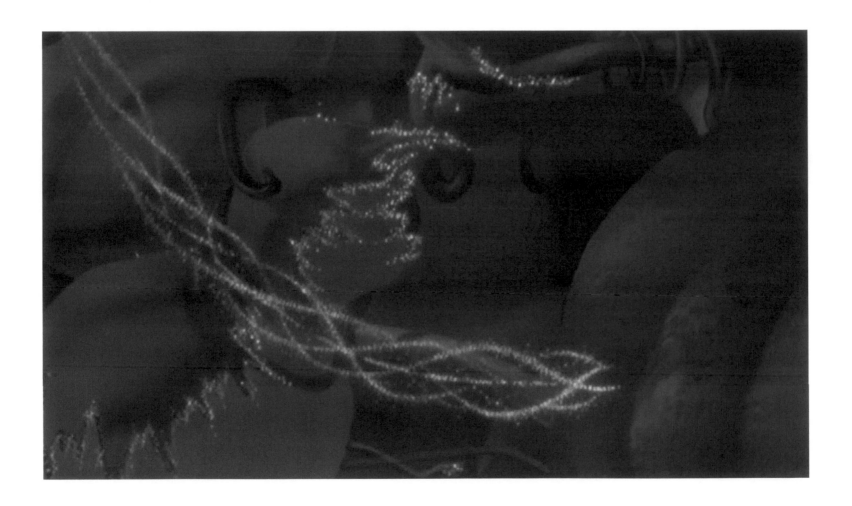

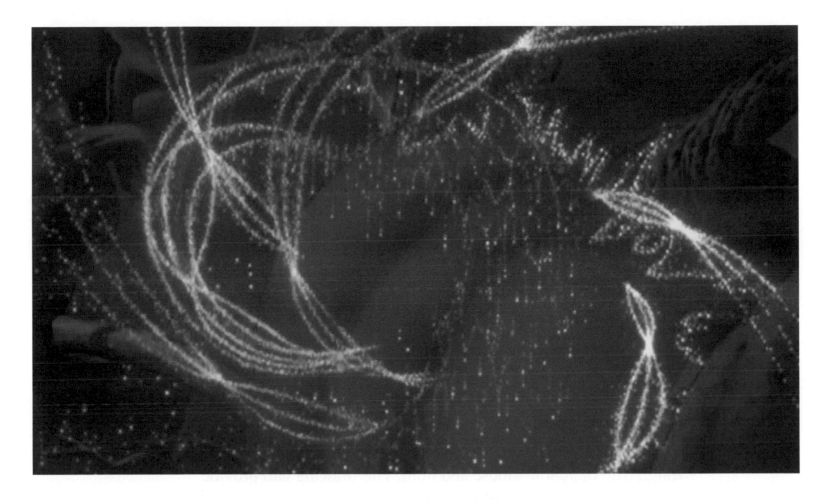

pixie-dust from the Disney classic, "Peter Pan". What I found out was that to create pixie-dust as complex, variable, and organic—as what is pictured here, was extremely difficult using CGI particles. The difference was that as I was drawing the pixie-dust by hand, I was able to improvise. I split the pixie-dust into several streams, spiraled them around each other, and varied the speeds and behaviors of all the particles intuitively, spontaneously, and at will.

To do this with computer animation, the behavior of every individual particle needs to be described to the computer. This is not impossible, but when we are doing it by hand, it is a split second creative decision, rather than a technical exercise of figuring out precise mathematical coordinates. Fantastic organic-looking effects can be achieved digitally, but tweaking individual particles intuitively, and unpredictably on the fly, is far more easily achieved by hand.

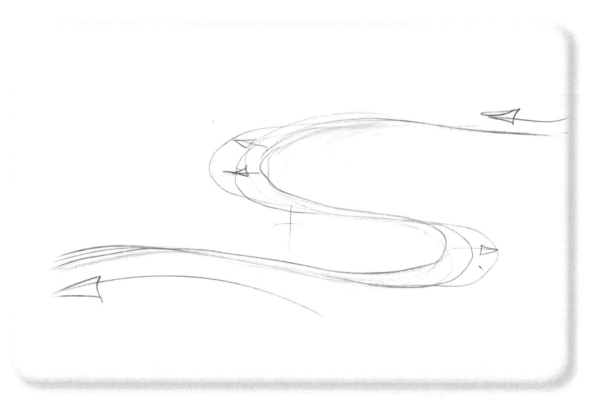

When animating classical pixie-dust, it is best to begin with a very
rough path of action—loose and fluid. This drawing will provide
the underlying structure of your effect. When you are ready to
animate, don't start out by drawing lots of little dots of pixie-dust!
As with any and all special effects animation, the looser and more
energetic your initial drawings are, the more fluid and dynamic
your animation will be. So forget about the details at first, and just
animate with as much fluidity as possible.

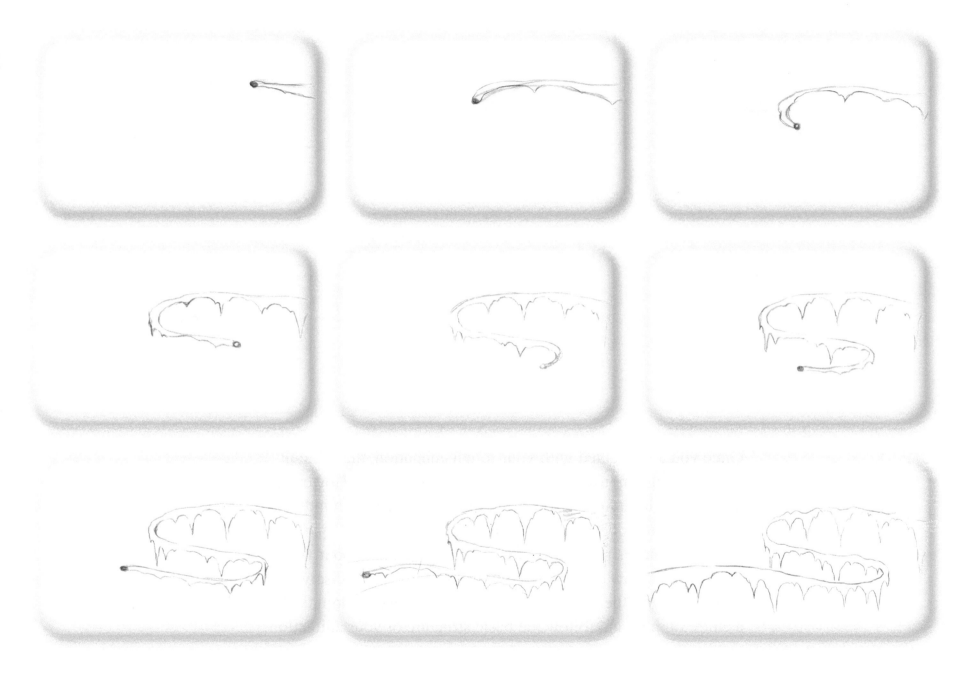

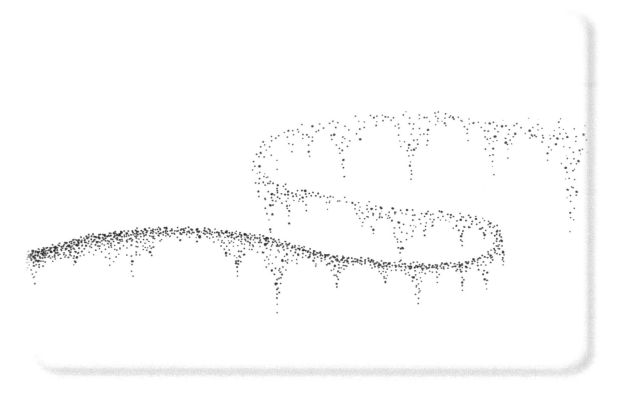

Once you are satisfied with your rough animation, the difficult task of adding thousands of pixie-dust points begins. However, this need not be as tedious as one might imagine. Keep in mind that a certain amount of randomness will add to the magical, sparkling effect that makes pixie-dust look so fantastic. Only about 10% of the dots you draw actually need to follow through precisely from one drawing to the next, the majority can be very random, as long as they support and follow the basic structure of your animation.

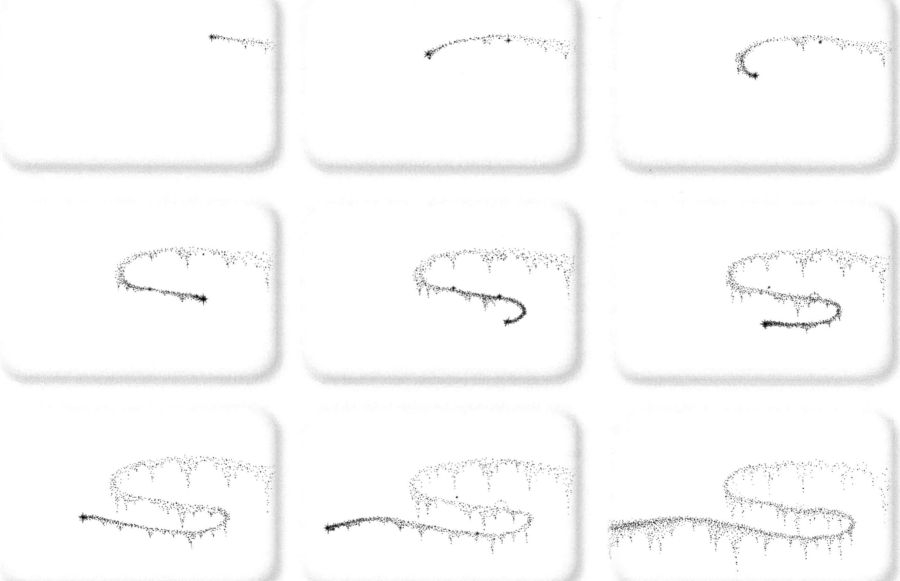

Digital Magic

Magic, of all the elements discussed in this book, is perhaps the element most well suited to digital techniques. One of the greatest challenges that face computer animators is to coax something that looks natural out of a machine that by its very nature creates perfectly logical (by mathematical standards) and frequently un-natural looking movement. Character animation, and effects animation created on the computer by less experienced artists, who lack the foundational knowledge of classical animation techniques, looks lifeless and overly smooth.

Left to its own devices, and without the dynamic use of strong, pose-driven animation, a computer will invariably give us a mathematically sound, yet artistically flat performance, no matter what it is that we are attempting to animate. In the world of magic, however, computer animation can be a truly fantastic tool, because here what we are attempting to create is something that feels un-natural. It is for this reason, that so much of the computer-generated magic that we see in feature films in the 21st century really does work extremely well.

The case for computer-animated special effects magic is not hard to make. Experiencing the simplicity with which computers can create extremely complex magical effects, that would never have been possible in the days of classical hand-drawn animation, is an exhilarating experience for an *old-school* animator. However, not all is so wonderful when attempting to create magical special effects on a computer.

As long as the effect we are creating has no basis for comparison—as long as it is purely a flight of fancy—computers are incredibly well suited to the task. But if we are trying to re-create a magical effect that has already been done extremely well in the classical hand-drawn technique, then recreating it on a computer can be a very frustrating and complex affair. Making minute adjustments intuitively, moment-to-moment organic tucks and nudges to our animation, does not fly well on a computer. Computers need to be given all the information ahead of time. Improvisation is not the computer's comfort zone! My own first-hand experience at attempting to recreate convincing *"Peter Pan Style"* pixie-dust at Walt Disney Studios in 1994, using particle-generating CGI technology, showed me just how difficult computers are to manipulate frame-to-frame.

It is not extremely difficult to come up with very interesting, elegant and visually stunning pixie-dust type effects on a computer, but to create something that looks hand-drawn, is almost impossible. So, why even bother? The way I see it, if we want old school Peter Pan style pixie-dust, we should just create it the same way they did way back in 1953. Computers should be used for what they are best at, not for trying to recreate classical animation.

Where computers really shine is when we can input vast amounts of complex data governing countless attributes. Give the computer a path of action, a starting point and an end point, and just let the digital magic unfold.

The basis for particle-generated special effects, is what is frequently called a particle emitter. Imagine a point in space, or a shape like a sphere, that creates points of light or energy, and then spits them out into 3D space. The effects animator has control over an incredible array of forces that act to move these particles in an infinite number of ways. They can be affected by gravity or reverse gravity. They can expand outward at any variation in rate of speed, or they can be caught up in a spinning vortex of turbulent energy. They can change size, shape, and color, as they are caught up in these forces. The variations are as infinite as are the incredible numbers of particles that we can manipulate in this manner, given adequate computing power.

With this incredible technology, special effect artists have been given an entire new world of possibilities. We can now go far beyond the constraints of pencil and paper, into the magical realms of unfolding fractal geometry and vision unlimited by numbers or visual complexity.

However, all of the classical sensibilities that I have touched on in this book still hold the key to creating lively, dynamic and captivating visual effects. If we allow our computers to do all the work, the results will be lacking in vibrancy and vitality. Not enough can be said about the importance of the human, or natural touch, when we are creating animation of any kind, and special effects magic is no exception. In fact, there are no exceptions.

Every day, whether we draw on paper or fire up our computers, the magic we are looking for is in our hearts and in our imaginations. Keep this in mind always. Bring it to the forefront of all you do as a special effects animator, and the magic will appear before your very eyes.

Chapter 7

Props and Everything

Can you imagine: Arthur ruling Camelot without his trusty sword, Excalibur? Luke defeating the Empire without his light saber? Indiana Jones surviving one archeological boobytrap without his bullwhip? John Henry beating the steam drill without his hammer? Bruce Lee facing a cadre of ninjas without his nunchucks? The answer in all cases is an emphatic "No!" In all five examples, these props are extensions of the character's personality, signifiers of strength or ingenuity. But props don't have to possess such masculine traits, they can also act as more benign, feminine metaphors, such a young girl's doll, a child's storybook, or Cinderella's glass slipper. In the case of Disney's film the legend of Mulan, her choice of props reflect her shifting character: A jade hair comb remains part of her feminine costume until she symbolically casts it away (along with her role as a naïve girl), only to replace it with her father's helmet, armor, and sword (accepting the role of a male warrior).

Props can also be signifiers of magic, wisdom, or judgment—such as Moses with his stone tablets, Gandalf with his staff, Father Time with his hour glass, the Grim Reaper with his scythe, Harry Potter with his wand and broom, or Thor with his hammer, Mjolnir. Props can even represent a character's weakness, imminent danger, or futility: Jacob Marley beset with his heavy chains, the White Rabbit antagonized by his pocket watch, Sisyphus forever pushing his boulder up the mountain, Snow White eating her poisoned apple, or the Little Match Girl shivering with her last warmth-giving matches.

In the world of traditional animation, "props" are defined by their
function and utility. For instance, Cinderella's glass slipper is
a costume element, but once it is separated from her body it
becomes a prop. A boulder, on the other hand, is not a man-made
object, it has been shaped over time by natural forces, and as such,
it is a background element … but once Sisyphus starts push-
ing it up the mountain, it becomes a prop. As a rule of
thumb, if an organic element, such as a tree branch,
a rock, or a pine cone, becomes utilized by

another life form, or if it moves as the result of
gravity, wind, or pressure, it can be construed
as a prop. An inorganic element, such as a
toaster, an incense burner, or a computer, can
automatically be viewed as a prop because
of its inherent function, but it must also be
"active" (that is, either a character or a force
must utilize it … otherwise, in the world of
animation, it would merely remain part of the
layout).

This toaster, should it remain in its static state, would be a part of the scene's background layout, and as such, would not need to be handled by the special effects animator. However, as soon as the toaster is moved in any way, it becomes an animating prop—as we see in the subsequent drawings—as the toaster springs into life, exploding violently as the toast is shot up out of it. In cases like this, a solid, inanimate object can become as volatile, stretchy, rubbery and animated as any animated character. This is very important to remember when modelling and rigging a prop in CGI, that may need to animate. The prop may need to be able to stretch and distort quite wildly, in order to give it the kind of life it needs, to be at home in an animated cartoon!

The possibility of exaggerated physics is very important to consider when animating a usually inanimate object like this toaster, whether we are animating it by hand or as a digital 3D object.

Combining organic elemental effects with our prop animation is frequently necessary. A smoking toaster, a breaking teapot full of tea, a gun firing, or two cars smashing into each other will require all kinds of organic effects. Explosions, liquids, sparks, dust, fire, or smoke can be used to add life to our solid, inorganic props.

Let's talk a little more about a prop's function versus its utility. If you're a pacifist, like me, you probably wouldn't know what to do if someone gave you a Colt 45 handgun for a Christmas present. After all, its function is quite clear: It is designed to kill or injure other life forms. However, if I were a mad inventor, I could reconfigure the gun as a kitchen utensil by putting an egg beater in the barrel, then using the trigger to regulate the speed of the beater's rotation. I have thus altered the gun's original function by utilizing it to make a nice cake for my mother. Yet as artists, we have more to consider than function and utility we must also consider design and aesthetics through both line and shape.

Let's imagine that the gun was an old-fashioned Colt six shooter, with a revolving barrel and a spur hammer. I might want to choose an eggbeater from that time period to match the Old West style, as opposed to a more modern version; otherwise, I run the risk of creating an "anachronistic" design. (A perfect example of an anachronism is a Roman soldier in "Ben Hur" wearing a modern wristwatch).

In Disney's "Lilo & Stitch," director Chris Sanders determined that the main style for all the props, characters, backgrounds, and natural effects, had to maintain a curvilinear simplicity. Therefore, all props with sharp angles and rectilinear lines had to be reconsidered as rounded off, "bowed-out" shapes, with thick-and-thin lines to match the character. He put it rather succinctly: "Imagine taking a bike pump and filling every prop with air."

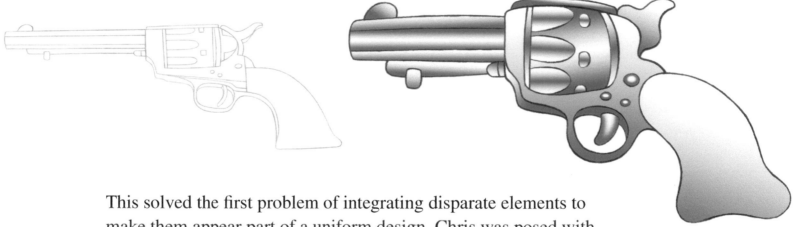

This solved the first problem of integrating disparate elements to make them appear part of a uniform design. Chris was posed with an interesting challenge: How could he integrate the alien culture with Hawaii from the 1950s (replete with hot rods, Elvis, and Tiki bars)? He decided to look no further than the shores of Kauai, creating a stylistic substyle from the depths of the ocean (which is not unlike interstellar space) and its marine life. This is why the alien spaceships, weapons, and armor mimic the shapes of whales, manta rays, and crabs.

Props are so expansive as a group because they cover so many universes, cultures, and epochs, and therefore require copious amounts of research. Oftentimes, the best design has already been fully realized by a culture or by another artist, engineer, or architect (i.e., the cannon designs from both "Pocahontas" and "Mulan"). In most cases, the effects artist will research design motifs and commonalities from a particular culture, or a group of cultures, and create an "amalgam design"—that is, an object which combines the best elements from a host of other designs.

For instance, I may want to illustrate a Chinese vessel with the overall shape from a typical T'ang Dynasty piece, but complement it with patterns and illustrations from the Shang Dynasty. Please note that the more complex a pattern or texture, the more you should push to simplify. It's not necessary to draw every thread of a wicker basket or every link in a piece of chain mail. When designing props for animation, try pushing the detail until the design fails, then minimizing the detail until the design fails—the perfect iteration will lie somewhere in-between.

One technique I use to "see" a prop without so much detail, is to squint when looking at it. When we do this, we see less detail and more of the shadows and light that define the object. The photo on the right on the preceding page has that simplified look. From there we can design a concise, simple version of the object, as in these two drawn versions. Shading can then be applied to add lighting to the line drawing.

This bamboo and wicker chest has a great deal of detail, and it would be almost impossible to draw every tiny little line and shadow. The drawing on the right is vastly simplified, yet it still communicates clearly exactly what it is we are looking at. This technique can be very helpful when designing and modelling 3D props as well.

There are times when a prop's scale can give a story more meta-physical menace. For instance, what kind of threat would Darth Vader and the Emperor have posed without the Death Star? And would the Borg Queen from Star Trek have been as threatening without the Borg Planet? From H.G. Well's ominous tripods to John Henry's nemesis, the steam drill, oversized machines have become the modern equivalent of the bad guy par excellence. In "Howl's Moving Castle," the castle has both menacing and be-nevolent overtones, a force of nature and a personality at the same time. Once a prop becomes imbued with too many human attri-butes, however, it becomes a character in its own right.

Props with complex moving parts, particularly machines, are the most difficult to conceive and animate, which is why many enterprising directors will utilize computer graphics in a traditional picture. This saves the animator from copious amounts of pencil mileage and three-point perspective headaches—the key is to not let the CGI in these instances diverge stylistically from the rest of the picture. Because of these breakthroughs in visualization aids for complex man-made props, we will narrow our focus to organic props (and perhaps some simplified inorganic props, like bottles), both in terms of their design and structural variability.

Stitch wielding a Volkswagen Beetle, is a great example of a CGI prop, well designed to integrate with a 2D cartoon environment.

© Disney Enterprises, Inc.

Perhaps the most complex prop is cloth, as it straddles the worlds
of the inorganic and the organic; after all, it's made by human
hands, but it's structure is mutable like an effect element. We could
dedicate an entire book to the behavior of cloth, particularly as
it relates to the human figure, but that would use up the rest of
this guide (so I'll refer you to an excellent resource by Barbara
Bradley: "Drawing People: How to Portray the Clothed Figure").
However, I will touch on the main folds and talk a little bit about
methodologies for drawing cloth as it is affected by various forces,
such as wind or gravity.

One of the most difficult problems from my early days as an animation student was the flag test. The goal is simple: Take a flag hanging from a flag pole and make it flap with a large gale of wind. Sounds simple, right? The first thing to consider is that the "shape" and direction of the wind must manifest in the interior folds and the exterior silhouette (imagine how wind might affect a wheat field). The trick is to maintain the sense of the flag's volume, while simultaneously collapsing and expanding convex and concave masses.

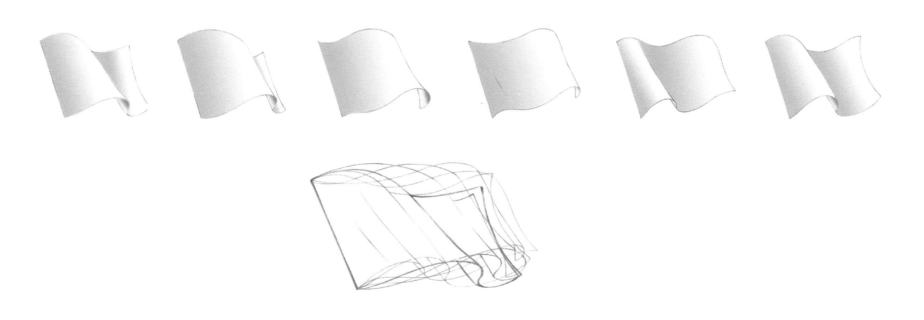

The most common types of folds are pipe folds, diaper folds, zigzag folds, spiral folds, half lock folds, falling folds, and inert folds. A pipe fold looks like it sounds, it's a long, cylindrical fold with a concave surface that begins with a pinched top and flares slightly outward toward the bottom. If you hang a robe on a hook, these will most likely be the types of folds you will see. A diaper fold is the result of cloth being suspended from two contact points. If you take that same robe and hang it from two hooks, the resulting pipe folds will meet in the middle, causing them to crease into one another. Zigzag folds are a series of tight, interconnected back-and-forth folds, creating a zigzag pattern.

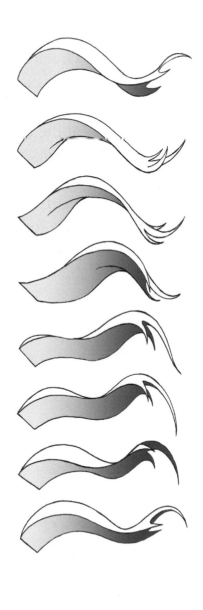

We typically see these types of folds in complex ribbon-work and in crimped dresses. Spiral folds are small, cylindrical convex folds that wrap around arms and torsos with lighter types of cloth. Most Greek sculptors employed an inordinate amount of spiral folds in their clothed figures. Half lock folds occur when a character bends a leg or an arm, thereby creating a series of interconnected folds at the locus of the joint. Falling folds occur when a hanging cloth begins to collide with a surface, causing the bottom part to bunch up in a complex array of folds. Lastly, an inert fold is just that— inert. There are no underlying forces or geometries affecting its makeup, it's just a random piling or bunching of folds. The best example of this is an unmade bed.

Drawing folds well is an art form unto itself. When animating any kind of cloth or fabric, clothing or hair, simply apply the same animation principles that apply to all effects. Wave and whipping actions, overlapping timing, follow-through, and weight. Keep in mind that the texture, softness, stiffness, or thickness of the fabric will affect its behavior as well.

Organic props, as we mentioned, are things which occur in nature
that have not been manipulated by a living creature, but never-
theless have been made "active," either by a character or a force.
Leaves, grass, pine needles, branches, rocks, ice chunks, dirt clods,
flowers, fruit, vegetables, etc. all fall under the umbrella of organic
props. For more dynamic representations of these props, remem-
ber all the design pointers from the earlier chapters: employ big,
medium and small shapes, utilize asymmetrical silhouettes, avoid
"twinning" of similar shapes and patterns, and avoid parallelism by
"pinching" shapes wherever possible. Be very careful not to create
"buzz-saw" designs with repetitive shapes in grass and hair. There's
also the temptation to make leaves wholly symmetrical, both the
outward silhouette and the interior network of lines … but again,
in nature we never see perfect bilateral symmetry, unless we're
focusing on a microcosmic, fractal level.

Animating leaves is similar to animating cloth, though a leaf has
more tensile strength and does not form complex, interweaving
folds. It will rotate, twist, and bend, however, when blowing in
the breeze. When clumps of leaves move in the wind, the overall
mass will follow a general path of action, just like a flock of birds.
While some leaves will spin off from the main group and do their
own thing, the main body will move together, each leaf maintain-
ing its own discrete rotation and twist.

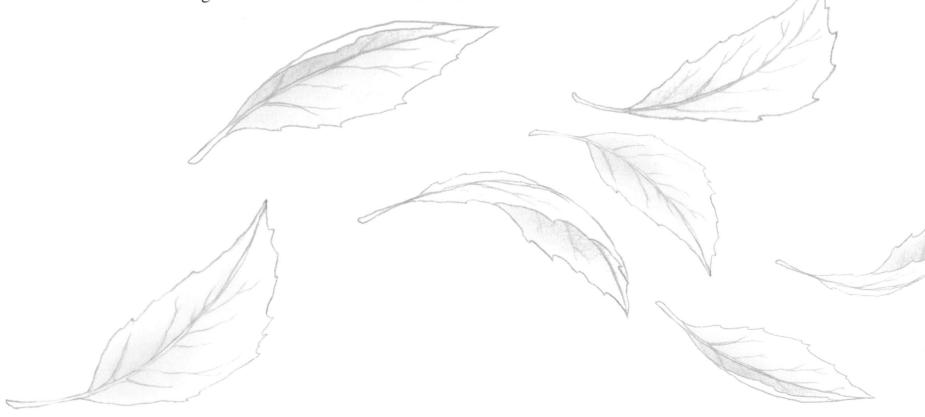

There are literally hundreds of overlapping actions in this type
of phenomena. So what is the difference between leaves blowing
freely in the air, versus leaves blowing in a bush or a tree?
There are similarities, but in the former example, the leaves are
connected by a common network of solid bodies—the branches.
Just as the head is the unwitting passenger on the human body,
a blowing leaf must follow the primary path of the branch first,
regardless of how it reacts to the wind. This is why it is critical to
animate branches before leaves!

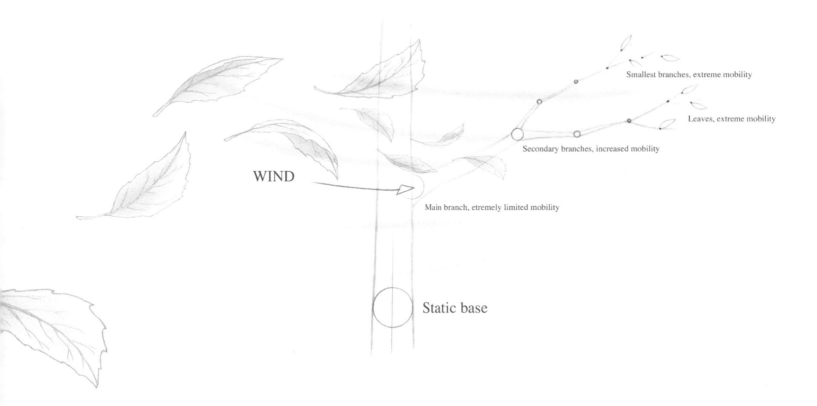

Smallest branches, extreme mobility

Leaves, extreme mobility

Secondary branches, increased mobility

WIND

Main branch, etremely limited mobility

Static base

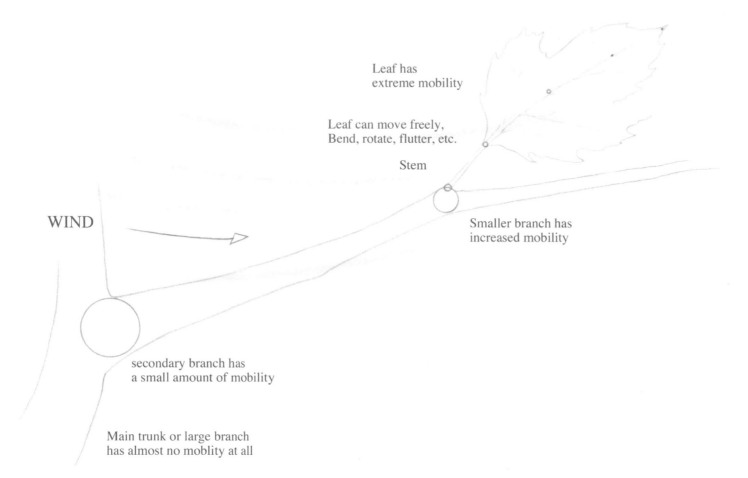

Leaf has
extreme mobility

Leaf can move freely,
Bend, rotate, flutter, etc.

Stem

WIND

Smaller branch has
increased mobility

secondary branch has
a small amount of mobility

Main trunk or large branch
has almost no moblity at all

When animating branches and leaves moving in the wind, it is
helpful to break down the structure of a tree into its main trunk,
largest branches, smaller secondary branches, and so on down to
the smallest leaves, flowers, fruits, seed pods, etc.

The same technique can be used when animating a wide variety of props and anything with an underlying structure that is being blown in the wind. Before beginning your animation, imagine you are engineering the element from its structural base. The more you understand the characteristics of its materials, the easier it will be to animate.

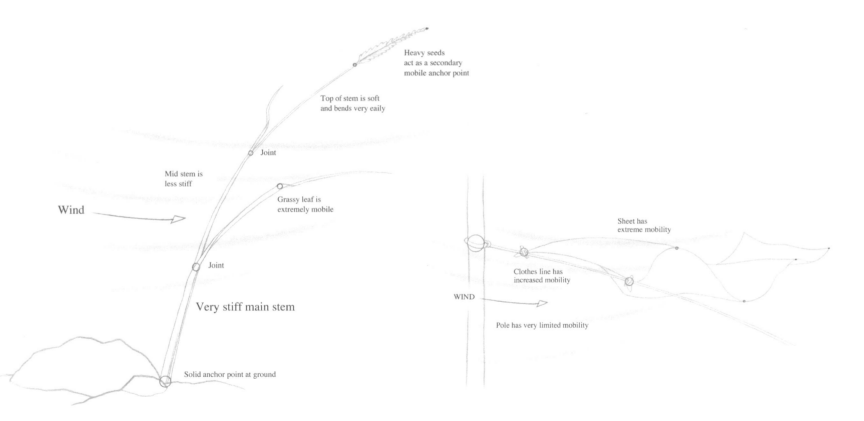

Sometimes a gust of wind is so strong that it actually manages to break a large branch off of the main body of a tree. There are dozens of parameters that determine how that break will occur. If it's a younger, more resilient tree, the branches may have more spring to them. The resulting break may look like this. If the branch is older and dryer, the shattering effect may be more explosive and contain far more smaller bits of wood debris. Yet there are other things to consider that may affect the outcome, such as the intensity of the wind, the size of the branch, or the type of tree. The design of the break and the behavior of the shattering debris is dependent on all the aforementioned scenarios.

The wood debris will explode out from the center of the break much in the same way water splashes outward in proscribed paths of action. The larger pieces will have more hang time and generally rotate slower than the smaller pieces, and again, it's important to employ big, medium, and small chunks with varied timings.

Collisions of solid bodies and explosions are affected by gravity, wind, air pressure, the velocity of the impacting force, as well as the physical makeup of the object (or objects) being affected. In 3D dynamics, an animator will tweak these forces bit-by-bit and has the latitude to run many simulations of the colliding bodies. The 2D artist must use more planning and commit to a final choreographed scene before committing pencil to paper.

Perhaps the most dreaded visual effects problem an animation stu-
dent can be assigned is the breaking teapot test. The parameters are
simple: Animate a teapot half-filled with liquid dropping from
12 o'clock (as opposed to entering the scene at an angle) and impact-
ing the ground in the center of the field. In this instance, gravity is
the only physical force defining the outcome. After viewing hun-
dreds of feet of visual reference, as well as researching photographic
reference, I have observed the general similarities and created a basic
formula for successfully depicting the collision of the teapot and its
resolution. In most cases, an initial ring of debris quickly forms at
the initial area of impact, with few pieces of the ring overlapping.

Meanwhile, one large piece will remain intact, moving at a slight angle away from the center; sometimes this piece will spin around as it moves, then will settle on the ground in a rocking type motion; other times this piece will break into two or three smaller pieces as it resolves. In the interim, there are many pieces that fly out-of-screen, or that spin like coins as they spread out from the center. There will undoubtedly be a variety of shapes and sizes, and at least 50 to 80 overlapping timings with various pieces of debris. The liquid may also be responsible for the behavior of some teapot chunks, depending on how it reacts to the initial impact. As with the bucket of water putting out a fire, you can see how quickly this problem can overwhelm an animator.

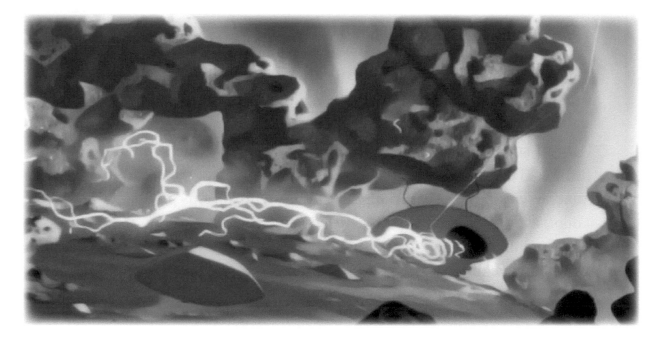

It's interesting to note the similarities between the dynamics of a water splash and an exploding teapot (even if the teapot is empty): Both actions have similar outward thrust, hang times, paths of action, overlapping actions, and concentric rings which form at the base. You can apply many of these principles to larger scale explosions or collisions. Remember that the most critical aspect of scale is the viewer's orientation to the scene. If an explosion of debris happens up close in the camera, the conventions for depicting depth vary. In Disney's "Mulan," the exploding munitions cart is a close-up shot, so the initial thrust of debris clears the field within four or five frames, which is a fraction of a second … this means that new debris has to generate from the center at the fifth frame, otherwise there will be nothing for the eye to hold onto.

In other words, there's simply not enough space in the field to
show how some of the pieces resolve. The same explosion from
the distance would look completely different, however, because we
could see all the discrete paths of action for the resolving debris,
and even watch where the pieces come to rest. Never forget that
it's the forces in nature that create similarities between disparate
actions: the teapot and the splash, the mountain range and the
wave, the crack in the sidewalk and the bolt of lightning. Even ani-
mating a character moving through snow or dirt employs the same
basic tenets of ocean wave timing, with some slight differences.

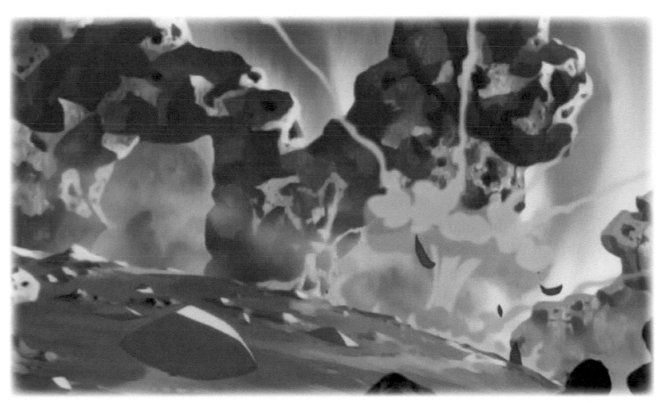

An excellent exercise for learning how to understand how different
materials react differently to outside forces, is to take the standard
bouncing ball animation exercise, and try it with a ball made of
a different material other than a bouncy rubber ball. I have two
examples, one is a ball made of ceramic. Imagine a hollow ball
made out of china, or glass perhaps, falling from a height of one
meter or so, and colliding with a solid, unmoving surface.

The second example on the following pages, is a water balloon
falling from the same height. One of the things that jumps out
at me when I consider these two balls made of entirely different
materials, striking a solid surface, is that the trajectory path of
action, timing and overall energy patterns of the two, are extremely
similar. What does change is the shapes and patterns of the actual
breaking object, dictated by its molecular makeup—the way its
molecules hold themselves together, and the way they break apart
when their ability to adhere to each other is challenged by an
abrupt impact.

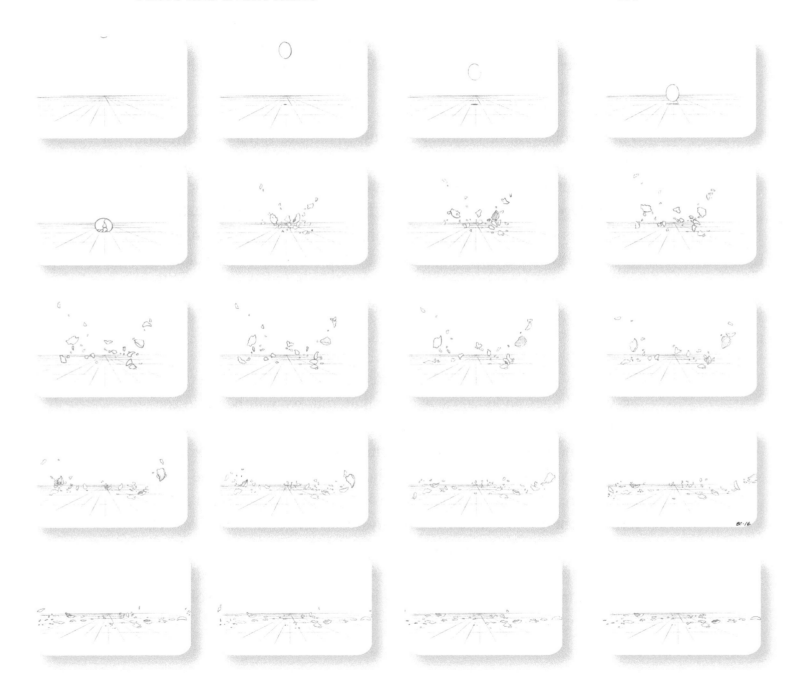

The ability to understand how various different materials behave under stress is a key element in understanding how to animate props well.

This exercise can be conducted using an infinite variety of different materials. Imagine a ball of mud or an icy snowball. A solid crystal ball or metal ball bearing. A ball made out of old, slightly decomposing wood, or a ball made out of fresh hardwood. A delicate Christmas tree ornament, (there's one that's quite easy to imagine breaking!) or a ball made out of putty. Each one of these examples will break apart in its own unique way. The cracks that form will have shapes that clearly indicate the underlying structure of the material.

If we move away from the ball, and experiment with objects of varying shapes and sizes as well as material, we will begin to see even more variables come into play. A randomly shaped chunk of dried cement impacting a solid surface will obviously break up in an entirely different way than a delicate ceramic teapot. The possibilities are endless. However, regardless of the material, the patterns of energy that underlic thc physics of any collision of objects will contain similarities. As with a typical water splash, there is an initial impact, a shooting outward of energy and matter, a slowing down of that energy at the apex of its movement, and a resolution.

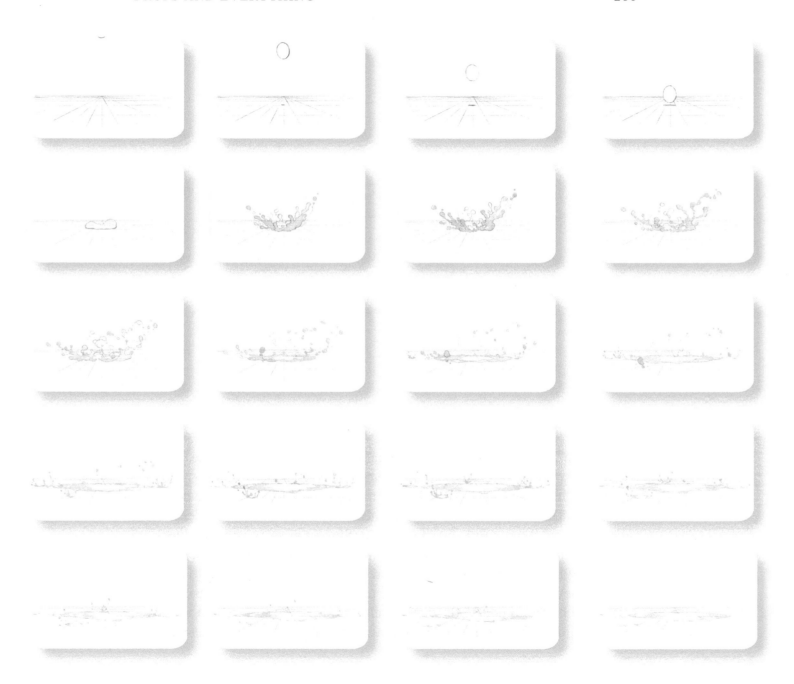

An old brick smashing to the ground breaks up in its own very unique way. There is a specific "brickness" to it, the way the chunks break up into smaller pieces, and the way some of it will be completely pulverized to a fine powder on impact. There is also a particular bounce to a piece of brick. It is dense and quite solid, but it has a little bit of give to it. Since it gives in and crumbles slightly on impact, its bounce is not as abrupt as something like glass, or ceramic. When the smaller pieces that break off on impact fall back to the ground, they will not skitter and slide as much either, due to the abrasive texture of the brick. Of course the density and texture of the surface that a given object collides with has a lot to do with the way the object bounces as well.

An icicle and a snowball, although they may be considered to be close relatives in the world of organic props, could not be more different in the way they react to an abrupt collision with an unforgiving surface. An icicle is extremely brittle, and if it lands on a very solid surface, it will really explode quite violently on impact, with many of the pieces breaking off flying quite far from the point of impact. The pieces break off in pointed shards and very sharp, angular pieces, due to ice's brittle, crystalline nature. A snowball on the other hand, will not bounce at all, but disintegrates into very small chunks of snowy powder on impact. Most of the pieces will not travel all that far, and when they land, they will stop abruptly. Depending on how wet the snowball is, there will be a certain amount of splatter to a snowball's impact as well.

There is no end to the variations you can find in the world of organic prop effects animation. It is exciting and fun to analyze whatever material it is you are going to animate. It is a journey into the molecular structure of the world around us, coupled with the patterns of pure energy that are released when matter collides with matter.

FRAME 0

This is a simple rendition of what a small electric bulb might look like when it bursts. In the first frame we still see the shape of the bulb, as the pieces initially crack up into fragments. In the next two frames, the pieces shoot outwards away from the bulb in an arcing, splash-like manner. This type of glass is very thin and light, and the pieces are quickly slowed by the surrounding air resistance, falling and fluttering, down and away.

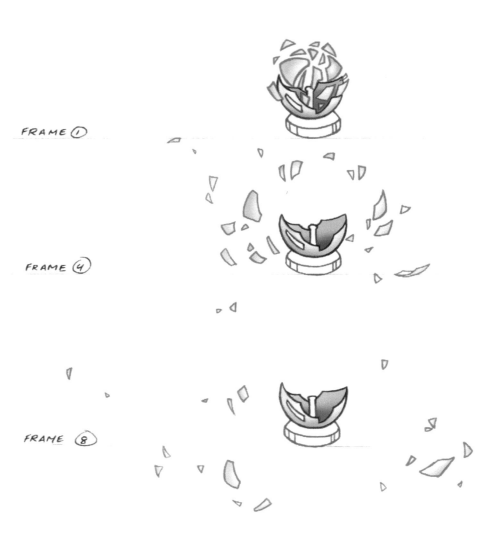

FRAME ①

FRAME ④

FRAME ⑧

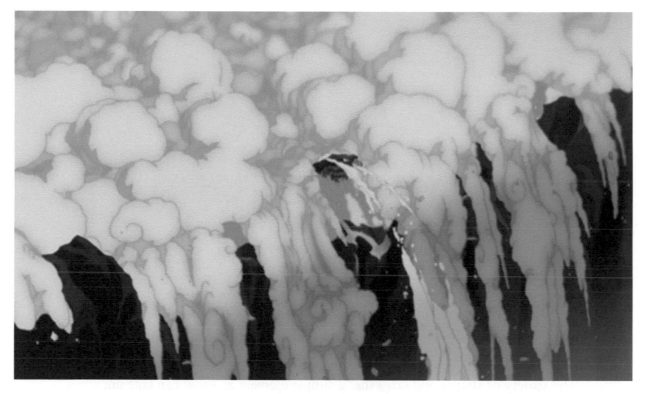

© Disney Enterprises, Inc.

One of the most stunning sequences of special effects animation ever created, was the avalanche in Disney's "Mulan." Taking over six months to animate, it was an extreme example of organic "prop" animation. The idea of animating snow took on completely new meaning, as our team of effects animators drew countless incredibly complex drawings of snow billowing, pouring, rolling, and exploding through the screen. This masterful scene, animated by effects animator Garrett Wren, is a wonderful example of just how complex much of the artwork actually was.

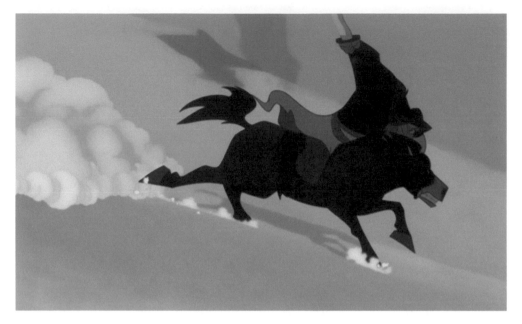

The variety of shapes and sizes that a simple element as snow can take on, were quickly apparent when we we challenged to animate an avalanche catching up to, and overtaking, an army of Huns as they galloped down the side of a mountain. Rolling, billowing clouds of snow needed to be filled with massive sheets of compressed snow, that would explode and break into pieces as the avalanche engulfed everything in its path.

Here we see the leading edge of the avalanche as it catches up to Shan Yu, the evil leader of the Hun army. In this effects scene, the snow began as subtle and delicate puffs of snow and small chunks of snow being kicked up by the horse's feet as he ran full speed to escape the onslaught of the avalanche.

(The sword in Shan Yu's hand also was animated by the effects department, but it was a small task compared to the intensity of the snow animation.)

As the rolling, boiling leading edge of the avalanche catches up with Shan Yu, we wanted to give the impression that within the clouds of snow there were massive sheets of snow crust. So as the billowing shapes overtake the horse and rider, we see the crust explode into chunks as it impacts them. Note the extreme variation in size of the various chunks, and the explosive silhouette of the shapes as they shoot outwards from the point of impact.

When we think of snow, the shapes we see in this scene definitely aren't the first images that come to mind. This is the challenge of animating organic props of all kinds. When objects we are familiar with, like teapots, trees, cars, and snow, are affected by outside forces and brought to their breaking point, fantastic and unexpected visual effects are frequently the result. It is a fascinating and endlessly challenging job to portray these amazing phenomena accurately.

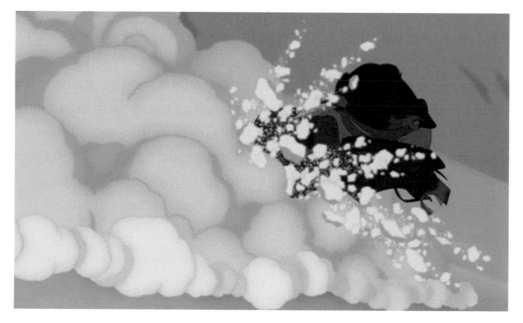

© Disney Enterprises, Inc.

Matter Meets Computer

Of all the effects we have observed and discussed thus far, none is better suited to utilizing CGI animation technology than that of props, both man-made and organic. By their very nature, props lend themselves well to being created in virtual 3D space, much more simply and practically than water or fire.

As far as special effects animation goes, things like doors, cars, pots and pans, trains, planes, bird cages, etc. are by far the most uninteresting and tedious to draw. This is technical drawing at best, or perhaps still life, if we want to put a positive spin on it. Animating rigid objects like this, is incredibly difficult to do, but not at all the same type of difficulty we encounter when animating organic effects like smoke and fire. Rather than "feeling" the energy inherent in an organic effect event, with man-made props we are limited to analyzing geometry, perspective, and minute measurements when we attempt to draw them moving. Only when these objects are broken, smashed, lit on fire or otherwise caused to interact with an outside energy force, do they become interesting to animate.

In the first ten or fifteen years of my career in animation, I was frequently assigned difficult-to-draw, man-made prop scenes, because I was a very accurate and experienced draftsman. My technical drawing abilities were pretty sharp, and knowing this, my supervisors would assign me the most mind-numbingly boring prop scenes to animate. Countless hours drawing door knobs, swords, vehicles and weapons of all description, and yes, bird cages too!

But computers finally came along, and soon I was saved from ever again needing to draw technical, rigid bodied props. Modeling and animating rigid geometric objects is a breeze with computer animation, compared to creating organic effects and characters. A door is such a simple piece of geometry, even a detailed old 17th century castle door can be modeled with relative ease. There are no difficult joints to deal with, no musculature, and no moving skin, hair or cloth to deal with either. And so, by the mid-nineties, the vast majority of rigid props that needed to be animated in big budget 2D animated feature films, was done using CGI technology.

Computer-animated cloth simulation, on the other hand, took much longer to become commonplace. Cloth is more difficult to manage with computers, especially when extremely broad movement is required, or a great deal of detailed overlapping folds. But simpler fabric effects elements are becoming easier and easier to manage, with increased computing power available, as well as more and more sophisticated software, that has specifically designed cloth capabilities.

Exploding, breaking, smashing and destroying props is becoming a simpler proposition for computers to handle extremely well. The only thing we need to always keep in mind, as with CGI character animation and with the organic elements discussed earlier in this book, is that if we are going to animate digitally, we need always to work with the classical principles of good quality animation.

Know the subject matter. Do your research and make sure you understand the material you are working with. Just as a character animator needs to know what inner thought process motivates his character, an effects animator needs to know what physical attributes lay under the surface of any material or prop he or she needs to animate. How much does it weigh, how dense is it? Is is brittle or soft? Do its molecules hold together in a specific way, like the grain of a piece of wood, or the texture of a clump of dried clay?

Then, once the material properties are understood,, we know how it needs to react. We can push the object around, or break it, throw it, crush it, whatever needs to be done. Dynamic CGI effects are complex, and very technically demanding, but if we have done our homework, there is an enormous advantage from the get-go.

We are then more free to focus on the important principles of all good quality effects animation—Energy. Dynamic, flowing, natural, pure energy. Always keep that at the center of your CGI animation. Add to it your understanding of weight, exaggeration, anticipation, overlapping action and dynamic timing, and your effects animation will sparkle.

Chapter 8

The Last Element

Writing and illustrating a book about special effects animation turned out to be a far greater undertaking than I had ever anticipated. Now, in retrospect, I can only see how much ground I did not manage to cover, although I was, to the best of my knowledge, as thorough as I could possibly be. What has now come to light for me is that this topic, this fantastic and utterly unique art form, is truly one of the most vast and varied disciplines in the animation world as we know it.

One has only to go back and read the first couple of paragraphs of Chapter 3 of this book to see what I mean. In that chapter, I ran through an extensive list of special effects elements that I have had to animate through the years. And now that I am finished with this book, how many of those effects did I manage to cover in detail? About half of them.

My experience with animating has made it abundantly clear to me that the art of animating the elements carries with it a learning curve that never ends. Every single time I animate a special effect, no matter how many times I have animated it before, I learn something new about the element I am attempting to create.

I have animated bubbles enough times to tell you that I could easily write an entire book just about animating bubbles. I have animated smoke enough times to tell that a complete book could easily be dedicated to the topic. For all of the elements, without exception, volumes could and should be written.

I wish I had another three or four hundred pages to fill, so that I could finally say to myself, "Now *that* is a complete book on special effects animation!" But as the nature of time and practical conventions would have it, I am out of time, and out of paper to put it all on. I am driven, by some inexplicable reason, to keep at it. Special effects animation has not even begun to tire me out. I return each day to the drawing board, or the computer, as excited about creating elemental magic as I was as a young man in art school over 33 years ago. And I will continue to compile effects drawings, photos, scribbles, notes and the like, as long as I am walking and breathing.

Using the incredible new tools we now have before us, we are only limited by our imaginations. Animation is now an art form where *literally* anything is possible. If we can dream it up in our mind's eye, we can create it. We can even go farther than that, with just a little *more* imagination, a little *more* energy, and just a little more love!

Until next time, keep drawing, keep looking, keep imagining, keep animating, and spill your elemental magic out into the world! Keep asking the questions, keep pushing the envelope, and keep raising the bar on what we can do with our imaginations.

Joseph Gilland, September 2, 2008

Image Credits

All photos and illustrations by Joseph Gilland except those specified here.

Front matter image credits
Figure X15, Page XI – © Michel Gagne
Figure X.10, Page XVII – © Myriam Casper
Figure X.11, Page XVIII – © Andrew Davidhazy, Professor, School of Photographic Arts and Sciences/Rochester Institute of Technology
Figure X.13, Page XX – © Andrew Davidhazy, Professor, School of Photographic Arts and Sciences/Rochester Institute of Technology
Figure X.14, Page XXI – © Michel Gagne

Chapter 1 image credits
Figure 1.1, Page 1 – © Disney Enterprises, Inc.
Figure 1.7, Page 4 – © Disney Enterprises, Inc.
Figures 1.9 and 1.10, Page 6 – © Andrew Davidhazy, Professor, School of Photographic Arts and Sciences/ Rochester Institute of Technology
Figure 1.12, Page 7 – © Disney Enterprises, Inc.
Figure 1.14, Page 8 – © Jazno Francoeur
Figure 1.18, Pages 12 and 13 – © Michel Gagne
Figure 1.19, Page 14 – © Michel Gagne

Chapter 2 image credits
Figure 2.25, Page 19 – © Myriam Casper
Figure 2.14, Page 20 – © Phil Roberts
Figure 2.15, Page 21 – © Photo by Rick Doyle, Drawing by Joseph Gilland
Figure 2.22, Page 25 – © Photos by Rick Doyle, Drawings by Joseph Gilland
Figure 2.52, Page 36 – © Andrew Davidhazy, Professor, School of Photographic Arts and Sciences/Rochester Institute of Technology
Figure 2.66, Page 44 – © Disney Enterprises, Inc.
Figure 2.76, Page 45 – © Michel Gagne
Figure 2.70, Page 46 – © Michel Gagne
Figure 2.70a, Page 47 – © Phil Roberts
Figures 2.72, 2.74, Page 47 – © Disney Enterprises, Inc.
Figure 2.75, Page 48 – © Michel Gagne
Figure 2.69, Page 49 – © Michel Gagne
Figure 2.77, Page 50 – © Michel Gagne
Figure 2.78, Page 51 – © Michel Gagne
Figures 2.106 and 2.107, Page 63 – © 1973, J. Kim Vandiver and Harold E. Edgerton
Figure 2.110, Page 65 – © iStock_000005753923 Photo courtesy of iStockphoto, Scott Vickers, Image #5753923
Figure 2.111, Page 66 – © iStock_000005465093 Photo courtesy of iStockphoto, Nicholas Campbell, Image #5465093

Figure 2.113, Page 67 – © iStock_000005693330 Photo courtesy of iStockphoto, Image #5693330
Figure 2.114, Page 68 – © iStock_000002334436 Photo courtesy of iStockphoto, Image #2334436
Figure 2.115, Page 69 – © iStock_000003289653 Photo courtesy of iStockphoto, Vladimir Sazonov, Image #3289653
Figure 2.112, Page 70 – © iStock_000000484765 Photo courtesy of iStockphoto, Tina Rencelj, Image #484765

Chapter 3 image credits
Figure 3.4, Page 76 – © Jazno Francouer
Figure 3.14, Page 86 – © Phil Roberts

Chapter 4 image credits
Figure 4.2, 4.3, 4.4, Page 88 – © Phil Roberts
Figure 4.5, Page 89 – © Phil Roberts
Figure 4.11, Page 95 – © Andrew Davidhazy, Professor, School of Photographic Arts and Sciences/Rochester Institute of Technology
Figures 4.14, 4.15, 4.16, 4.17, 4.18, 4.19, 4.20, 4.21, 4.22, Page 98 – © Andrew Davidhazy, Professor, School of Photographic Arts and Sciences/Rochester Institute of Technology
Figures 4.23, 4.24, 4.25, 4.26, 4.27, 4.28, Page 99 – © Andrew Davidhazy, Professor, School of Photographic Arts and Sciences/Rochester Institute of Technology
Figure 4.29, Page 100 – © Andrew Davidhazy, Professor, School of Photographic Arts and Sciences/Rochester Institute of Technology
Figure 4.43 Page 109 – © Andrew Davidhazy, Professor, School of Photographic Arts and Sciences/Rochester Institute of Technology
Figures 4.53 and 4.54, Page 115 – Myriam Casper
Figure 4.152, Page 132 – © Phil Roberts
Figure 4.153, Page 133 – © Phil Roberts
Figure 4.154, Page 134 – © Phil Roberts
Figure 4.155, Page 135 – © Phil Roberts
Figure 4.187, Pages 151, 152, and 153 – ©U.S. Geological Survey Photo by D.W. Peterson
Figure 4.205a, Page 155 – © iStock_000004719781 Photo courtesy of iStockphoto, Alexandr Tovstenko, Image #4719781
Figure 4.206, Page 156 – Ice Age: The Meltdown © 2006 Twentieth Century Fox. All Rights Reserved.
Figure 4.207, Page 157 – Ice Age: The Meltdown © 2006 Twentieth Century Fox. All Rights Reserved.

Figure 4.207a, Page 158 – © iStock_000001280939 Photo courtesy of iStockphoto, Jacob Wackerhausen, Image #1280939
Figure 4.210, Page 159 – © iStock_000005578742 Photo courtesy of iStockphoto, Image #5578742

Chapter 5 image credits
Figure 5.109, Page 193 – © 1973, J. Kim Vandiver and Harold E. Edgerton
Figure 5.10, Pages 198 and 199 – © Myriam Casper
Figure 5.122, Page 209 – © U.S. Geological Survey Photo by Jim Vallance, July 22, 1980
Figure 5.127, Page 212 – © USGS Photo by D.W. Peterson, April 12, 1971
Figures 5.129 through 5.144, Pages 214 and 215 – © Michel Gagne
Figures 5.145 through 5.160, Pages 216 and 217 – © Michel Gagne
Figure 5.161, Pages 218 – © Michel Gagne
Figure 5.166, Pages 219 – © iStock_000005406020 Photo courtesy of iStockphoto, Dave Logan, Image #5406020
Figure 5.163, Pages 220 – © iStock_000000302038 Photo courtesy of iStockphoto, Rosica Daskalova, Image #302038
Figure 5.164, Pages 221 – © iStock_000005753923 Photo courtesy of iStockphoto, Scott Vickers, Image #5753923
Figure 5.165, Pages 222 – © iStock_000006255789 Photo courtesy of iStockphoto, Image #6255789
Figure 5.162, Pages 223 – © iStock_000005850595 Photo courtesy of iStockphoto, Image #5850595

Chapter 6 image credits
Figures 6.7, Page 232 – © Disney Enterprises, Inc.
Figures 6.8 and 6.11, Page 233 – © Disney Enterprises, Inc.
Figure 6.13, Page 234 – © Disney Enterprises, Inc.
Figures 6.20 and 6.23, Page 235 – © Disney Enterprises, Inc.
Figures 6.28 and 6.29, Page 238 and 239 – Thumbelina © 1994 Twentieth Century Fox. All Rights Reserved.

Chapter 7 image credits
Figure 7.21, Page 262 – © Disney Enterprises, Inc.
Figure 7.46a, Page 276 – © Michel Gagne
Figure 7.47a, Page 277 – © Michel Gagne
Figure 7.88, Page 285 – © Disney Enterprises, Inc.
Figures 7.90 and 7.92, Pages 286 and 287 – © Disney Enterprises, Inc.

Chapter 8 image credits
Figure 8.1 Page 295 – © Michel Gagne

Index

T - #0664 - 071024 - C328 - 219/276/15 - PB - 9780240811635 - Gloss Lamination